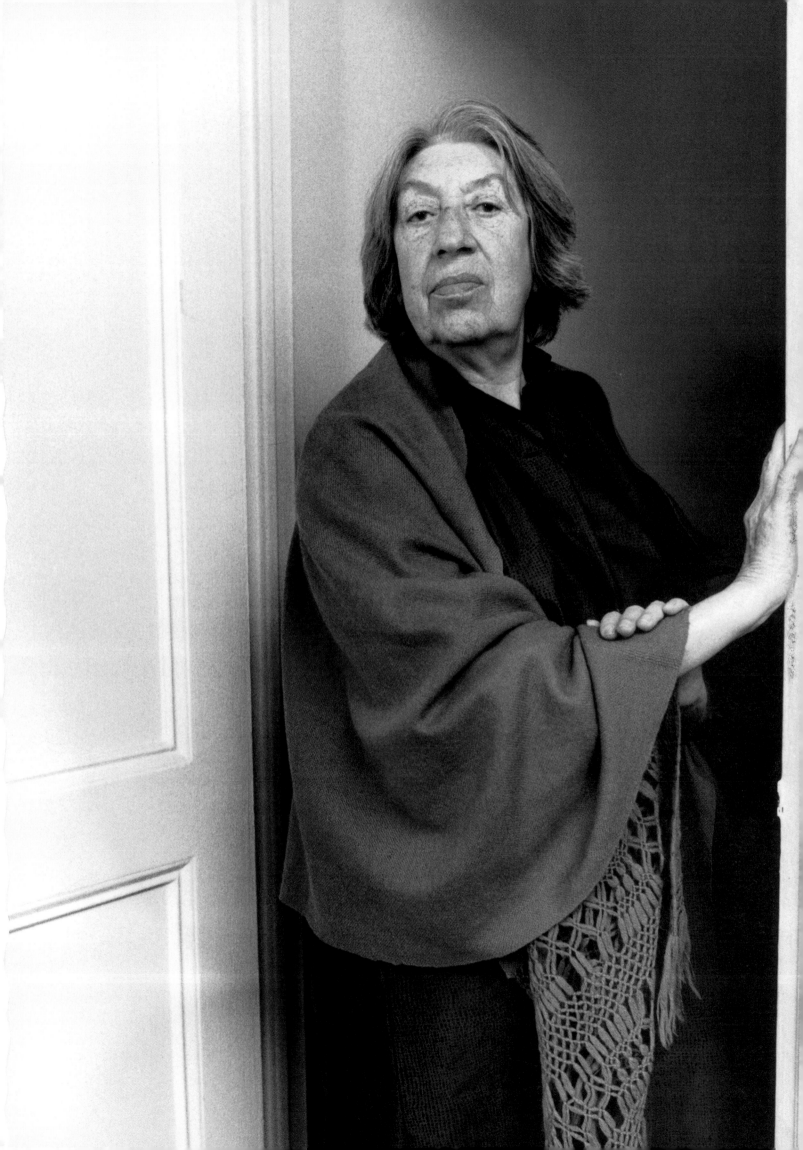

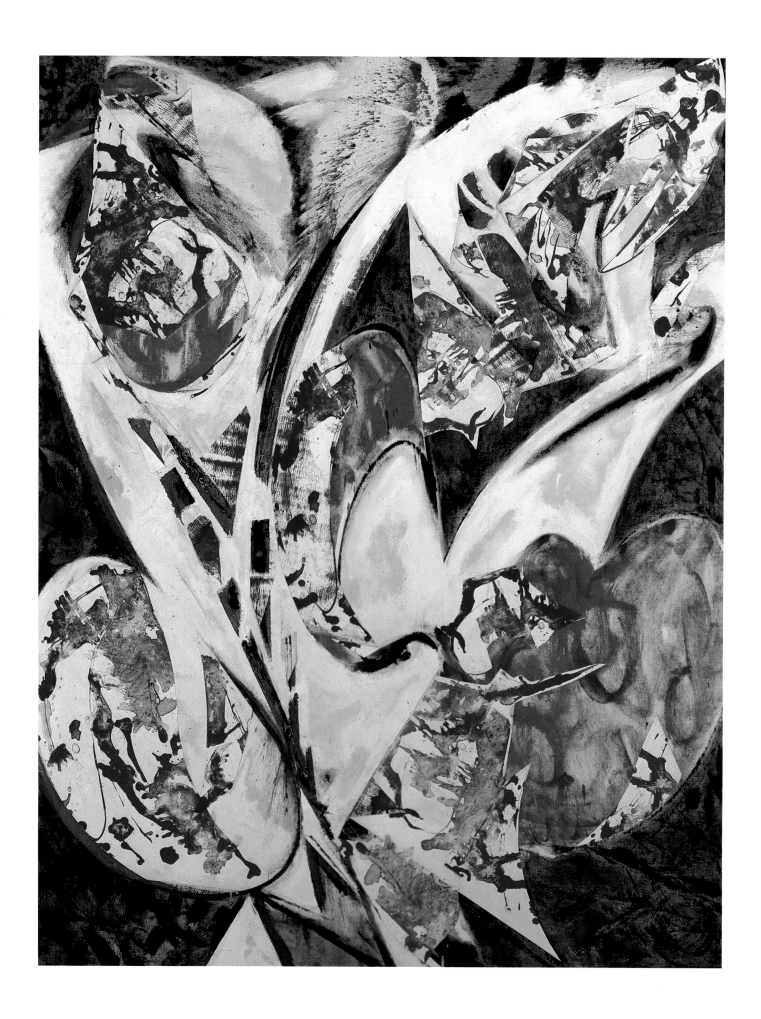

Lee Krasner

ROBERT HOBBS

INTRODUCTION BY

B. H. FRIEDMAN

INDEPENDENT CURATORS INTERNATIONAL

NEW YORK

IN ASSOCIATION WITH

HARRY N. ABRAMS, INC., PUBLISHERS

Robert Hobbs gratefully dedicates this book to Jean Crutchfield Hobbs

Exhibition Funders

Robert Lehman Foundation, Inc.
Principal Sponsor

Additional support has been provided by
The Pollock-Krasner Foundation
The Eugene V. and Clare E. Thaw Charitable Trust
The Ida and William Rosenthal Foundation
Betsy Wittenborn Miller and Robert Miller

Published in conjunction with the traveling exhibition *Lee Krasner*, organized and circulated by Independent Curators International (ICI), New York. Guest curator for the exhibition: Robert Hobbs, the Rhoda Thalheimer Endowed Chair, Virginia Commonwealth University.

Exhibition Itinerary

Los Angeles County Museum of Art
Los Angeles, California
October 10, 1999–January 2, 2000

Akron Art Museum
Akron, Ohio
June 10–August 27, 2000

Des Moines Art Center
Des Moines, Iowa
February 26–May 21, 2000

Brooklyn Museum of Art
Brooklyn, New York
October 6, 2000–January 7, 2001

© 1999 Independent Curators International
799 Broadway, Suite 205, New York, NY 10003
Tel: 212-254-8200 Fax: 212-477-4781
info@ici-exhibitions.org

Library of Congress Catalog Number: 99-71500
ISBN 0-8109-6395-7 (hardcover)
ISBN 0-916365-55-7 (softcover)

Hardcover distributed in 1999 by
Harry N. Abrams, Incorporated, New York

Harry N. Abrams, Inc.
100 Fifth Avenue
New York, N.Y. 10011
www.abramsbooks.com

Editor: Stephen Robert Frankel
Designer: Bethany Johns Design, New York
Printed in Germany by Cantz

Frontispiece: **Crisis Moment**, ca. 1972–80. Oil and paper collage on canvas, 69 x 54 ¼ inches. Courtesy Robert Miller Gallery, New York

Contents

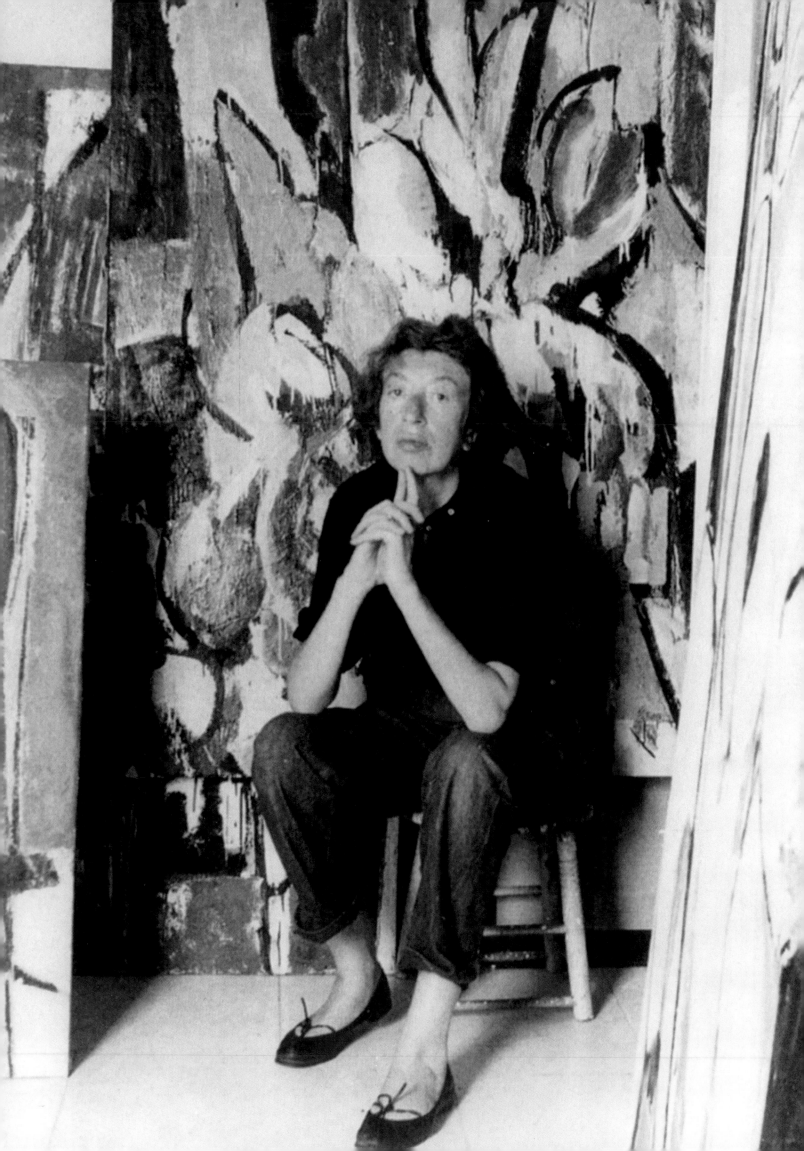

Foreword and Acknowledgments

Independent Curators International (ICI) is dedicated to creating traveling exhibitions of national and international importance that focus on contemporary art, and to educating diverse audiences about the art of our time. It was with great excitement that ICI, working with the distinguished art historian Robert Hobbs, embarked on this retrospective exhibition on Lee Krasner (1908–1984)—which represents the first full-scale showing of the artist's work since her death—and its accompanying book. Although this show was conceived independently of the recent Jackson Pollock retrospective organized by the Museum of Modern Art in New York (1998–99), the timing provides a most opportune occasion to reassess Krasner's art.

Krasner established a reputation for herself as a strong avant-garde artist, who exhibited with the American Abstract Artists group before she became associated with Pollock in 1942. Hobbs has investigated these early years and found her friendship with critic, poet, and political activist Harold Rosenberg to have been of crucial importance to her development. In addition, he has examined her strong support of Leon Trotsky's radical Communist agenda and her commitment to the thought of French proto-Symbolist poet Arthur Rimbaud, and has found them particularly significant. In his analysis, Hobbs has looked at Krasner's art in terms of broad cultural patterns, including her role as a prominent member of New York's Jewish intelligentsia. In the process of investigating Krasner's uniqueness, Hobbs has developed an overall theory for Abstract Expressionism that takes into consideration the role of Sartrean existentialism. He explores the idea that existentialism represented a brief, yet significant phase for most Abstract Expressionists, and a lifelong challenge for Krasner.

This book and traveling retrospective exhibition have been made possible with the encouragement, dedication, and generosity of a great many people. First and foremost, we extend warmest thanks and appreciation to guest curator Robert Hobbs. Throughout our collaboration, he has exercised great intelligence, perseverance, and good humor so that together we could bring an expanded understanding of Lee Krasner's work to audiences across the country.

Hobbs joins ICI's Board and staff in thanking all the other individuals and institutions that helped to make this project a reality. We would like

Lee Krasner, August 30, 1956, two weeks after Pollock's death

to begin by expressing our deep appreciation to B. H. Friedman for his important contribution to this book. His Introduction, which incorporates entries from a journal he kept at the time, gives us a fresh and intimate sense of the artist that could only be gained through such a source. He generously offered this previously unpublished look at Krasner and her circle, along with his personal knowledge and insights into her life and art.

This project would not have been possible without the involvement of the lenders, to all of whom we would like to express our enormous appreciation for their generous participation. We share a special bond in our dedication and affection for Krasner's work, and it is the lenders' willingness to share their works that has made this project a reality. Among these lenders, we want to single out the special generosity of the Pollock-Krasner Foundation, and the efforts of the Robert Miller Gallery, as well as Rena "Rusty" Kanokogi, Lee Krasner's niece, who is not only a lender but has also been an energetic and effective advocate and fund raiser in support of this project.

We are also very proud to acknowledge the foundations and individuals that share our vision for this endeavor and who have made generous contributions to make it possible. First of these supporters is the Robert Lehman Foundation, which has long been recognized for its commitment to excellence in the visual arts; its leadership grant was crucial to the development of the entire project. Also of great importance are substantial grants from the Pollock-Krasner Foundation, and the Eugene V. and Clare E. Thaw Charitable Trust, both of which were crucial early supporters who provided much needed financial assistance. Both Charles C. Bergman, Chairman of the Board, and Eugene V. Thaw, President of the Pollock-Krasner Foundation, gave their invaluable endorsement to the project, along with their advice, guidance and encouragement, all of which were essential to our success and for which we express very warmest thanks. We are also deeply grateful to Betsy Wittenborn Miller and Robert Miller, who provided important support and also generously shared their extensive knowledge of Krasner's work. We also acknowledge with warmest appreciation the Ida and William Rosenthal Foundation for providing significant initial funding for this project.

As ICI has no space of its own, its exhibitions must travel to be seen. Thus, we wish to recognize, and to express our appreciation for, the extremely important and enthusiastic collaboration of the four museums that are hosting this exhibition. In this regard, we would like to acknowledge Graham W. J. Beal, Director, Carol S. Eliel, Curator of Modern and Contemporary Art, and Lynn Zelevansky, Curator of Modern and Contemporary Art, Los Angeles County Museum of Art; Susan Lubowsky Talbott, Director, M. Jessica Rowe, Associate Director, Des Moines Art Center; Mitchell Kahan, Director, Barbara Tannenbaum, Chief Curator and Head of Public Programs, and Jeffrey Grove, Curator of Exhibitions, Akron Art Museum; and Dr. Arnold L. Lehman, Director, Charlotta Kotik, Chair, Department of Painting and Sculpture, and Curator of Contemporary Art, and Brooke Kamin Rapaport, Associate Curator of Contemporary Art, Brooklyn Museum of Art. It is through the highly professional and dedicated efforts of these colleagues and their staffs that Krasner's work will be experienced and appreciated by many thousands of viewers, literally from coast to coast.

It was a great pleasure to work with designer Bethany Johns and her assistant Jackie Goldberg, who brought sensitivity and intelligence to the creation of this book, and with editor Stephen Robert Frankel, who again provided ICI with his expert skills. We also extend our thanks to Kathleen B. Lindquist for her editorial work on Robert Hobbs's essay. We are proud to publish this book in association with Harry N. Abrams, Inc. and want to thank Paul Gottlieb and his able staff for their special efforts.

Throughout this complex project, we received generous help, both for the exhibition and the book, from galleries and individuals who assisted in locating works, facilitating loans, and providing visuals. In this regard, we extend our sincerest thanks to Robert and Betsy Miller and their staff, especially Michelle Heinrici, Jan Riley, and Amy Young, who deserve a special note of appreciation; Meredith Long, of Meredith Long Gallery, Houston; Andrew Massad of Christie's, New York; and John Post Lee of Gorney Bravin Lee Gallery, New York. And I want to express special thanks to Sandra Weiner and Dorothy Beskind for sharing their archives, photographs, and personal stories of Lee Krasner.

For their excellent and thoughtful suggestions, the following individuals deserve special thanks: Jonathan Geldzahler, Christopher Gilbert, Mark Lindquist, Barbara Meyeron, and Kathryn Shields.

The entire staff of ICI has worked tirelessly in producing the exhibition and this publication. I want to express warmest thanks to Carin Kuoni, Director of Exhibitions, and in particular William Stover, Exhibitions Associate, who worked with great care, dedication, and enthusiasm to pull together all the loans and visuals, and coordinate all aspects of the catalogue production; Jack Coyle, Registrar, who focused his professional expertise on the innumerable details of caring for and transporting all the works; Angela Gilchrist, Director of Development, and Douglas Gatanis, Development Associate, who so successfully carried out our complex fundraising efforts; Exhibitions Assistant Jennifer Kay, present Executive Assistant Elizabeth Moya-Leiva and former Executive Assistant Samuel Ong III for their wonderfully efficient and enthusiastic support of all our efforts; and Dolf Jablonski, ICI's exacting and dedicated bookkeeper. I also wish to acknowledge the contributions of ICI's former Director, Sandra Lang, and former Exhibitions Coordinator, Lyn Freeman, who helped to get the project started.

Working with all these people over the past months and years to bring the myriad parts of this challenging project together has been a tremendously rewarding experience for ICI's staff. To everyone who recognized the importance of this exhibition and publication and gave generously in so many ways to ensure its success, ICI's Board of Trustees joins me in expressing our enormous appreciation and gratitude.

JUDITH OLCH RICHARDS

Executive Director

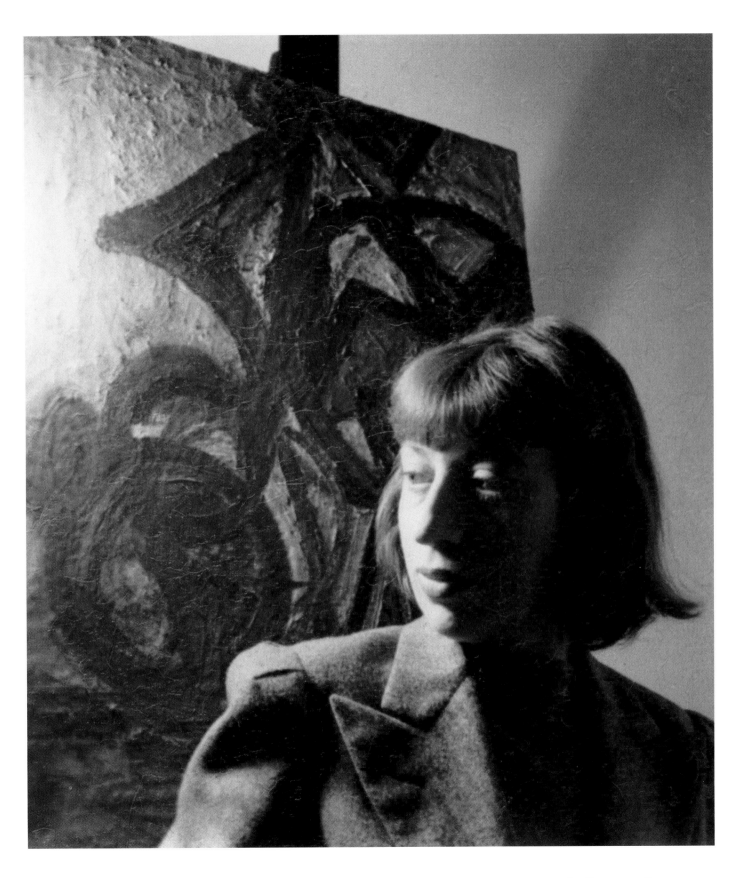

Lee Krasner, ca. 1938

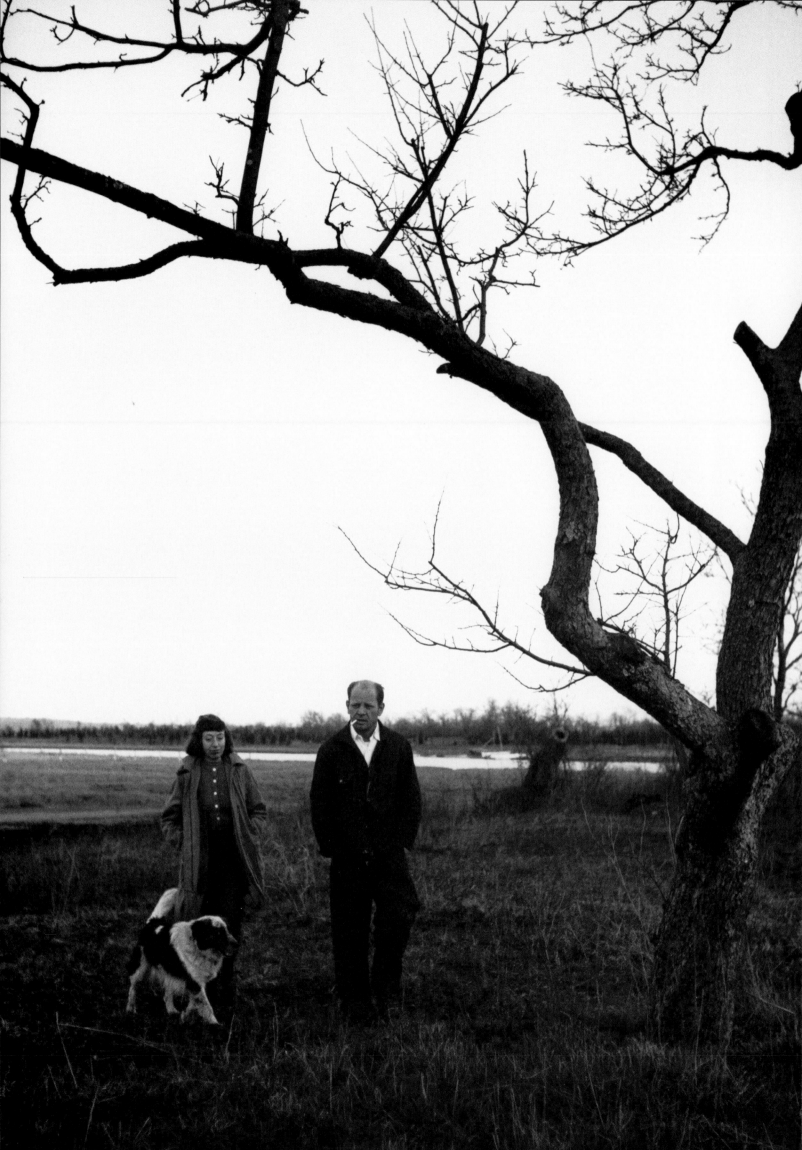

Lee Krasner: An Intimate Introduction

BY B. H. FRIEDMAN

From early in 1955 when he met Lee Krasner (through his interest in her husband, Jackson Pollock) until 1970 when he completed the first Pollock biography, Energy Made Visible, *B. H. Friedman was an extremely supportive friend to her. He bought four of her paintings—three Little Image works from the late 1940s and* Listen, *1957, a piece from her first one-person show after Pollock's death. For that exhibition, he helped title paintings and wrote the announcement. While working for Uris Buildings Corporation, he commissioned two mammoth, technically radical mosaic murals for 2 Broadway and an edition of lithographs for the New York Hilton; he subsequently wrote articles about both of these projects. After leaving Uris, he wrote the Introduction to the catalogue for Krasner's Whitechapel Gallery exhibition in London and interviewed her for the Pollock* Black and White *show at the Marlborough-Gerson Gallery. This interview reveals more about her contributions to Pollock's work than had previously been known.*

During these years (and before as well as after), Mr. Friedman kept a journal, which Robert Motherwell, his friend and neighbor in Provincetown, described to me in the mid-1970s. It occurred to me that excerpts from it, together with added transitional material, would present some significant aspects of Lee Krasner not found elsewhere.

—R.H.

Lee Krasner had two profound commitments. The first was to her own art, beginning in high school and lasting until her death at seventy-five. The second was to her husband, Jackson Pollock. From the moment she first saw his work, just prior to the 1941 exhibition *American and French Painting*, organized by the artist John Graham—which included, at this early date, works by Krasner and Pollock as well as Willem de Kooning— she worked hard to encourage Pollock's career and enhance his reputation. She continued the latter effort not only after his death but after her own, through some of the stipulations in her will. Krasner's tough, resilient intelligence is apparent both in her own work and in her work for Pollock. What isn't apparent is another aspect of that intelligence: her wit. In this

Lee Krasner and Jackson Pollock, The Springs, 1949

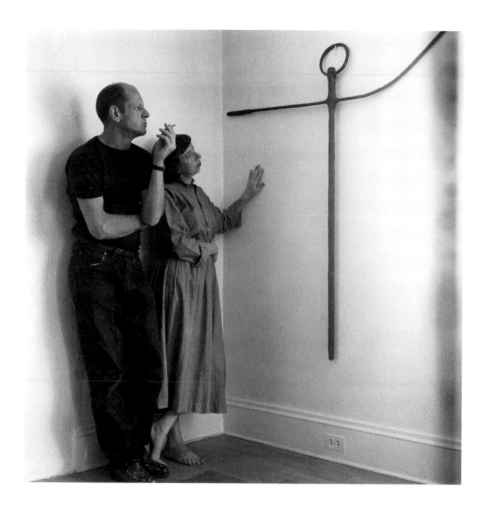

Lee Krasner and Jackson Pollock,
The Springs, 1950

monograph, Robert Hobbs thoroughly presents important components of
Krasner's work, so I will concentrate less on her art and more on her words
and those of her friends, excerpted mostly from my journal.

In *Jackson Pollock: Energy Made Visible*, I describe my wife Abby's and
my first meeting with the Pollocks early in the spring of 1955. At that time,
although I knew Jackson's work and had written about it, I had never seen
anything by Lee. I met her, really, as "his wife." All that changed quickly.
Enough to say that when they arrived at our apartment Jackson was drunk,
having stopped for many beers on the way to the city from The Springs,
East Hampton, and that he was aggressive, particularly about a 1917
Mondrian which I thought he'd respond to because of its rhythmic move-
ment and its suggestion of continuous space extending beyond the canvas.
Lee quietly asked us not to offer Jackson liquor and urged him to take a nap.

Once he was sleeping Lee said, "He'll be all right. He gets like this
when we come to New York. Every week. Until August, when the doctors
take their vacations. Tomorrow we have our sessions. Then the real battle
begins—to get him back out to Long Island. He's okay there, but when
he's with those cronies of his at the Cedar [Bar], it's not easy. I never know
when he's going to show up. One in the morning. Two. Three. Noon.
Afternoon. Sometimes we stay an extra day. . . Well, now *I* could stand
a drink, a real drink."

This was the woman we met—strong and protective, her direct manner of speaking almost entirely focused on Jackson. Even when, soon after our meeting, Abby and I visited them in The Springs and saw some of Lee's intense small-image paintings of the late 1940s and her collages of the early 1950s, she spoke more about his work than her own. And when they made their regular visits to the city, I saw more of him than her. Jackson and I frequently drank at the Cedar or went to hear jazz—Dixieland or Chicago—in the Village and on Fifty-second Street.

After Jackson's death on August 11, 1956, it took months for Lee, who was in a state of shock, to get back to painting—first, in the small upstairs bedroom she had been using as a studio; later, with great difficulty and anxiety, in the comparatively large barn that Jackson had used as his studio.

Oct. 8, 1956 Morty [Feldman, who wrote the music for Hans Namuth's film on Pollock] observed that since Jackson's death, Lee has had to face the reality of nothing interfering with her work.

In fact, everything interfered—dozens of meetings with dealers, collectors, curators, historians, lawyers, accountants—all these impositions reminding her that she is still Mrs. Jackson Pollock and all still provoking guilt for not being there when he died.

Jan. 1, 1957 It's 10 a.m. and somehow I'm up and over New Year's Eve. Abby and Lee are still asleep. They floated through the evening along with Helen [Frankenthaler], Betty and Bob [Motherwell], Musa and Philip [Guston]. They floated. Jackson's ghost was more real.

April 24, 1957 Evening with Lee and [dealer] Sidney Janis re pricing Pollock paintings for the Whitney Museum's consideration. Lee's insistence on distinguishing between economic symbolism (i.e., market price) and value. Her fear that the price will affect the true value of Jackson's work because price is an acceptance of *other people's values*. Thus, her refusal to think in terms of a current market, only a future market. Oscar Wilde comes full circle: knowing the value of everything and the price of nothing.

Later in 1957 Lee was completing some of her paintings that would hang in her show the following year at the Martha Jackson Gallery. These seemed to represent a joyful release from her earlier, sometimes darker and more constricted work but were actually the product of lingering intense depression and many distractions.

In titling the recent paintings, Lee and I followed a procedure similar to that which Lee herself and friends of hers and Jackson's had used in the past. I free-associated, saying, for example in front of *Upstream I* and *II* that I had a sense of salmon fighting their way upstream to spawn, or of *The Seasons* that the painting seemed to contain the entire seasonal cycle, or of *Listen* that it was as quietly exuberant as flowers bursting into bloom. In each instance Lee would pick up on a word or image and select what she wanted or take the free-associative process still further.

March 2, 1958 At the Half Note [jazz club] with Abby, Lee, Clem and Jenny [Greenberg], I invited [saxophonist] Lee Konitz to our table for a drink. Konitz, shy, unassuming, and deliberate, spoke of his house in Levittown and his wife and five kids. I approached his world by talking about the last jazz I'd heard: Phil Woods at the Five Spot after our party for Lee [after her opening]. I asked Konitz what he thought of Woods and if his playing was too much like Parker's. Konitz paused a long time, then said in effect that he thought Woods played potentially too well to let himself be so completely dominated by Parker's style, that Woods was probably afraid to be himself.

Clem observed that when an artist finally does something that's completely his own, he gets frightened because he doesn't recognize it, not having seen it before.

July 25, 1958 Lee has been "dismissed" (her word) by her therapist. In this case dismissal means that he has gotten as much help from her as he can.

Jan. 17, 1959 Sitting opposite two of Pollock's paintings and struck again by the music and dance in them, I asked Lee and Barney [Newman] if Jackson had ever played a musical instrument. As usual, Barney did most of the talking, turning occasionally to Lee for confirmation about Jackson's love of music and his having said that he would rather have been a musician than a painter.

Later, Barney talked about women. It was another long speech, a series of Talmudic paradoxes. In brief, "I worship women and therefore thank God I am a man."

Lee became more and more angry as Barney expanded on this theme. "The thing I hate most about Jewish culture is the condescension toward women, the primitive carry-over of the woman as dirty, the prayer I said every morning in Hebrew for 17 years—approximately: 'Thank you, oh

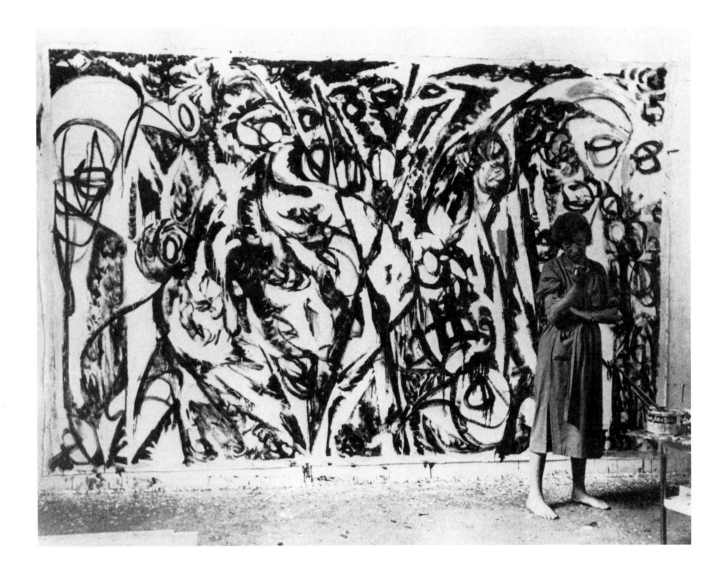

Lee Krasner with an early version of *The Gate*, 1959

Lord, for making me as you saw fit,' whereas I later learned, a man says, 'Thank you, oh Lord, for making me in your image.' "

Barney insisted that this was not condescension but compassion and that everything good in the world had come from patriarchy and everything bad from matriarchy. He crossed over to Lee, put his index finger to her temple, and said, "You've got a gun at your head. Tell me in one sentence what Jackson was involved with."

"I don't know, Barney."

"You've got to know. There's a gun at your head. What do you think *She-Wolf* or *The Totem* are all about?"

"Maybe someday if there were a real gun at my head I'd know. What do you think Jackson was involved with, Barney? In one sentence."

"Compassion for male and female—that's what he was involved with, that's what his paintings are about."

Feb. 11, 1959 Like Jackson, Lee says the artist equals his work. Painter Jim Brooks says the artist is smaller than his work. I say the artist is bigger than his work.

Referring to *Who's Who*, an unpublished novel of mine that Lee has read some of, she asks, "Do you think that book isn't you?"

"It's me, but not all of me. It's smaller. But, in Jim's sense, it's also bigger, stronger."

Later, I write: *Quantitatively, the work of art can never be as big as the artist.*

Qualitatively, the artist can never be as big as the work of art.

July 18, 1959 Jack Kerouac arrives at Lee's surrounded by an entourage: "I thought this was an open party."

Lee: "It's not *that* open."

Sept. 5, 1960 Lee talked for a long time about "complexity." Throughout, though others were heard—Abby, [my brother, writer] Sandy Friedman, [poet/critic] Richard Howard, [Lee's psychiatrist] Len Siegel—it was clear that the word is not neutral, that Lee, like the rest of us, wants to be complex. Late in the evening I suggest that complexity may have more to do with our fantasies than our actions. Lee mentions [artist Alfonso Ossorio's companion] Ted Dragon as an example of someone who acted out his fantasies. I say he didn't, that his action (stealing during a difficult period in his relationship with Alfonso) was in itself a fantasy behind which he hid the real fantasy (hurting Alfonso), and that Ted's thefts didn't do anyone else much harm whereas the harm he may have really wanted to commit, etc. Finally even Lee agrees that Alfonso—and certainly not Ted—is the most complicated person we know.

Nov. 29, 1960 Headache, jitters, fatigue after party at [Conrad] Marca-Relli's and then another at the Jazz Gallery for a successful younger painter. Lee snarls, "first-rate public relations for a second-rate artist."

Dec. 17, 1960 Lee: "Art dealers all want the same combination. They want corpses because they're easy to handle and present no problems—living artists are problems—and they want great productivity. They want productive corpses."

Feb. 22, 1961 Sandy and Richard discuss Harold Rosenberg's review of (attack on) Bryan Robertson's Pollock monograph. Richard had already been requested by Lee to help her write a reply and said he would. However, he had also run into Harold and told him how brilliant his

article was. Now, on reconsidering, Richard does not want to write the letter and argues that Lee would be at a disadvantage trying to match wits with Harold. Sandy feels that historical inaccuracies in the review have to be answered.

Lee, who was once a close friend of Harold's, did go far out of her way to feed Bryan the sentence about Jackson's responsibility for the phrase "action painting." Even assuming that Jackson had talked about "the act of painting," Lee refuses to acknowledge the difference between this phrase and Rosenberg's, and she certainly won't acknowledge Rosenberg's development of a sustained critical argument. Rosenberg, on the other hand, has gone equally far out of his way by attacking Pollock, Robertson, and Robertson's "informant" (Lee), all because of a single sentence that pricked his pride of authorship. It is a strange dance between the keeper of a flame which can without help keep burning brightly and the intellectual vanity of a critic whose intellect is not questioned.

During the five years or so following Jackson's death, Lee did some of her best work. The two mosaic murals (one 86 x 12½ feet, the other 15 feet square) over the entrances to 2 Broadway, which were completed in 1959, with the assistance of her nephew Ronald Stein, are particularly remarkable. The originality of their vast, consistently lively surfaces deserves recognition, especially for the use of freely shattered glass plates—which resulted in great variation in texture and shape—rather than conventional, more rigid tesserae.

Lee had taken an apartment in the city, and in addition to creating this ambitious work, was going out more than when Jackson was alive—to, among other places, progressive jazz clubs. More significantly, she had come to accept her power as both an "art widow" and an artist in her own right. And now she was allowing herself luxuries not possible before or during her marriage: designer clothes, fur coats, period furniture, bearskin rugs. At the suggestion of fellow artist Fritz Bultman, Lee had dresses made by avant-garde couturier Charles James.

May 19, 1961 Alfonso discusses the mystique of James's clothing: "Using a material so you exploit its ultimate tension. . . . Putting Lee's breasts down at her hips, her navel at her throat." [Of course James's high style was not as surreal as Ossorio's comment.]

July 3, 1961 Yesterday afternoon Lee and I left the beach early. We had hardly gotten into the car and turned on the radio when there was an

announcement of Hemingway's death, "an accident while he was cleaning a shotgun." Lee knew immediately that it was suicide. I was shocked by that possibility. Now, a day later, a *New York Times* later, it seems a probability.

When we returned to Lee's house there was more gloom: a call from New York telling her that John Graham had died in London.

Jan. 7, 1963 Ronnie [Stein] called to say that Lee's operation for an aneurysm was successful. Since she had a brain hemorrhage Christmas night, I've called the hospital, spoken to her, to floor nurses, to Frances and Ronnie; finally visited her; and kept Alfonso posted.

Jan. 29, 1963 After seeing Lee, following her operation, Fritz said, "Not only didn't she lose any wheels, she seems to have added a few."

Feb. 3, 1963 For the first time since her operation I visited Lee yesterday evening at the Hotel Adams. I talked and talked, feeling that she didn't want to, that I had to entertain her. She clenched and unclenched her hands. She drummed on the arm of her chair. She explained several times that she felt cut off, that she couldn't, as her doctors wanted her to, return to her normal routine. "So here I am," she said, "twenty floors above New York."

"I envy you. I'd like a suite like this, with no one knowing where I was until I finish the novel I'm working on. Well, if I should disappear, tell everyone I'm all right, tell them what I've done."

"Why don't you try? You might not like it. Maybe one needs all the pressure down there."

Jan. 10, 1965 When Lee and Jackson moved to East Hampton, Bob Motherwell was already there considering a piece of property across the road. One night at their place, after many drinks, Bob said, "I'm going to be the best-known artist in America." Lee replied, "I'd be very lucky to live opposite the best-known artist in America and be married to the best."

Jan. 8, 1966 Lee is again thinking about an apartment in the city. Meanwhile, she's in a room at the Elysée Hotel surrounded by separate piles of catalogues, announcements, Christmas cards (unacknowledged), correspondence (unanswered), books (unopened or with place markers near the beginning), real estate brokers' business cards, three different

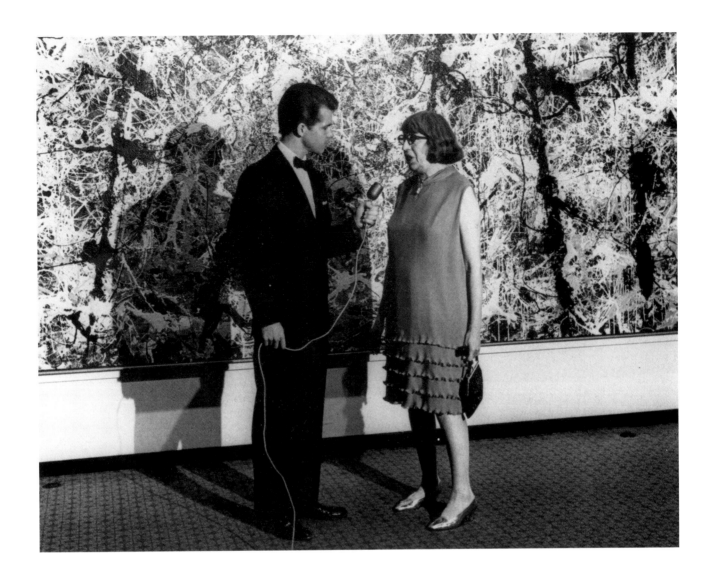

address books . . . all stacked, arranged and rearranged, seemingly according to some system of priority. But her highest priority seems to be total inertia. She may be in this room forever, with only the company of its television set, always on.

Lee Krasner being interviewed in front of Pollock's *Blue Poles*, 1973

March 3, 1966 Lee: "Motherwell said somewhere—I don't remember where, he's all over the place—that after a time he stopped painting with just his hand and wrist and began using his arm. He discovered his arm! He moved up from the wrist to the shoulder. But it still hasn't occurred to him that you can paint with your whole body, that that's what American painting is all about."

Jan. 22, 1968 Once again Alfonso played perverse games with Rosalind [Constable, a Time-Life reporter on cultural events]. At her apartment he insisted she drag his other work out of the closet. Then he attacked her Sylvia Plath recording. When it was very late and there seemed to be no more energy or opportunity for mischief there, he asked her to have lunch with him the next day. Lee described the lunch (of course

he brought her along):

Alfonso to Lee: "I have a present for you—a malachite box."

Rosalind, bridling: "If you want to know what *I'd* like, *I'd* like a malachite Easter egg."

Lee: "I'll lay one for you."

Jan. 21, 1969 Lee, after waiting a long time for me to answer the phone: "You know, I also get calls when I'm working, when the paint is running, but I answer them."

The call was about changes she wanted in my interview with her [for *Jackson Pollock: Black and White*], each a further clarification of previous clarifications made during previous calls. And yet, despite the nuisance of all these re-re-revisions, I appreciate her caring so much. Almost every change has been self-diminishing, a lessening of her role in relation to Jackson and an enlargement of his as they decided which side of a painting was the top, where he should sign, what margins to retain, if any, etc.

March 21, 1969 Lee will have two paintings in the show that [William] Rubin is organizing for MoMA. She explains that the show will only include paintings owned by the museum; that Alfonso was pressured into giving one of hers because of a policy, just for this show, not to buy work by living artists; that both paintings are early, one "hieroglyph" and one of a year or two later; that Rubin's commitment is to history and not to the paintings themselves. "So I can't go around crowing about this. It's like marrying someone you've lived with for ten years."

Dec. 4, 1969 Last year when I began work on my Pollock biography, I asked Lee what color Jackson's eyes were. I couldn't remember if they were light hazel or gray. To my surprise, Lee couldn't either—Lee, who gave fifteen years of her life to Jackson while he was alive and who has already given almost as many since his death. I called some friends and determined that his eyes were hazel.

July 4, 1970 Fritz told me that a male artist once said to Lee, "I hear you have to take a Wasserman [the then standard V. D. test] before you can get into Peggy Guggenheim's gallery" [Art of This Century] and that Lee replied, "You should certainly take one before you *leave.*"

July 5, 1970 I'm afraid that before I finish the Pollock biography something will happen to destroy my relationship with Lee. A fight like Abby's with

her last year? Or an argument like Sandy's last week? Or the continuing tension between her and Alfonso, some of it now focused on me? . . . I worry about the awkwardness of working with her under such conditions—the disturbance to a relationship which must be based on mutual trust. So far, our relationship has remained steady, but what if a situation develops like that between Jackie Kennedy and William Manchester, one in which the widow is not satisfied with the book? By the time I'm through, I will have put a large part of three years into this book. Would I then, in the face of objections, be willing to do more than make factual corrections and minor revisions or omissions? I'm sure not.

Other questions bother me and make me anxious: How much do I owe Jackson? How much do I owe Lee? Do I owe them more than the truth? If so, what? Beyond what I owe Lee as a friend, what do I owe her for her help with the biography? If she clarifies one point, is she entitled to obscure another? Should she have asked me to destroy my copy of my final letter to Jackson, where I wrote about his difficulty in deciding between Ruth Kligman and Lee—a letter which, from Lee's viewpoint, validated the seriousness of his relationship to Ruth? Was I right to have complied with her wish? And should I—as, again, she asked and as I did—have suppressed reporting her first encounter with Jackson, some five years before John Graham's McMillen show, when he said only, "Do you like to fuck?"

Sept. 25, 1970 I told Jack Baur [then director of the Whitney Museum] about some of the problems I've been having with Lee in finishing my book on Pollock. "Artists' widows!" he replied. "There isn't a curator or a biographer who doesn't wish they all believed in suttee."

Nov. 11, 1970 A few gaps remain in my Pollock book, mostly where I'm waiting for replies to calls or letters. But the biggest and most aggravating hurdle left will be my continuing "negotiations" with Lee. It's ironic that in my Whitechapel essay on her I chided Harold Rosenberg for writing that the widow "is the official source of the artist's life story, as well as of his private interpretation of that story. The result is that she is courted and her views heeded by dealers, collectors, curators, historians, publishers, to say nothing of lawyers and tax specialists. It is hard to think of anyone in the Establishment who exceeds the widow in the number of powers concentrated in the hands of a single person." Then—in 1965, when Lee seemed to be giving me her complete cooperation while I was writing about her—I accused Rosenberg of having a "thirties view of things" in

which "art is only a commodity to be manipulated by economic powers, now in the person of widows." But as Lee withdraws her cooperation while I write about Pollock, I see that Rosenberg has a point.

I have not yet recovered from the shock of receiving a lawyer's letter from someone who was a very close friend, nor the shock of its closing, "As ever": a compromise, I suppose, between "Love," and "Very truly yours." As ever! As if our relationship will ever again be as it was.

Oct. 7, 1971 At the Mondrian opening at the Guggenheim, Abby and Lee literally bump into each other on the ramp. We all shake hands.

Lee says to me, "I got your letter. I haven't had a chance to read it yet."

I smile, not believing her. What she means, I think, is that she hasn't had a chance to *study* it or discuss it with her lawyer. Still smiling, I say, "You're my most faithful correspondent."

"I wish you'd drop me from your list."

"I will, if you let me."

June 17, 1972 Alfonso called to thank me for the Pollock biography. Though he told me he had not "read it," he had surely examined it carefully, very carefully. In his naughty way he said he wished they hadn't used "that cookbook blue" on the binding and then, knowing the answer, asked why Lee's name wasn't among the acknowledgments.

Oct. 2, 1973 At last night's farewell party for Pollock's *Blue Poles*, sold by [collector/dealer] Ben Heller to Australia for $2,000,000, he made a speech, saying it was sad that Jackson couldn't be with us—and Barney, Mark, Franz [all dead]—and too bad that "Lee had other plans."

Afterwards I asked Ben if he thought Lee would have considered her presence an endorsement of the sale. He said he didn't know what she thought but was sure whatever it was was complicated.

The Gramercy Quartet played chamber music, during which Ben, with his back to the musicians, sat facing *Blue Poles*, looking melodramatically depressed. When the music ended, I said, "Don't be sad. Buy it back from Australia. Offer them a profit of half a million."

We went to the dining room for dessert, a chocolate cake iced with a reproduction of *Blue Poles*.

"It's from Greenberg," someone said.

"Clem?"

"No, William—the baker."

Feb. 26, 1976 [Dealer/art impresario] John Myers talked endlessly about the Rothko case, how much the art world had changed, how UGLY, EVIL, CORRUPT it had become. As he went on, having come here to interview me but unable to stop interviewing himself, I thought how little he has changed: he talks more, drinks more, weighs more, laughs more hysterically, but still he is the same John Myers—not always accurate but often entertaining.

John was close to Lee at the time of Ben's Farewell-to-*Blue Poles* party. He tells me his version of Pat Heller calling Lee: "We're so sad about *Blue Poles* leaving. It's been in the family so long. We're having a small party for a few friends who have been close to the painting."

Lee: "I know exactly how long *Blue Poles* has been in your family, and I'm *very* occupied that night."

I can hear Lee. To hear John *is* to hear Lee.

Lee Krasner's work was as exciting to live with as that of the other major Abstract Expressionists. She should have been invited to sign the 1950 "Irascibles" protest, which led to the famous photograph in *Life*. And she should have had a retrospective exhibition long before 1965 at the Whitechapel. Etc. But she was a woman in a generation of predominantly male American artists who were aggressively macho. Yes, some part of my interest in Lee's work was probably based on sympathy for her situation in art history. Nevertheless, it was mostly based on my response to the work itself. After first seeing it in The Springs, this response was soon reinforced by her comparatively well received shows at the Stable Gallery in 1955 and the Martha Jackson Gallery in 1958. I bought her paintings and one large collage because I admired them and, at the same time, admired her courage in going on without Jackson and daring to deal with increasingly larger scale in her paintings, especially after completing the murals at 2 Broadway.

Like many others, including some dealers, curators, critics, and colleagues, I had problems with Lee. But also like many, I continued (and still continue) to respect her difficult personality and her powerful body of work, both of which are now an inspiring example to men as well as women. As I look back, I am gratified that, even following the publication of Ellen Landau's catalogue raisonné in 1995, Robert Hobbs has, for this handsome new monograph, been able to write such a fresh and perceptive text, full of original discoveries, critical analysis, deep and perceptive insights. It is an important addition to Lee Krasner studies and one that will illuminate this well-chosen and well-deserved look at her work.

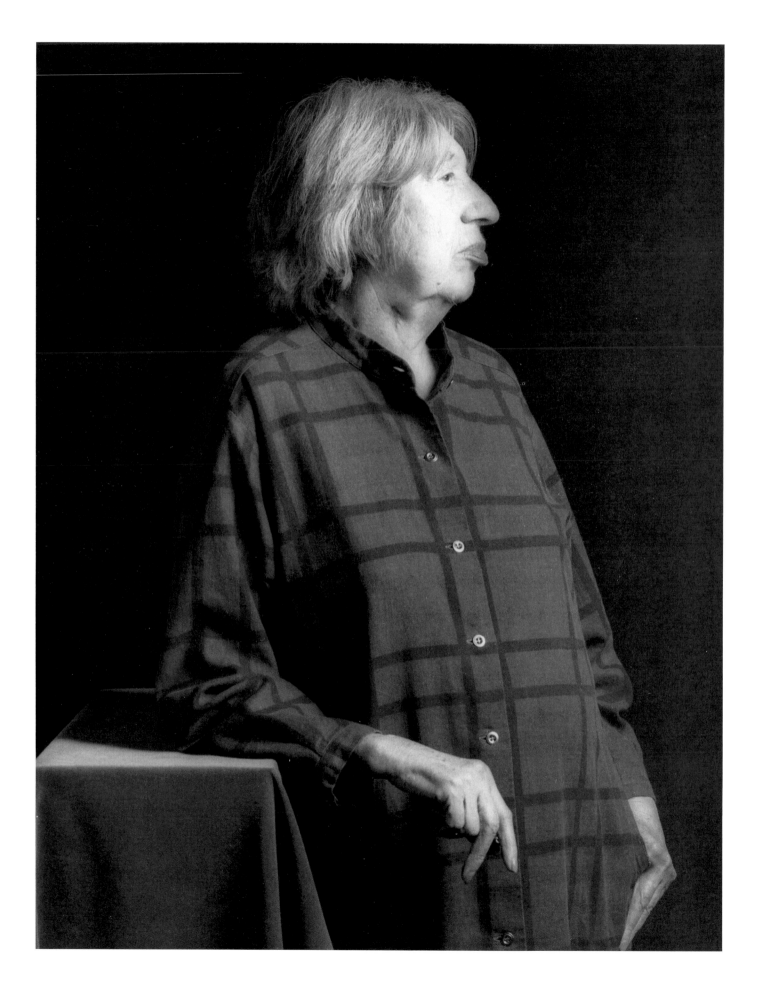

Lee Krasner

BY ROBERT HOBBS

In the mid-twentieth century, the Abstract Expressionists replaced a School of Paris aesthetic with New York School process-oriented art.[1] But, with the notable exception of Lee Krasner,[2] a nineteenth-century romanticism still tinged even their most advanced works with a distinct bias in favor of artists as individual geniuses. As a means for dispensing with the eighteenth century's overemphasis on rationality, romantics in Europe and the United States had lauded individual sentiments and courted intuition. In the early 1940s most Abstract Expressionists cobbled together aspects of ego psychology, primitivism, empiricism, and romanticism in their attempts to find artistic styles capable of directly manifesting such individualism. Lee Krasner's art, however, diverges from this mainstream Abstract Expressionist path and assumes almost by default, a critical role as an unrelenting search for a dynamic identity that continually outdistances her work. Eluding her grasp, this artistically constructed self remains provisional.

Her approach is diametrically opposed to the objectified individuality characteristic of most other Abstract Expressionists who began achieving hallmark styles in the late 1940s. Before securing these distinguishing modes, these artists, including Krasner, had embraced existentialism, as well as the Surrealist method of psychic automatism. The latter was a means of free association that served as a procedure for discovering what were considered formal equivalents of themselves, but these painters soon permitted these experiments in improvisation to congeal into static styles. Krasner, however, remained committed to the existential imperative to confront the monstrous freedom of the modern world by facing her own contigency.[3]

Krasner's marriage to Jackson Pollock, who became the group's first proclaimed leader, and her position as the only female member of Abstract Expressionism's first generation have put both herself and her work in a position of otherness. Unfortunately, critics and art historians have tended to undermine this distinctive role by casting her accomplishments in the perennial shade of Pollock's widely proclaimed genius. Although several prominent scholars since the early 1970s have asserted that she is at last free from the secondary status of being Mrs. Jackson Pollock, others have regularly incorporated references to her phantomlike existence vis-à-vis

Lee Krasner, 1982.
Photograph by Robert Mapplethorpe

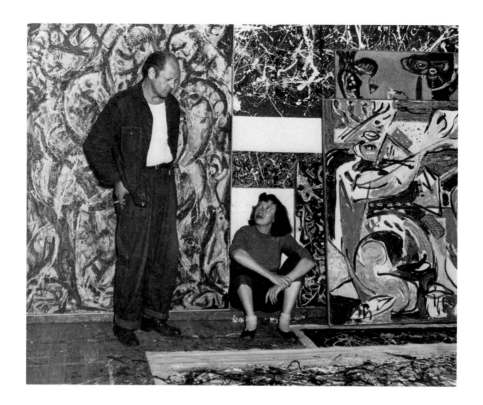

Lee Krasner and Jackson Pollock in
Pollock's studio, ca. 1949

Pollock, as the following headline descriptions of her readily demonstrate:
"Out of the Shade," "Overshadowed by Late Husband," "Out of the
Shadows to Gain Recognition," "Out of Jackson Pollock's Shadow,"
"Bursting Out of the Shadows," "Shining in the Shadow," and "In the
Shadow of an Innovator." Using such catch phrases, these writers have
unfortunately legitimized the problem by rallying around it.[4] As Krasner
herself commented, "The cliché is that Lee is overshadowed by her husband
and that's easy and we don't have to think about it. It is outrageous."[5]
And so it is.

Lee Krasner was assured a significant position in the history of twentieth-
century art the moment critic Clement Greenberg (fig. 1) stated in his
factually oriented *Evergreen Review* eulogy of Jackson Pollock in 1956 that
"even before their marriage [Krasner's] eye and judgment became impor-
tant in [Pollock's] art, and continued to remain so."[6] But even though her
historical position was secured at this time, the significance of her work
and the intellectual currents that it both apprehends and extends still need
to be discerned and assessed if we are to appreciate how she responded to
her times and in turn molded them through her work. In her art, Krasner
dramatizes a change of enormous import as she moves from the monolithic
definition of individual identity evident in the single-image compositions
prevalent in the mature works of many Abstract Expressionists toward
a more open-ended perception of the self as a dynamic constellation of
forces. This new mode of conceiving oneself can be most fully appreciated
in Krasner's decision in the mid-1950s to start working with Dr. Leonard
Siegel, an analyst conversant with the ideas of Harry Stack Sullivan

(1892–1949), rather than put herself in the care of a Freudian or Jungian specialist.

Although this essay deals with Krasner's art in a basically chronological manner, I investigate three enduring and at times interlocking themes affecting her work that are in turn transformed by it. These three subjects need to be established at the outset so that readers can be on the lookout for the ways that they at times subtly and at other times broadly frame her work and constitute the terms of the artistic conversation that she maintains with herself throughout her life. These themes represent the new contribution to Krasner studies that this book offers. Stated briefly, they are: (1) viewing oneself as other, which Krasner learned from French poet Arthur Rimbaud and enriched through her work with a Sullivanian analyst; (2) finding artistic equivalents to existentialism and its assumption of an unremitting freedom that makes the self an unresolvable lifelong project, and (3) being a responsive member of the New York Jewish intelligentsia in a pre- and post-Holocaust world. Apropos the dynamisms of her life, it is not surprising that in the 1970s Krasner took comfort in the following lines from T. S. Eliot's *Four Quartets*:

> *We shall not cease from exploration*
> *And the end of all our exploring*
> *Will be to arrive where we started*
> *And know the place for the first time.*[7]

Fig. 1. Clement Greenberg, ca. 1940s

Krasner's Beginnings

Paralleling her open-ended attitude toward her identity, Krasner underwent a long apprenticeship in the 1930s in which she initially moved from academic realism to Surrealism. Later she began to explore the international modernism that German expatriate Hans Hofmann (fig. 2) codified, transformed into a pedagogy, and disseminated in his school in New York City.

The theme of the self as other is established early in Krasner's career with *Self-Portrait*, 1930 (plate 1), which she undertook in the backyard of her parents' home in Huntington, Long Island, in order to be promoted to the level of "Life Drawing from Plaster Casts" at the National Academy of Design. Although the jury did not believe that her work was painted outdoors, Krasner explained that she had nailed a mirror to a tree and worked throughout the summer of 1930 on the picture. In this portrait, Krasner paints not herself but her mirrored reflection: the distinction is important since this artist remained throughout her life philosophically attuned to representation as an approximation of ongoing reality and a process of attempting to give form to that which exceeds itself. Instead of realizing

Fig. 2. Hans Hofmann

an *imitation* in which correspondences between the representation and its model are aligned, Krasner opts for a *resemblance* in which properties are shared but not assumed to be identical. The artist's stubborn intensity, her left-handed image that differs from her right-handedness, and the loose overall paint handling indicates the status of this work as an approximation of reality, and therefore a necessary abstraction, rather than an attempt to imitate nature exactly.

Her attraction during this early academic period to Michelangelo's *ignudi*, his famed male figures in the ceiling of the Sistine Chapel, gave rise to a series of conté crayon drawings in 1933 of heroically scaled strong nudes such as *Study from the Nude* (plate 2). This fascination with his work may have been catalyzed by a newspaper account describing the New York Customs Authority's contention that the nudes in the Sistine Ceiling were obscene and that photographic reproductions of them should not be allowed in the United States.[8] Her reaction to this controversy indicates that even at this early date Krasner enjoyed taking middle-class mores to task, however innocently and tentatively she was able to do so at the time.

In the next few years, her art moved in a more contemporary direction. The first sign of this is in *Gansevoort I*, 1934 (plate 3), an American Magic Realist tempering of Surrealist ideas which she took further in *Gansevoort II*, 1935 (plate 4), influenced by the more mysterious Italian Pittura Metafisica of Giorgio de Chirico. Krasner's full-fledged involvement with Surrealism is evident in *Untitled (Surrealist Composition)*, ca. 1935–36 (plate 5), in which she thematizes the power of sight in the form of a pair of connected yet disembodied eyeballs. Held to the ground by a stake, one eye appears to be levitating, through the sheer power of its vision, a broken, bleeding pedestal supporting the arm of a skeleton and an enshrouded figure, while the other weeps veins of blood and stares disconsolately in the direction of the work's assumed viewers. This emphasis on the power of sight to create and support worlds, as well as to empathize with these realms to the point that it is in danger of destroying itself, was to become highly significant for Krasner's later art, which would frequently feature disembodied eyes in even her most abstract pieces.

Krasner's Introduction to Modern Poetry:
Harold Rosenberg and Arthur Rimbaud

At the time that she began working on *Untitled (Surrealist Composition)*, Krasner, along with her live-in companion Igor Pantuhuff, a White Russian emigré who later became a portrait painter of little reknown, was sharing an apartment on West Fourteenth Street with poet and

Fig. 3. Harold Rosenberg

critic Harold Rosenberg (fig. 3) and his wife, May Natalie Tabak. Krasner had met Rosenberg in 1932 when she worked as a cocktail waitress at Sam Johnson's nightclub in Greenwich Village, which was frequented by such well-known figures as Lionel Abel, Maxwell Bodenheim, Joe Gould, Harold and David Rosenberg, and Parker Tyler. As Krasner has recalled, "They would come in evenings and discuss 'the higher things in life.' I was quietly in the background for a while and then I began to know them and I identified myself."[9] Soon after their meeting, she and Igor rented rooms in Rosenberg's apartment. Literary critic Lionel Abel has recalled the insightful discussions about art that he had with Krasner during this time and later in the 1940s when he became acquainted with Jackson Pollock. He believes Krasner to have been far more knowledgeable about art than Rosenberg, and, in fact, considered her to be Rosenberg's artistic mentor.[10] This assessment of her intellectual prowess and the respect she commanded among demanding intellectuals in New York is crucial to understanding the dynamics of her lifelong friendship with Rosenberg.

The bond between the two was no doubt cemented by the similarity of their backgrounds and interests. Both had been brought up by Orthodox Jews living in Brooklyn. Both were upwardly mobile, and both were committed to art.

Graduating from law school in 1927, Rosenberg suffered from a chronic bone infection and decided to forsake law in order to follow his father's love of poetry; he taught himself to write and also determined during this same period to undertake a related creative track, painting. A few informal classes in painting enabled him to obtain a position as an assistant with the Mural Division of the Fine Arts Project of the Works Progress Administration (WPA/FAP), and during the years 1938–42 he served as art editor for the WPA's *American Guide*.

Krasner was also intent on making the leap from a simple parochial background to a sophisticated modern one: she studied first at the Cooper Union (1926–28), then the Art Students League (briefly), the National Academy of Design (1928–32), and City College (1932–33) where she intended to obtain a teaching certificate. After a hiatus of four years, she returned to school in 1937, attending Hans Hofmann's School of Fine Arts for several years, continuing even as late as 1940 to give it as a reference whenever the WPA periodically needed to verify her occupation as a practicing artist. Her intimate acquaintance with Hofmann's theories enabled her to pass on his ideas to both Rosenberg and his young protégé Clement Greenberg, whom she met through Rosenberg.[11] Examples of works made under Hofmann's tutelege, around 1938–40, include a series

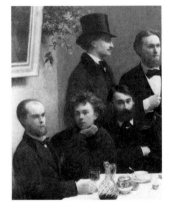

Fig. 4. Henri Fantin Latour, *Un Coin de Table*, 1872 (detail), showing Authur Rimbaud (second from left) sitting with fellow poet Paul Verlain (at extreme left).

of charcoal drawings of nudes, each entitled *Nude Study from Life*, 1938 (plates 6 and 7), and such painted still lifes as several oils entitled *Untitled (Still Life)*, 1938 (plates 8 and 9), and *Red, White, Blue, Yellow, Black*, 1939 (plate 10). Her *Mosaic Collage*, 1939–40 (plate 11), was also influenced by Hofmann's teachings.

In 1935, the same year that Krasner and Pantuhoff found housing on Twelfth Street and Second Avenue and moved out of the Rosenbergs' apartment, she and Harold Rosenberg were both assigned by the WPA's Mural Division to assist Max Spivak, an artist, who specialized in a range of subjects, including clowns for childrens' hospitals. Since Spivak preferred to work alone, both Krasner and Rosenberg spent their days running errands, cleaning his studio, and discussing at great length radical politics and intellectual trends.[12]

Frequently Rosenberg would read aloud to Spivak and Krasner,[13] but his readings were never polite recitations; instead they were liberally diced with pungent asides, full-blown tirades, and proselytizing epithets that constituted an ongoing seminar on the strengths, limits, and future direction of modern culture. Highly impassioned, Harold Rosenberg was incapable of restraining his opinions to genteel discussions. Abel remembers Rosenberg once confiding to him "that in his view the best way to converse with someone . . . would be to knock him down and pour everything one had to say in his ear."[14]

Never a meek follower of anyone, including Rosenberg, Krasner by all accounts was fiercely independent, opinionated, curious, argumentative, and capable of delivering quick ripostes with a sharp and well-aimed wit. Although Rosenberg and Spivak may have schooled her in leftist politics, and Rosenberg most likely introduced her to the poetry and thought of Charles Baudelaire and Arthur Rimbaud (see fig. 4), Krasner held her own when the conversation turned to painting.

In retrospect, it appears that Baudelaire's poetry and thought were of passing interest to Krasner, while Rimbaud's was to prove of enduring importance to her development. Born in 1854 and dead thirty-seven years later, this French poet, who was briefly associated with Paul Verlaine, became a critical influence on the Symbolists. In the brief period between 1870 and 1875, he wrote all his poetry and two letters (May 13 and 15, 1871) explaining his new aesthetic program that were later called "Lettres du Voyant." Beginning in the 1920s and continuing until the 1940s, his contributions were hailed by Surrealists and other members of the avant-garde as being particularly relevant to twentieth-century creative investigations. So Rosenberg's discussions of this poet would have

1. **Self-Portrait**, 1930. Oil on linen, 30⅛ x 25⅛ inches.
Pollock-Krasner Foundation, Inc., courtesy Robert Miller Gallery, New York

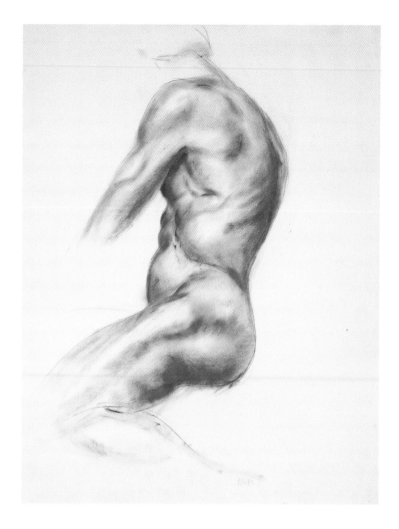

2. **Study from the Nude**, 1933. Pencil and conté crayon on paper,
21 x 15 ¾ inches. Pollock-Krasner Foundation, Inc.,
courtesy Robert Miller Gallery, New York

resonated with Krasner and would have reinforced critical views held by
a number of her associates.

The close and, by turns, embattled friendship that developed between
Rosenberg and Krasner was both mutually reinforcing and at times
alienating. Even though there were outbursts of anger and occasional long
standoffs, their association assumed over the years the character of an
intense family relationship.[15] When Krasner and Jackson Pollock decided
to marry on October 25, 1945, she requested that Peggy Guggenheim,
Rosenberg, and Tabak be the only people in attendance. Unfortunately,
Guggenheim was unable to participate; and, for some reason, Pollock
objected to Rosenberg, although he soon thereafter became friends with
him.[16] Thus, Tabak and the custodian of the Marble Collegiate Church in
New York were the only attendants. A few days later, Krasner and Pollock
purchased a house in The Springs, Long Island, on the outskirts of East
Hampton. A key factor in this decision, for Krasner, was the proximity of
a house owned by the Rosenbergs.[17] Over the years, Krasner depended on
the closeness of the Rosenbergs. Their daughter Patia remembers that in

3. **Gansevoort I**, 1934. Oil on canvas, 19 ¼ x 24 ¼ inches.
Metropolitan Museum of Art; gift of the Pollock-Krasner Foundation, Inc.

the 1940s in particular, Krasner would often appear unannounced and
would lie in the hammock relaxing and talking for hours with her par-
ents.[18] This relationship continued even though Rosenberg became a key
supporter of Pollock's arch-rival Willem de Kooning, and it persevered
even after Harold Rosenberg died in 1978, when Krasner remained one of
the few, from among the Rosenbergs' many friends, who was both under-
standing and kind to May Tabak, who was beginning to suffer from senility.

If we imagine Krasner, Rosenberg, and Spivak holding forth day after
day during the Great Depression about such then-current topics as the
strength of the U.S.S.R.'s brand of Communism as opposed to the weak-
ness of the United States' capitalism, the relative merits of Picasso versus
Matisse, whether the Surrealists were merely effete revolutionaries or were
truly innovative, and the role of French Symbolism in the formation of
modern art and poetry, we can begin to appreciate the profound intellectual
milieu in which Krasner was developing. Its intensity, and the seriousness
with which Krasner embraced it, are illustrated by her reaction to comments
made by playwright Tennessee Williams during a visit to her studio. When

4. **Gansevoort II**, 1935. Oil on canvas, 25 x 27 inches.
Pollock-Krasner Foundation, Inc., courtesy Robert Miller Gallery, New York

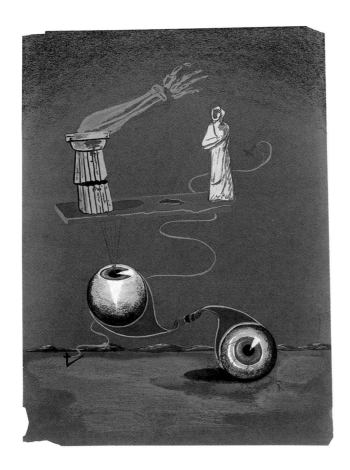

5. **Untitled (Surrealist Composition)**, ca. 1935–36. Mixed mediums on blue paper, 12 x 9 inches. Pollock-Krasner Foundation, Inc., courtesy Robert Miller Gallery, New York

Williams made fun of the lines from Rimbaud's *A Season in Hell* that she had written in black and blue chalk on the walls of her studio, she asked him to leave her studio. The quotation, which she kept on her walls until the autumn of 1942, when she gave up her separate quarters and moved into Pollock's apartment, was as follows:

> *To whom shall I hire myself out? What beast must I adore?*
> *What holy image is attacked? What hearts shall I break?*
> *What lie must I maintain? In what blood tread?*[19]

The lines were written in black chalk, with the exception of the question "What lie must I maintain?" which was written in blue. Separating this portion by a different color may have been a way of emphasizing it as an exception to the credo expressed in the lines to which she obviously subscribed. She later reaffirmed their importance in a conversation with critic Eleanor Munro. "They express an honesty which is blinding," she

6. **Nude Study from Life**, 1938. Charcoal on paper, 24 ½ x 18 ¾ inches.
Private Collection

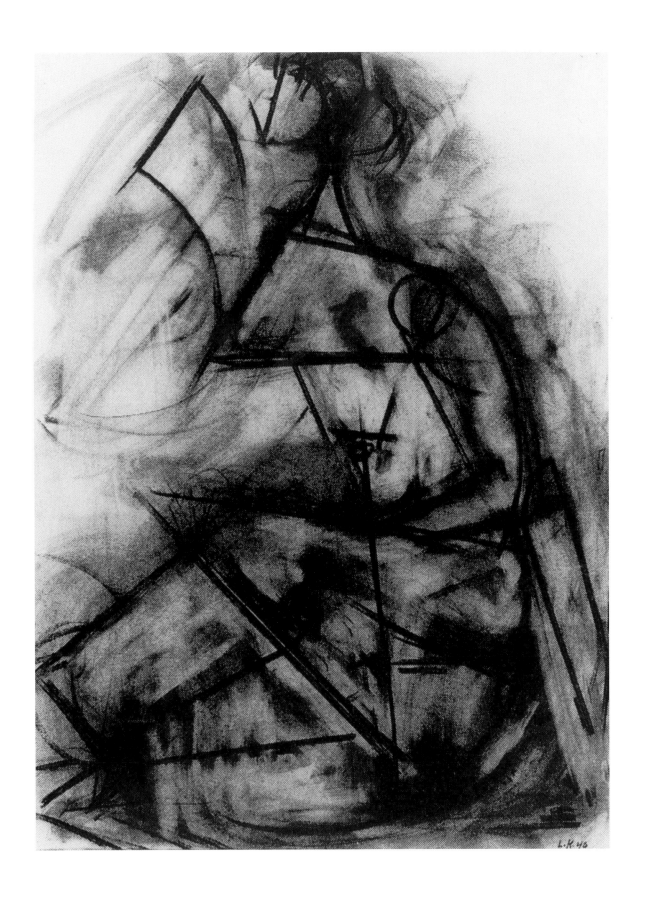

7. **Nude Study from Life**, 1940. Charcoal on paper, 24¼ x 19 inches.
Collection of Robert Glickman

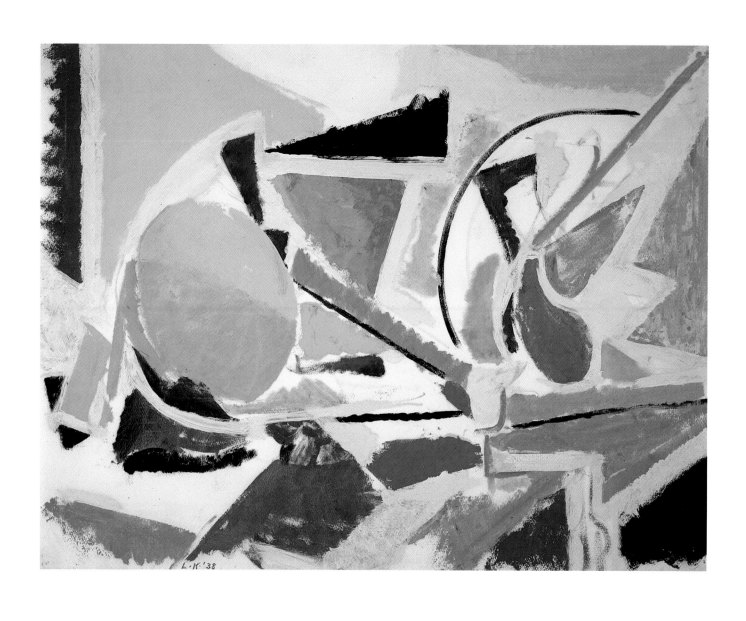

8. **Untitled (Still Life)**, 1938. Oil on paper, 19 x 24¼ inches.
Collection of Fayez Sarofim

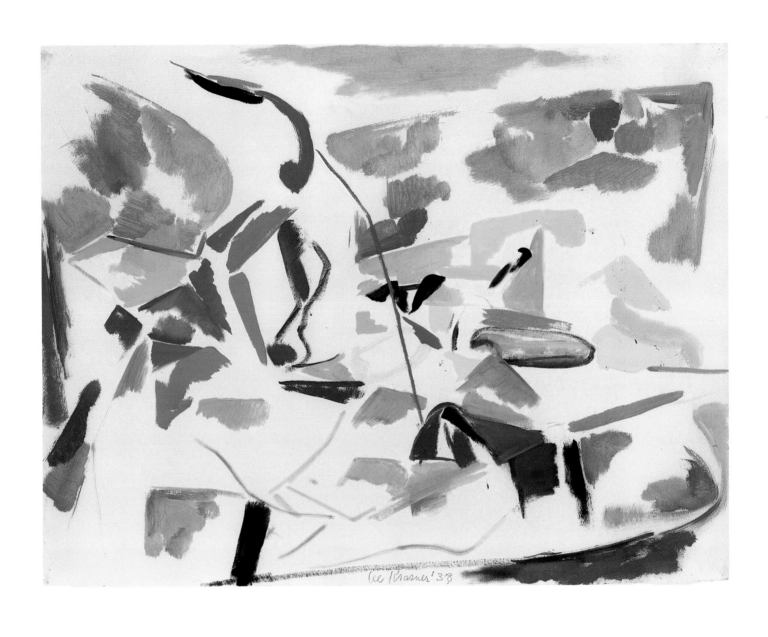

9. **Untitled (Still Life)**, 1938. Oil on paper, 19 x 24¼ inches.
Whitney Museum of American Art, New York

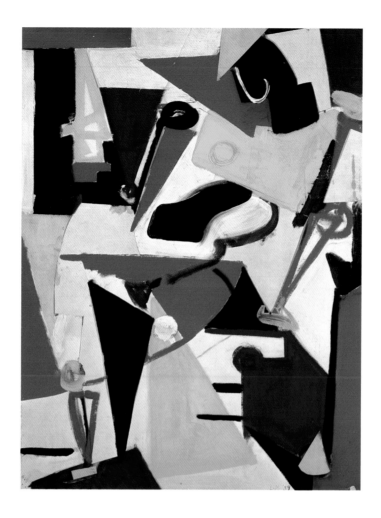

10. **Red, White, Blue, Yellow, Black**, 1939. Oil on paper with collage, 25 x 19⅛ inches. The Thyssen-Bornemisza Foundation, Lugano-Castagnola, Switzerland

said. "I believe those lines. I experienced it. I identified with it, I know what he was talking about. How much more reality do you want? Those lines have to do with reality—not lies," she repeated.[20]

Krasner's conviction differs from the more dialectic approach taken by Rosenberg. A confirmed Marxist, who in the mid-1930s was sympathetic to Soviet Communism because it promised to transcend bourgeois individuality in favor of a new group solidarity, Rosenberg was capable of taking both sides of an argument. While in many writers this flexibility can result in simply facile polemics, in Rosenberg's case it was joined with a determination to remain open and a commitment to give up untenable positions, and so it constituted a genuine means of understanding. Given the elasticity of Rosenberg's mind and his love of argument, it is not surprising that he enjoyed the challenge of taking a distinct point of view in one essay, and then, if necessary, reversing it in another. His openness may have served as a model for Krasner.

In several essays over a fourteen-year period, Rosenberg looked at both the pros and cons of Rimbaud's art. Since the different positions taken

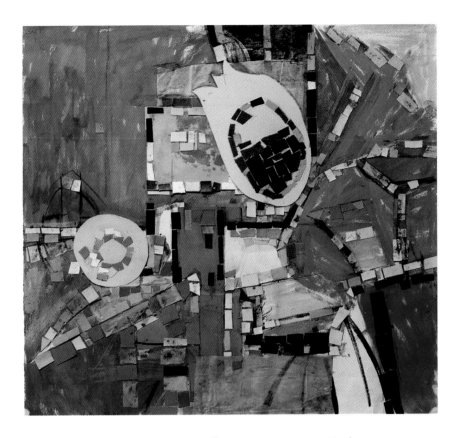

11. **Mosaic Collage**, 1939–40. Paper collage on paper, 18 x 19 ½ inches.
Private collection

indicate a powerful and often contrary sounding board for Krasner's
own ideas about this poet, his discussions are worth analyzing. Instead
of weakening Krasner's beliefs, Rosenberg's dialectics evidently helped her
strengthen them. In his essay "The God in the car" (1936), he quotes the
first two lines of the Rimbaud passage from *Season in Hell*, already noted
as important to Krasner, and comments that such a religious approach is
superannuated in light of the present "actual physical crisis: unemploy-
ment, suppression, war, social conflict."[21] While his socialist realist
orientation in this essay correlates with that of John Reed Club members
with whom he was associating,[22] seven years later in "The Profession of
Poetry" he accords Rimbaud's revolutionary ideas far greater prescience.
At that time, he quotes the following lines from Rimbaud's May 15, 1871
letter to Paul Demeny: "I wish to be a poet and work to make myself a
seer. . . . It is false to say: I think. One should say: I am thought. Pardon
the play on words. I is another."[23] Rosenberg concludes, "In the inspired
act, society and the individual are one, but beyond the will or egotism of
either."[24] This dovetailing of individual intuitions with cultural changes
results in works of art transcending individual egos. As Rosenberg admits
later in this essay, this "other 'I' is indefinable, though it can be affected
in precise ways."[25]

12. **Untitled**, 1940. Oil on canvas, 30 x 25 inches.
Collection of Fayez Sarofim

13. **Untitled**, 1940. Oil on canvas, 30¼ x 24¼ inches.
Collection of John Cheim

14. **Untitled**, ca. 1940–43. Oil on canvas, 30 x 25 inches.
Private collection

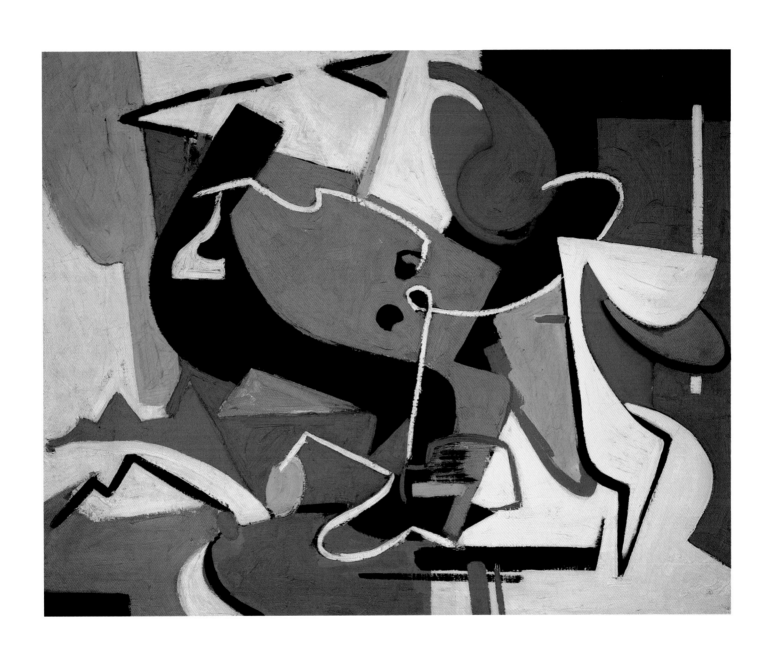

15. **Lavender**, 1942. Oil on canvas, 24⅛ x 30¼ inches.
Pollock-Krasner Foundation, Inc., courtesy Robert Miller Gallery, New York

16. **Untitled Mural Study**, 1940. Gouache on paper,
sheet: 15 x 20 inches, image: 6⅛ x 18⅛ inches.
Pollock-Krasner Foundation, Inc., courtesy Robert Miller Gallery, New York

In his Introduction to the English translation of Marcel Raymond's highly acclaimed *From Baudelaire to Surrealism*, Rosenberg endorses Rimbaud's treatment of the text as an object instead of subscribing to the romantics' espousal of poetry as the preeminent form for their deepest sentiments:

> Lifting up a word and putting a space around it has been the conscious enterprise of serious French poetry since Baudelaire and Rimbaud. With this "alchemy" poetry dissolves traditional preconceptions and brings one face to face with existence and with inspiration as a fact. Or it re-makes the preconceptions and changes the known world . . . Poetry as verbal alchemy is a way of experiencing, never the expression or illustration of a "philosophy." It neither begins with ideas nor ends with them. It means getting along without the guidance of generalizations, which is the most difficult thing in the world.[26]

The importance of this statement is its emphasis on works of art as communicators of their own mysteries and meaning that removes them from the subservient position of merely telegraphing artists' feelings. Instead of becoming surrogate egos for their creators, works of art constitute messages in and of themselves. The envelopes of space that Rosenberg describes in Rimbaud's poetry defamiliarize the reader's customary relationship with the world, endowing aspects of it with a new and almost hallucinatory reality.

The Symbolists, who in many ways followed Rimbaud's ideas, enabled Rosenberg to see that poetry needed to free itself of conventional meanings. However, they believed that it required doing so in order to intimate the

inexpressible mystery of one's inner life and to suggest the state of the poet's mind without bothering to delineate its prosaic contents. More in line with Rimbaud is their belief in poetry's ability to indicate the unity of pre-rational thought through *correspondences* between the senses; it portended a deeper reality by going beyond both materiality and individuality in order to give free play to this subjective emotional realm. But, rather than make this descent into the deeper realms of an alien self in order to present reality with greater clarity, as Rimbaud did, the Symbolists contented themselves with allusiveness and innuendo, developing a hothouse aesthetic unconnected with the world. Because Rimbaud wanted to reveal the unexamined power of the world rather than merely transcend it, he provided Rosenberg with an understanding of how an aura of space isolating a concrete noun or adjective could make it paradoxically more abstract and real and at the same time more evocative and powerful.

Hans Hofmann's School

Rosenberg's discussion of the power of space around words seems so relevant to Krasner's Hofmann-inspired abstracted still lifes of the late 1930s and early 1940s that one wonders if Rosenberg influenced Krasner or if, in fact, her ideas had a major impact on him. Whatever the direction of the influence, their relationship was based on mutual interests and respect reinforced by his expertise in poetry and hers in painting.

Beginning in 1938 and continuing until 1942, when her work and thought became imbued with Jackson Pollock's way of painting, Krasner adhered to a Platonic hierarchy of value in which more generalized forms were regarded as the most real. In the abstract paintings she created during this period, she deemphasized the shadowy realm of images, which Plato viewed as mere copies of objects, in order to posit the works as participants in a higher order of forms—eternally true archetypes—that can only become apprehensible in art through intellectual copies and corporeal reproductions. The way that she positioned her work in this hierarchy of value is similar to that of a number of other geometric abstract painters working in the first half of the twentieth century, who began the project of prying form loose from a merely illustrative function so that it would begin to approach the higher order of Being outlined by Plato. In her work, this separation/alienation of form from conventional subject matter is evident in the envelopes of space surrounding passages of pure color.

Hofmann's elaborately constructed studio arrangements helped her in this undertaking. In order to set up a still life that would enable students to appreciate individual shapes of objects and their interconnections with

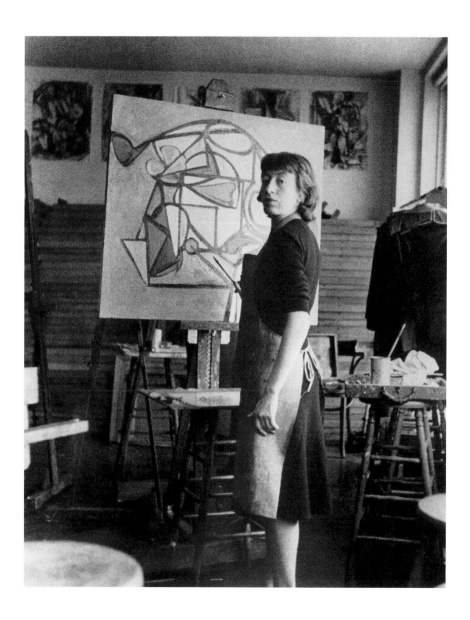

Lee Krasner at the Hans Hofmann
School of Fine Arts, ca. 1940

other elements, Hofmann would create elaborate assemblages from a host
of studio and office detritus, including paper or broken cups, playing
cards, bowls of fruit, teapots, and bits of string.[27] To emphasize the strategic
role played by the in-between spaces that help build tensions in a work
even as they provide a scaffolding for abstract forms, he would use crumpled
sheets of cellophane and construction paper. In this way, the ensuing
paintings by his students, including Krasner (see plates 8 and 9), became
exercises in constructing forms. The use of these elaborate schemes, which
would often take Hofmann an entire afternoon to assemble, was buttressed
by his own theory that in art one represents first a medium and then one-
self. And that self can be defined only in so far as it can be channeled into
a particular medium. His three-step understanding of this process depended
on, first, a comprehension of nature's laws; second, the artist's empathy for
both nature and a chosen artistic medium; and third, the ability of an
artist to translate his or her inner world into a medium, being careful to
acknowledge both its limitations and its strengths.[28] Although this emphasis

on the artist's inner world seems more in line with the Symbolists than Rimbaud, the rigor with which the medium was approached in Hofmann's schema prevented works of art from becoming merely ideosyncratic musings.

Decades later, Krasner confirmed her understanding of Hofmann's integrative process constituted through a uniting of self and medium when she told her then assistant John Post Lee, "but looking at, as you say, the tree or the flower or sky, one absorbs it, and it becomes part of you, your so-called soul. When you draw from your own sources you're drawing from what you've absorbed."[29] No doubt, she was referring to such late works as *Crisis Moment*, ca. 1972–1980 (frontispiece), which was acquired by John Post Lee's father. And when Lee responded to Krasner, "So you filter nature through," she corrected him with the Rimbaudian assertion, "*It* filters through," thus demonstrating how she had joined aspects of Hofmann and Rimbaud in her understanding of her creative process.[30]

Beginning in the late 1930s, Hofmann's overriding concern with the medium and his acknowledgment of the subsidiary yet constitutive role played by nature enabled Krasner to create increasingly abstract still lifes in the manner first of Matisse (ca. 1938) and then, particularly from 1939 to 1943, in the manner of Picasso (see several works referred to as *Untitled*, 1940 (plates 12, 13, and 14). In these works, color and geometric shapes are poised between illustrative and self-affirmative roles, between supporting a host of associations with still-life phenomena and standing alone as abstract colors and shapes important in their own right. In this hiatus between illustration and abstraction, they begin to dissolve known realities and to portend their own affinities with the universal and suprasensory values Plato reserved for transcendent forms. Regarding Matisse's importance, Krasner later recounted, "Mainly, I would say it's the air-borne quality of it. It allows you to move into space."[31]

In these works, Krasner began what proved to be a long evolutionary process of coming to terms with the theories of Rimbaud, a journey that would eventually lead to a full appreciation of his assertion, "I ended up by finding sacred the disorder of my spirit."[32]

Radical Politics and the American Abstract Artists

Krasner's artistic competency was greatly respected in the transitional period after the hegemony of socialist realism in the mid-1930s and before the United States' entry into World War II. During those years, she served in a supervisory role in the WPA and its bureaucratic stepchild, the War Services Project, and participated in American Abstract Artists (AAA) annual exhibitions by exhibiting paintings similar in style to the abstract

still lifes appropriately named *Untitled* that date from the early 1940s as well as *Lavender*, ca. 1942 (plate 15).

Many leftists, who had looked to the Soviet Union as a model for failed Western economies, began to question their idealism when Joseph Stalin embarked on a reign of terror in which former Communist leaders, who might be his potential contenders, were summarily tried and executed; their allegiance was further weakened in 1939 when Stalin signed a non-aggression pact with Hitler and invaded Finland, a neutral country.

The primary recourse for these New York liberals, including Krasner, was to turn to the ideas of former Russian Communist leader Leon Trotsky (fig. 5), who offered in several essays published in *Partisan Review* a ready solution for how they could be both advanced abstract artists and entrenched leftists. After suffering himself from a Communist orthodoxy that had easily been subsumed under Stalin's totalitarian dictatorship, Trotsky, who had been a longtime proponent of modern art and a critic of state-directed aesthetics, began to value even more the nonaligned role that creative individuals must play in any society.

In 1938 *Partisan Review* published an article ostensibly by French Surrealist leader André Breton and Mexican muralist Diego Rivera that was actually co-authored by Breton and Trotsky. Their pointed message to artists stressed that

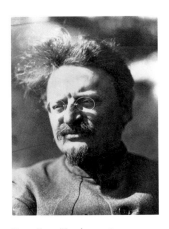

Fig. 5. Leon Trotsky, 1936

> the communist revolution is not afraid of art.... In the realm of artistic creation, the imagination must escape from all constraint and must, under no pretext, allow itself to be placed under bonds.... If, for the better development of the forces of material production, the revolution must build a socialist *regime with centralized control, to develop intellectual creation an* anarchist *regime of individual liberty should from the first be established. ... We believe that the supreme task of art in our epoch is to take part actively and consciously in the preparation of the revolution. But the artist cannot serve the struggle for freedom unless he ... freely seeks to give his own inner world incarnation in his art.* [33]

Not only were Trotsky and Breton permitting modern artists the right to deviate from politically sanctioned art if it did not accord with their own inner voices, but they also empowered them to form an ongoing, anarchist faction that would ensure their society freedom of speech and prevent leaders from turning people into mere puppets.

The next year in a letter of congratulations to Breton and Rivera for their manifesto and for the formation of FIARI, (in the U.S., called IFIRA, International Federation of Independent Revolutionary Art]), Trotsky reaffirmed this position. "The struggle for revolutionary ideas in art,"

he wrote, "must begin once again with the struggle for artistic *truth*, not in terms of any single school, but in terms of *the immutable faith of the artist in his own inner self.* Without this there is no art," he added. "'You shall not Lie!'—that is the formula of salvation," he predicted.[34] Whereas earlier in the decade, John Reed Club members had crusaded for a programmatic socialist realist art that could be understood by workers who they hoped would form an eventual proletariat,[35] Trotsky's position now allowed members of an elite vanguard to believe that their work would contribute to an eventual Communist state so long as they rigorously adhered to their own vision.

Unless one is versed in the full context of these statements by Trotsky, the American Abstract Artists and their fervent commitment to the difficulty, abstruseness, and elitism of modernism might appear to be far removed from liberal politics. Differing from both Midwestern Regionalists with their isolationalist policies and from the socialist realists with their reactionary aesthetics aimed largely at an uneducated populace, AAA members regarded internationalism as the most advanced route for enlightened individuals wishing to keep faith with the future. In the words of their leading exponent George L. K. Morris, a regular contributor to *Partisan Review*:

> The slogan of the [American Artists'] Congress is For Peace, For Democracy, For Cultural Progress, *and obvious comments upon these phrases echo resoundingly from every wall. The Abstract Artists share these convictions, but they also believe that the aesthetic impulse cannot become a tool for concrete political or philosophic dissemination—at this stage of our cultural metamorphosis at least.*[36]

About this same time, Morris also pointed out that AAA painters worked without the support of a public, without the promise of remuneration for their efforts, and with only themselves for an audience.[37] His realization that their commitment constituted a heroic monasticism without visible rewards provides the necessary context for Clement Greenberg's statement in his famous early essay "Avant-Garde and Kitsch":

> Yet it is true that once the avant-garde had succeeded in "detaching" itself from society, it proceeded to turn around and repudiate revolutionary politics as well as bourgeois politics. . . . Hence it was developed that the pure and most important function of the avant-garde was not to "experiment," but to find a path along which it would be possible to keep culture moving in the midst of ideological confusion and violence. Retiring from the public altogether, the avant-garde poet or artist sought to maintain the high level of his art by both narrowing and raising it to the expression of an absolute.[38]

While Greenberg correctly assesses the AAA reticence to innovate—remaining modern at this time was a major feat—he does not permit this group the political justification that Trotsky's writings accorded it.

Greenberg's position is surprising, given his participation in the contemporaneously founded group called the League of Cultural Freedom and Socialism, whose goals had been published that previous summer in *Partisan Review*.[39] Among the signatories of the L.C.F.S. were Lionel Abel, Clement Greenberg, George L. K. Morris, William Philips, Fairfield Porter, Harold Rosenberg, Meyer Schapiro, and Delmore Schwartz. They refused to subscribe to a reactionary culture that would accord with the Kremlin government's policies and instead

> demand[ed] COMPLETE FREEDOM FOR ART AND SCIENCE. NO DICTATION BY PARTY OR GOVERNMENT. *Culture not only does not seek orders but by its very nature cannot tolerate them. . . . We are not alone in these convictions. Our principles are in general agreement with those contained in a recent manifesto of André Breton, the French poet, and Diego Rivera, the Mexican painter.*[40]

In retrospect, the problem with such an elitist position as that taken by the AAA is that it ultimately became so personal that it constituted no political stance at all, and could not be differentiated from the group ethos of determined individualism later characterizing Abstract Expressionism. This affirmation of personally achieved truth was to become a primary basis for the Abstract Expressionists, many of whom forgot the original political import of their entrenched empiricism.

But unlike many of the Abstract Expressionists who soon opted for a romantic definition of the self, Lee Krasner never forgot her Trotskyite affiliations, even though she tended to conflate a number of the crucial issues, as her later statement to Barbara Rose indicates:

> *There was the Spanish Civil War, the clash of Fascism and Communism. In theory, we were sympathetic to the Russian Revolution—the socialist idea against the fascist idea, naturally. Then came complications like Stalinism being the betrayal of the revolution. I, for one, didn't feel my art had to reflect my political point of view. I didn't feel like I was purifying the world at all. No, I was just going about my business and my business seemed to be in the direction of abstraction.*[41]

Along with other AAA members and the burgeoning Abstract Expressionists in the early 1940s, Krasner was soon preoccupied with the task of developing her own mode of painting. For a brief time, she, like the others, had been assured by Trotsky that this stance was both politically and artistically sanctioned. But after his assassination and after the white heat of

political controversy that had fanned the flames of 1930s liberalism died down in the face of the war effort, the only memory of these complex and subtle distinctions that Krasner maintained was a tremendous pride in her Trotskyite stance.

She believed that this affiliation with Trotsky elevated her above Pollock. Throughout her life she permitted herself the luxury of openly condemning him for helping David Alfaro Siqueiros, a suspect in the Trotsky assassination plot, whom he had known in 1936 through this Mexican painter's experimental workshop at 5 West Fourteenth Street. Even though Siqueiros had been exonerated of any guilt in the May 24, 1940 attempt on Trotsky's life and the subsequent kidnapping and murder of his New York bodyguard, Robert Sheldon Harte, Krasner persisted in considering him guilty. She was particularly troubled that Pollock had admitted aiding Siqueiros during the time he was hiding from the police.[42]

Krasner's WNYC Mural Proposal

Among the two most important factions making up the AAA, Krasner sided with the group consisting primarily of former Hans Hofmann students who believed in abstracting from nature as opposed to those who were willing to dispense with ties to the external world.[43] Even though she revered the leading nonobjective painter, Piet Mondrian, as the preeminent European expatriate living in the United States and never forgot his advice that she should maintain in her art her predilection for strong inner rhythms,[44] her own early work, except for a brief flirtation with Neoplasticism (ca. 1939–40), in which her work closely paralleled Mondrian's, maintained connections with the abstract still-life genre taught at the Hofmann school.

The increasing respect accorded her art is documented by a request in 1941 from Burgoyne Diller, head of the WPA/FAP's Mural Division in New York City, for her to submit a proposal for a mural for Sound Studio A at radio station WNYC, located in the Municipal Office Building in lower Manhattan. Diller would certainly have been acquainted with Krasner's forays in this genre, such as her *Untitled Mural Study*, 1940 (plate 16). WNYC was already renowned in the late 1930s for owning important murals by Stuart Davis, Byron Browne, and John von Wicht. The proposed mural would be one of the few abstract mural projects in the New York area—the others being at the Williamsburg Housing Project in Brooklyn, the Chronic Disease Hospital on Welfare Island, and the New York World's Fair of 1939–40.

In order to comprehend the high regard Diller's request accorded Krasner, it is necessary to look at the reputation of WNYC at this time. A municipal

as opposed to an educational station, WNYC had been upgraded in the mid-1930s after Mayor Fiorello H. LaGuardia asked three prominent local radio executives in 1934 to provide a report on the present conditions and possible future developments of the station.[45] As a result of their report, the station increased its commercial operations, and in 1937 new soundproofed and air-conditioned studios were built. In the late 1930s WNYC became known for its classical music, provided by a federally supported station orchestra, as well as its consumer-service programs devoted to municipal agencies and area university educational programs. Also in the late 1930s, its staff innovated live broadcasts of government proceedings dealing with the Coast Guard inquiry into the Morro Castle disaster. Its somewhat later live broadcasts of New York City Council meetings became so celebrated for the humor of their bombast and outrageous polemics that the station's audience increased to a rumored million people, and comedian Eddie Cantor sent a tongue-in-cheek telegram to LaGuardia offering to purchase an audio recording of some of these council meetings for his own network radio program, providing he could omit sections he considered too funny. The important and innovative role played by WNYC in New York cultural and civic affairs, its nationwide reputation, and the high caliber of murals already in situ strongly suggest that Diller's invitation to Krasner had been carefully considered and that he was assured her work would be a credit to his agency.

Krasner's small gouache *Mural Study for Studio A, Radio Station WNYC,* 1941 (plate 17), exhibits her interest in Picasso's still lifes and in Mondrian's neoplastic works.[46] Less figurative and more constructivist is the abstract still life appearing in *Untitled (Alternative Study for Mural, Studio A, WNYC,* 1941 (plate 18). A slightly later example of her thinking about abstract murals is *Untitled,* ca. 1942 (plate 19). These studies indicate Krasner's ease working within the stylistic constraints of international avant-garde art and place her work at the forefront of the American Abstract Artists, who were similarly ambitious and orthodox in their avant-garde tastes. Instead of innovating a new style, they were content to synthesize various European avant-garde factions into an easily assimilated yet still elitist program. In this manner, they shared Hans Hofmann's ambition to disseminate the tenets of international modernism in the United States. Despite the subsequent acceptance of Krasner's mural study for WNYC by the WPA, it was never able to receive the approval of the New York City Art Commission, since WPA funds in March 1942 were channeled to the Graphic Section of the War Services Program, making the WPA a no longer active agency.

Promoted to the role of supervisor in the War Services Project in May, Krasner was responsible for overseeing in 1942 the creation of twenty-one

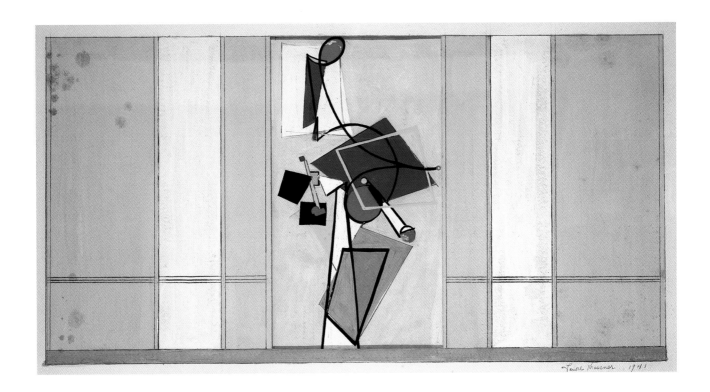

17. **Mural Study for Studio A, Radio Station WNYC**, 1941. Gouache on paper,
10 ¾ x 28 ⅛ inches. Pollock-Krasner Foundation, Inc., courtesy Robert Miller Gallery, New York

18. **Untitled (Alternative Study for Mural, Studio A, WNYC)**, 1941. Gouache on paper,
image: 14 x 11 inches, sheet: 20 ⅛ x 30 inches. Pollock-Krasner Foundation, Inc.,
courtesy Robert Miller Gallery, New York

19. **Untitled**, ca. 1942. Gouache on mat board, sheet: 15 ⅛ x 20 ⅛ inches, image: 10 x 13 inches. Courtesy Robert Miller Gallery, New York

20. **War Services Window: Chemistry**, 1942. Photomontage and collage, dimensions unknown. Destroyed

21. **War Services Window: Cryptography**, 1942. Photomontage and collage, dimensions unknown. Destroyed

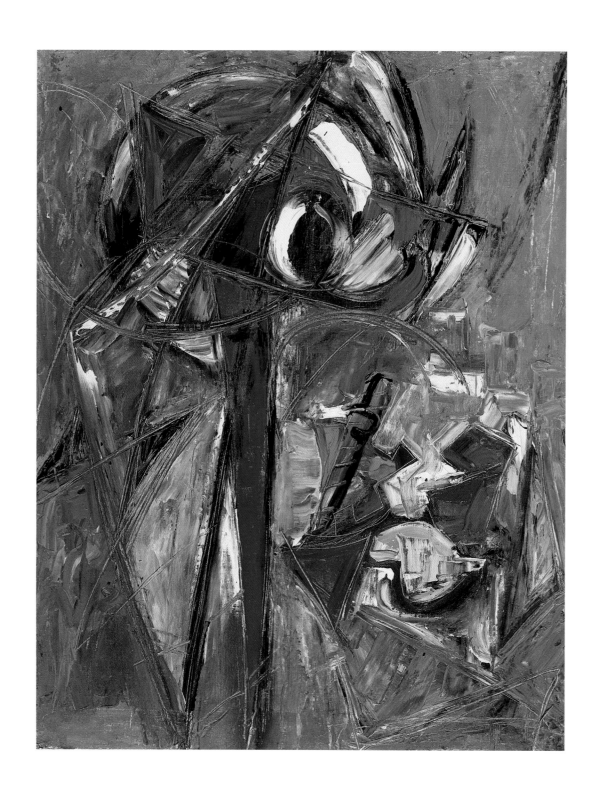

22. **Image Surfacing**, ca. 1945. Oil on linen, 27 x 21½ inches.
Pollock-Krasner Foundation, Inc., courtesy Robert Miller Gallery, New York

department-store window displays in Manhattan and Brooklyn. These presentations promoted war-training courses that were being offered by New York City colleges. *Chemistry* (plate 20) and *Cryptography* (plate 21), are typical of these efforts produced by Krasner and her team, which included Ben Benn, Jean Xceron, Frank Greco, and Jackson Pollock.

John Graham

Krasner's initial disappointment regarding the collapse of the WNYC mural commission was abated at the end of the year when painter John Graham (fig. 6) invited her to participate in the exhibition he was curating for a midtown design firm, McMillen, Inc. Graham had been born Ivan Dabrowsky and had served as a Russian cavalry officer during World War I before moving to Paris and becoming acquainted with modern art. His exhibition at McMillen was entitled *French and American Painting*, and its purpose was to demonstrate the strengths of American artists when seen in the company of such important Europeans as Braque, Matisse, and Picasso. Included among the Americans were Stuart Davis, John Graham himself, Willem de Kooning, Walt Kuhn, and Jackson Pollock. Although Krasner had met Pollock briefly at a party in the late 1930s, she had forgotten this brief encounter and set out to introduce herself to him once she determined that he was the only artist in the McMillen exhibition with whom she seemed to be unacquainted. Since their meeting, subsequent relationship, and marriage have already been well covered in the literature on Krasner and Pollock, and since their association has severely curtailed a full appreciation of Krasner's distinct artistic contributions, discussion of their interactions will be limited in this book to those contributing to an understanding of her work.

In retrospect, it is highly doubtful Krasner would have responded so strongly to Pollock's art if she had not already become acquainted with John Graham's thought, which is outlined in his peripatetic *System and Dialectics of Art* that she had read soon after its publication in 1937.[47] A guru capable of dramatizing esoterica, tribal artifacts, and intimate knowledge of the School of Paris, Graham created around himself an entourage of maturing artists that included prospective Abstract Expressionists de Kooning, Adolf Gottlieb, Krasner, Pollock, Richard Pousette-Dart, and David Smith. "He had an enormous influence on me," Krasner later acknowledged.[48] Because of his fecund and synthetic mind, ability to give intellectual coherence to a wide range of esoteric lore, and penetrating eye capable of assessing quality in new and often still undeveloped ideas, Graham was a major force in the development of Abstract Expressionism in general and the work of Lee Krasner in particular.

Fig. 6. John Graham, ca. 1934.

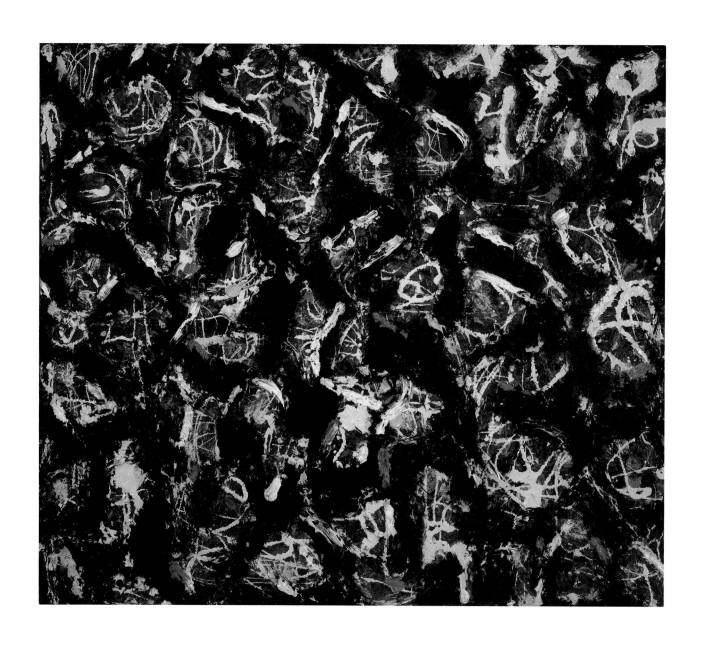

23. **Abstract #2**, 1946–48. Oil on canvas, 20½ x 23¼ inches.
IVAM. Instituto Valenciano de Arte Moderna. Generalitat Valenciana, Spain

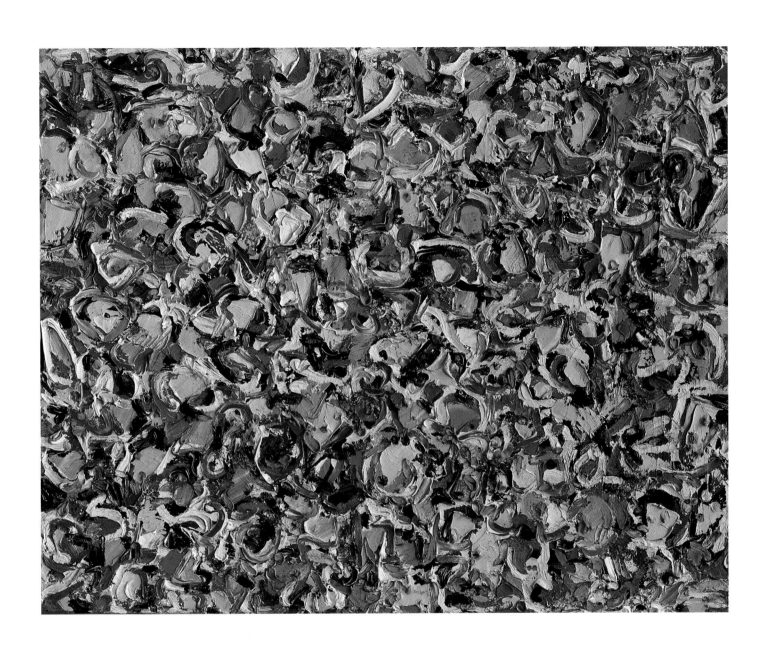

24. **Noon**, 1947. Oil on linen, 24 x 30 inches.
Collection of Roy Zuckerberg

In his *System and Dialectics of Art*, Graham set out to locate the source of creativity within each individual and proposed the unconscious as the true muse of modern art. So important was the synthetic faculty of dreams that Graham declared the conscious mind to be wholly incapable of creating and relegated it to serving as "only a clearing house for the powers of the unconscious."[49] Even though he took pains to separate the unconscious from Surrealism, he nonetheless expropriated in wholesale fashion its emphasis on automatic writing, which he renamed "automatic écriture." "By écriture," he explained cryptically, "is understood a *personal* technique. . . [which is a] result of training and *improvisation* in contradistinction to technique in general which is an accumulation of professional methods."[50] Such a means was intended not only to provide an "open sesame" to the unconscious, but it was also intended "to re-establish a lost contact with the primordial racial past."[51] Following in line with the highly regarded Swiss founder of analytical psychology, C. G. Jung, by regarding the unconscious as humanity's great wellspring, Graham stressed both its essential ambiguity and its ability to reconnect humans with each other as well as with their earliest beginnings, starting with "the first cell germination."[52]

This last idea was more important to Krasner's contemporaries than to her personally. She was struggling to find herself and would not have had the hubris to believe in her capacity to discover humanity's taproot. As we shall see, instead of reenacting a beginning, she consoled herself with its precious traces. Both her pragmatism and precarious self-esteem protected her from the grandiloquence and hyperbolic egotism of those Abstract Expressionists who believed themselves capable of conjuring humanity's most ancient and important truths.

Despite the success of the McMillen exhibition, Krasner's work took a decided turn that she later described as an attempt to move from Hofmann's external nature to Pollock's assertion, "I am nature."[53] But this change was already anticipated by her reading of John Graham's book and understanding of Rimbaud's theories. Pollock's presence acted as a catalyst for ideas with which Krasner was already conversant, forcing her to come to terms emotionally with such theories as automatic écriture that she had only begun to accept consciously.[54]

The Gray Slabs and the Holocaust

There may well be other, heretofore unexplored factors besides Krasner's difficulty of coming to grips with intuition that explain why most of her works during the years from approximately 1943 to 1946–47 so often ended up looking like gray slabs of paint, which she referred to as gray stones.[55]

One of the few exceptions is the optimistically entitled painting *Image Surfacing*, ca. 1945 (plate 22). As Krasner explained, "I went into my own black-out period which lasted two or three years where the canvases would simply build up until they'd get like stone and it was always just a gray mess. The image wouldn't emerge. . . . I was fighting to find I knew not what."[56] On another occasion, she referred to them as her "'mud' period."[57] Since Picasso in the preceding decade had made well-known references to Honoré de Balzac's "Le Chef d'Oeuvre Inconnu" (1831), Krasner might have legitimized her efforts through references to this tale regarding a frustrated old Baroque painter who kept reworking the portrait of a young woman to the point that the ensuing layers of paint resulted in an illegible abstract work similar to her own gray slabs. But at the time, she was far too frustrated and found painting far too much of a battle between her rationality and intuition to take comfort in such a respected prototype.

The classic account of Krasner presenting these works to Pollock's former teacher and mentor, American midwestern realist painter Thomas Hart Benton, has been by critic Amei Wallach:

"I must have been god-damned cheeky," says Krasner, with just the hint of a glimmer in her eye, remembering that visit.

"I had never met Benton, and I had no interest in his work. At one point Benton said to me, 'I understand you paint; may I see what you're doing?'

"There was a silence."

"I knew what was in my studio," says Krasner. "Jackson also knew. We walked into my studio. We looked at the slabs of gray. There was such a stony silence. Finally, Jackson said something to break the tension."

"I was saying, 'I paint. I paint every day. This is what's happening to me.'" Krasner said. "I faced the issue very aggressively. I was having a rough time, and I didn't care who knew it."[58]

None of these experiments with intuition now exist, because Krasner subjected them to a thorough soaking in the bathtub before scraping them down so that she could reuse the canvases.

A possible explanation for these dense, turgid works of the mid-1940s is that they were subliminal reactions to the mass murders of Jews in Nazi-occupied Europe, which were then being publicly acknowledged in New York. On December 2, 1942, the first public solemnization of the Holocaust took place when approximately half a million Jews and others in New York City elected to stop work for ten minutes in order to remember those who had been killed and also to alert the general public to the continuing massacre. Several radio stations observed two minutes of silence before broadcasting memorial services at 4:30 that same afternoon. Soon after

these acts of public mourning, the first newspaper accounts of the atrocities began to appear, usually embedded in lengthy war reports. The following spring a number of mass commemorations were held, including the "We Will Never Die" ceremony at Madison Square Garden that was dedicated to the two million Jews who had already been killed. In 1944 a pictorial history of the Nazis' devastation of European Jewry was presented at the Vanderbilt Gallery on Fifty-seventh Street. This exhibition may be the source for Harold Rosenberg's 1944 reference to "the watery-eyed gas chambers, and lime kilns that have done death to three million Jews in Europe."[59] Two years later a memorial to the "Heroes of the Warsaw Ghetto and the Six Million Jews Slain by the Nazis" was proposed for New York City. And the following year, on October 19, 1947, tens of thousands of people gathered along Riverside Park as Mayor William O'Dwyer dedicated a site to this future monument.

Contemporaneously with these acts of communal mourning and public acknowledgment of atrocities on a heretofore unheard-of scale, Krasner found herself face-to-face with the mounting resistance of the gray slabs she was creating. Although she characterized her difficulty as an inability to discover an intuitive self in her work, she may in fact have been far closer to her goals than she realized. The unbelievable horror of the Holocaust that is heightened by the clinical means with which it was carried out was so profoundly unsettling that many Jews were at a loss as to how they should react. They became truly speechless, words and images seeming to be inadequate responses to the heinous situation these bureaucratically administered killings represented. Krasner's gray slabs might be considered the first of a series of reactions that culminated in Newman's and Rothko's evocations of the Sublime under the aegis of Nietzsche's Dionysian realm, Edmund Burke's "danger at a distance," and Immanuel Kant's abject inferiority, indicating the failure or inability of reason to deal with certain overwhelming ideas.

The identity of what critic Alfred Kazin termed "the New York Jew" was severely challenged by the Holocaust. In the 1930s this particularly adventurous brand of intellectual, poet, and artist, which included Krasner among its members, had gone to great lengths to avoid all possible ortho-doxies, particularly those associated with religion and politics.[60] According to Kazin, their "aim was unlimited freedom of speculation, the union of a free radicalism with modernism."[61] Modernism became their religion, and new ideas their most respected currency. While Krasner's art is distanced and mediated, she was obviously intrigued by claims made for art as a surrogate religion and for its seemingly magical presence. In fact, she

conjectured, "It is possible that what I found later on—art—would be a substitute for what religion had been for me earlier."[62] The identity of these New Yorkers, according to Kazin, was predicated on tensions developing from both affirming and denying their traditional backgrounds:

> To be a Jew and yet not Jewish; to be of course a liberal, yet to see everything that was wrong with the "imagination of liberalism;" to be Freudian and a master of propriety; academic and yet intellectually avant-garde—this produced the tension, the necessary intellectual ordeal, that was soon to make [Lionel] Trilling the particular voice of intellectuals superior to liberalism. Freud said that "being a Jew, I would always be in the opposition."[63]

While Krasner, as an avant-garde artist, was not subject to the tensions of propriety and academe that affected some of the intellectuals described by Kazin, she did aspire to disembrace herself from inherited allegiances and affiliate herself with innovative trends. In order to do so, she had to undertake a series of enormous leaps: first, to surmount her humble origins and orthodox background with its proscriptions against visual imagery in order to prepare herself for entry into the world of international modern art; then to investigate the unexplored realm of internalized nature represented by Rimbaud's and Graham's theories as well as Pollock's paintings. With other New York Jewish intellectuals, including her friends Rosenberg and Greenberg, who were part of the *Partisan Review* circle that included Abel, Paul Goodman, Irving Howe, Schapiro (fig. 7), and Delmore Schwartz, she shared a common desire to function as an entirely independent agent, responsible only to the morality of the moment and the trenchancy of her formidable intellect.

Fig. 7. Meyer Schapiro

The biggest challenge that these self-directed New York Jewish liberals experienced appeared in the form of polarized forces created by the Holocaust, which presented them with specters of horror and outrage as well as the temptation to accept the solidarity of an inherited identity. Instead of allowing them an independent position consistent with the marginalized role assumed by modern artists that they had adopted in the past, the Holocaust seemed to censure them for evading religious unity.

Fig. 8. Jean-Paul Sartre, Paris, 1956

In a series of talks and essays written after the war, Rosenberg attempted to come to terms with the polarization that he and other New York Jewish liberals were experiencing. Since he and Krasner were close friends, we can safely assume that she took part in a number of discussions with him that culminated in his disquisitions on the problems of being a post-Holocaust, New York Jew. When taking issue with *Anti-Semite and Jew* of 1949 by Jean-Paul Sartre (fig. 8) because it consigned Jews to the position of being merely the creation of mainstream society's bigotry, Rosenberg pointed

out a key difficulty in accepting assimilation theories that would eradicate Jews' alterity:

> *Has not democratic universalism meant in practice not a society of man but the absorption of small nations and minorities into large ones, even if with full equality and freedom? Theoretically, the democrat is for the assimilation of all nations into man in general; actually, man turns out to be the American, the Englishman, the Frenchman, the Russian.*[64]

Even though he differed with Sartre in this piece, most of his writings concerned with the question of Jewish identity, including this essay, are couched in the existentialist terms of free choice. In rebutting Sartre's essay, Rosenberg arrives at the uneasy conclusion that the essence of Jewry is the ability to transcend all limitations:

> *Since the Jew possesses a unique identity which springs from his origin and his story, it is possible for him to be any kind of man—rationalist, irrationalist, heroic, cowardly, Zionist or good European—and still be a Jew. The Jew exists, but there are no Jewish traits.*[65]

While such wishful thinking might be perceived as merely self-serving, it did permit Rosenberg a rationale for maintaining a sense of group solidarity while still holding firmly to an existential faith in individuals' unlimited freedom to choose for themselves.

Rosenberg's solution the next year (1950) appears more carefully reasoned when he points out:

> *But even those who do want a clean slate usually find that some particular form has been rather heavily, if not ineradicably, engraved upon them. Be it preferred or not, we are not altogether Nobody. Nevertheless, we are not altogether Somebody either. We are anonymous enough to have to make ourselves; yet we are, too, and cannot make ourselves in utter freedom. Thus the problem of the* voluntary *aspect of modern identity is definitely upon us, even if we lack its solution.* [66]

Although more conciliatory to tradition in this piece, Rosenberg takes the idea of existential choice to the logical extreme of contending that even the most orthodox young Jews are acting as free agents since they "too, are *modern* men who having had to choose, have chosen to be Jews in the old style."[67] Because the shackles of freedom encumber all humans who must resist becoming mere objects created by others' gazes and who must avoid the bad faith of accepting without question traditional identities, Rosenberg suggests that maybe the most unconventional and seemingly least orthodox Jew might provide a new way for Jews to understand themselves. "The Jew whom the Jewish past has ceased to stir," Rosenberg conjectures, "whom every collective anguish or battle for salvation passes

by, may tomorrow find himself in the very center of the movement toward the future."[68] True Jews, for Rosenberg, are existentialists whose recognition of the perils and obligations of limitless freedom enables them hopefully to choose a possible route for all Jews when they commit themselves.

According to Rosenberg's existential system, Krasner chose the impasse represented by her gray slabs and elected to prolong her inability to resolve the double bind of kinship and disaffected modernism. These works are deadlocked between literal and figurative levels. Liquidating themselves in the process of being created, they result in a series of erasures that Krasner in turn obliterates when she scrapes down these efforts so that she can reuse the canvases again, only to repeat the process over and over again during the period when news of the Holocaust was first reaching New York. Whatever the reasons for this series of efforts—and there were no doubt many, in addition to the Holocaust—Krasner was unable to transcend the difficulties she was experiencing and take comfort in art's transfigurative or redemptive powers. She was lost in unrepresentability, caught up in a phase in which conventional visual language was inadequate to the level of intuition she wished to achieve. Rather than being able to subordinate her imagery to the good of art, she found art inadequate to convey her feelings, and so she left the unvisualizable in a turgid state. Her reactions may be understood in terms of recent efforts to distinguish between the codes of memory and trauma in which the former follows well-rehearsed scenarios while the latter remains caught up in the moment and never achieves the distance necessary to attain a rational form.[69]

The gray slabs can be regarded as tarpits of futile invention, barricades established by the conscious mind against intuitive understandings, and sublime events in which the mind collapses in the face of the unsayable and unrealizable. This liquidation of the world into resistant fields of gray paint no doubt had a profound effect on Pollock's work, becoming a possible basis for his use of this color to establish recalcitrant middle grounds in such works as *Guardians of the Secret*, 1943, *The She-Wolf*, 1943, *Totem Lesson I*, 1944, and *Totem Lesson 2*, 1945. In addition, these unyielding gray slabs need to be acknowledged in discussions of Pollock's decided preference in 1947 for aluminum paint in such paintings as *Full Fathom Five*, *Cathedral*, *Alchemy*, and *Comet*. And they also should be taken into consideration when looking at pieces by German painter Anselm Kiefer, who in the 1980s used lead to evoke the profound melancholy of the Holocaust.

The Little Image Series in Relation to Krasner's Background

About two years after the war, in 1946–47, Krasner was able to let go of these irresolvable paintings and move in a new direction. Without doubt, the way was forged by the all over compositions found first in Pollock's Sounds in the Grass series, 1946, and sustained in his drip paintings begun later that same year. The ebullience, freedom, and excitement generated by these works certainly had an impact on Krasner's Little Image series paintings that were initiated ca. 1946–47, such as *Abstract #2* (plate 23), *Noon* (plate 24), and *Untitled* (plate 25), and continued until 1950, but these are far from being merely delicate imitations of Pollock's ferociously innovative style as they have far too often been characterized in the past. In addition, the Little Image series needs to be extended to include Krasner's experiments in 1948 with tesserae and found objects, including old costume jewelry, coins, keys, rocks, and shell fragments, in the creation of an important pair of mosaic tables (plate 26).

As de Kooning noted, "Pollock 'broke the ice.'" He created a set of formal innovations that served as a backdrop for avant-garde painting of his time. However, within the general field established by Pollock, Krasner evolved her own sustained aesthetic investigations of the mystery and power of language.

Whereas in Pollock's *Stenographic Figure*, ca. 1942, notations suggestive of a range of language systems are casually distributed over the surface of the work, Krasner's Little Images present a much more systematic view of language as a regulated system of communication. Pertinent examples include *Painting No. 19*, 1947–48 (plate 27), and two pieces each named *Untitled*, both 1949 (plates 28 and 29). While her gray slabs were unable to resolve conflicts issuing from the diametrically opposed orientations created by modernism's isolated individual and the lure of group cohesion, as has been suggested, her Little Image series foregrounded what psychologist Otto Rank termed in his prescient book *Art and Artist: Creative Urge and Personality Development*, 1932, the "double character of language as a subjective means of expression and a collective medium of understanding."[70] Rather than settling in this series for an intelligible language that would turn her paintings into specific communiqués, Krasner made them abstract meditations on language's dual role by emphasizing her own painterly script while ensuring that her allusions to ancient sign systems remain mostly indecipherable. In this way, language in her art remains both personal, through her distinctive touch, and collective, through its allusions to ancient forms of writing.

Her focus on language shares a concern with abstracted signs evident in Pollock's drips, Gottlieb's pictographs, de Kooning's compositions built

from such ordinary words as "gone," Bradley Walker Tomlin's references to Chinese script, and Motherwell's Je t'aime series. In these works languages range from the personal and idiosyncratic in Pollock, to the ancient in Gottlieb, the mundane in de Kooning, and finally the exotic and foreign in Tomlin and Motherwell. In this alphabet soup of various sign systems all poetically referring to abstract art's ability to suggest meaning without detailing specific narratives, Krasner's work is distinguished, as I will argue, for its connections to a series of discoveries and decipherments of ancient languages that began in the late 1920s and continued through the time of her Little Image series.

Tablets and manuscripts unearthed in Syria in the early 1930s, which exhibit a formal similarity to her painted marks, are for the most part written in ancient Hebraic scripts and their antecedents, including Phoenician cuneiform. The significance of the use of Hebrew as the national language of the newly formed state of Israel also demands consideration when looking at Krasner's Little Image series.

Before undertaking a brief review of these ancient forms of writing, several salient and abiding aspects of Krasner's work with language from the time of the Little Image series until the end of her life need to be emphasized:

1. Beginning in the postwar years, sign systems were crucially significant to Krasner's art. She also made references to her own signature in paintings of the late 1950s, to Celtic and Islamic manuscripts beginning in the 1960s, and to the tenses of the verb "to see" that served as titles for a major series in the 1970s.

2. When she was a child, Krasner considered herself to be "very religious"[71] and learned at that time to write Hebrew. In 1979 she explained this situation to art historian Barbara Novak:

> These [Hebrew] markings I didn't understand. I learned how to write but I couldn't read it. So there's mystery right from the beginning. Visually, I loved it. . . . I couldn't write a sentence in Hebrew today that you could read, so I only had the gesture, and the visual thing that stays with me.[72]

In her 1973 catalogue on Krasner's large paintings, the then Whitney Museum of American Art curator Marcia Tucker pointed out that Krasner had made graphic signs all her life. Krasner referred to them as "a kind of crazy writing that isn't real."[73] From this revelation, Tucker conjectured that Krasner's "secret hieroglyphics, an automatic doodling or unconscious message-writing, may have its origin in the Hebrew writing she learned as a young child, for, in all her paintings, she works 'backwards,' that is, from right to left."

Delighted with this insight, Krasner recalled:

I have always been interested in calligraphy. Marcia Tucker . . . pointed out that I always started out my canvases on the upper right and went across them. I wasn't aware of this, and she said it undoubtedly was related to the time when I studied Hebrew as a child, since that is exactly how you would write it. I was astonished.[74]

Despite the tendency of critics and art historians to point out Krasner's rejection of her Jewish background, this statement indicates a great deal of latitude in her thinking about her religious past. As a child, "I went to services at the synagogue," she told Munro, "partly because it was expected of me. But there must have been something beyond, because I wasn't forced to go, and my younger sister did not. So some part of me must have responded. On the High Holy Days you fasted. Yom Kippur. I fasted. I didn't shortcut. I was religious. I observed." [75] While she might not wish to be restricted to the rigidity of her Orthodox upbringing, she certainly did not mind having her work associated with Hebrew script and even seemed pleased with the correlation, which she recalled on a number of occasions and even retrospectively connected with the early Hieroglyphs that formed part of her Little Image series.[76]

3. In Krasner's work, language participates in the celebration of mystery as a positive aesthetic component that should be enhanced rather than merely solved. To Novak she confided, "I thought of [my unconcious messages] as a kind of crazy writing of my own, sent by me to I don't know who, which I can't read, and I'm not so anxious to read."[77] Part of her fascination with language and its mystery no doubt stems from growing up in a household in which members of her family spoke several languages, including Russian, Yiddish, Hebrew, and, of course, English with a variety of accents. In her art this fascination with the enigmatic properties of language has its origins in the already mentioned theories of Rimbaud and Graham.

Although she was interested in Rimbaud's ideas, Krasner apparently did not risk subjecting herself to an altered state in order to enrich her creative faculties, even though she found ambiguity a positive aesthetic element in her own work. She was, however, intrigued with Rimbaud's cultivation of hyperbolic moments of exquisite and superhuman insights as a rationale for art's necessary ambiguity, particularly its ability to upset the norms of waking existence in order to approach the strange hyperreality of dream imagery, and she used these ideas in her art.[78]

In line with Rimbaud's thought, but certainly more measured and controlled, John Graham extolled the benefits to be accrued from

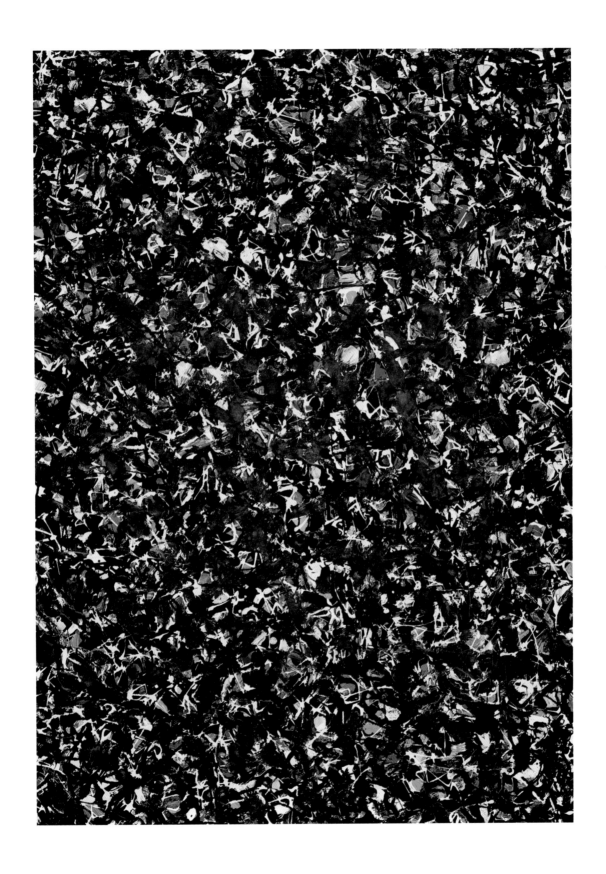

25. **Untitled**, 1947. Oil on canvas, 22⅛ x 15⅞ inches.
Collection of Mr. & Mrs. Eugene V. Thaw

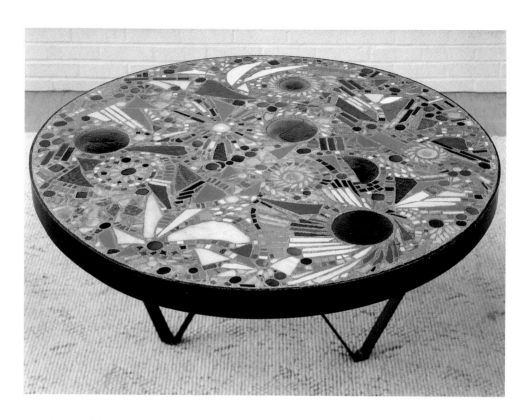

26. **Mosaic Table**, 1948. Mosaic and mixed mediums on wood, 48½ inches diameter.
Collection of Jeff & Bunny Dell

acknowledging the necessary mysterious forces of the universe, because
only after one comes to terms with these irresolvable secrets is one capable
of coming to terms with the improbable fact of life itself. "The value of
the strange and absurd," he wrote in *System and Dialectics of Art*, "lies in
their suggestion of a possible unknown, supernatural, life eternal. For
enigma is only a symbol of deity and deity is only a symbol of continuity
or life eternal."[79] His admiration for conundrums as the essential language
of the human spirit, signified through artists' automatic écriture, correlates
with Freud's estimation of the power of dreams, which "*are not made with
the intention of being understood*, [and thus] present no greater difficulties
to their translators than do the ancient hieroglyphic scripts to those who
seek to read them."[80] Freud's conjunction of irresolvable mysteries with
hieroglyphs may have served as a rationale for Krasner's own long-term
fascination with her dreams and her Hieroglyphs of the late 1940s,
which present the look of ancient languages that cannot be transcribed.
B. H. Friedman evokes the mood of this series in his essay for her first
retrospective. "They do indeed 'read,' like hieroglyphics, or cuneiform,

27. **Painting No. 19**, 1947–48. Oil and enamel on masonite, 32¼ x 34¼ inches.
Collection of Dr. Jerome & Rhoda Dersh

28. **Untitled**, 1949. Oil on canvas, 24 x 48 inches.
Collection of Mr. & Mrs. David Margolis

29. **Untitled**, 1949. Oil on linen, 38 x 33⅛ inches.
Private Collection

or some other ancient and mysterious writing," Friedman muses, "built, however, out of paint, rather than cut into stone. They are quiet secretive paintings. They twist in upon themselves. They speak in whispers."[81]

Ancient Languages and the Little Image Series

In the Jewish religion, ancient scriptures assume the role of sacred runes needing to be deciphered through elaborate exegesis, sometimes taking the form of gematria—the substitution of numbers for letters of the Hebrew alphabet—that medieval Kabbalists undertook. These Kabbalists borrowed from the ancient, esoteric Judaic *Sefer Yetzira* ("Book of Creation") that asserts the origination of the word to be both ideal and concrete: a complex cosmology based on correspondences between numbers and letters of the Hebrew alphabet that parallels the relationship between spiritual and physical worlds. Through their connections with numbers, which are considered the constitutive elements of the universe, the letters of the Hebrew alphabet become instruments of creation. Language composed of letters that are associated with divine numbers becomes not only a means of communication, but when it is verbally articulated, it also assumes an effective force. The effective power of speech, however, is limited to Hebrew. This belief regarding the mysterious, creative power of language explains the tremendous generative force attributed to the Judaic god in the book of Genesis who in calling out the words "Let there be light" effects its being.[82] When God's earthly replicant, Adam, names the earth's creatures, he too assumes a divine role.

In contrast to the originary force attributed to speech, writing assumes a secondary status, referring first to the absent god (known in English as Jehovah) who can never be fully designated by His name—the god whose name in Hebrew was represented by the sacred formula of the tetragrammaton that could only be written and never spoken—and then to history itself, which describes and affirms prior events without being able to create them. According to critical theorist Julia Kristeva,

> *Speech [in Judaic thought] unfolds on the inaccessible ground of the divine essence of language. There are two ways to break through this barrier to accede to a knowledge of la langue [which she terms "a surreal, extra-subjective, powerful, and active essence"]. The first is by triggering a symbolic chain, that is, a juxtaposition of verbal elements (words) that designate, by a kind of taboo, a single referent whose reality is thus censored and unnamed, and consequently takes on, finally, the name of God. . . . The second means, which displaces the subject from speech . . . , is the change of speech into writing.*[83]

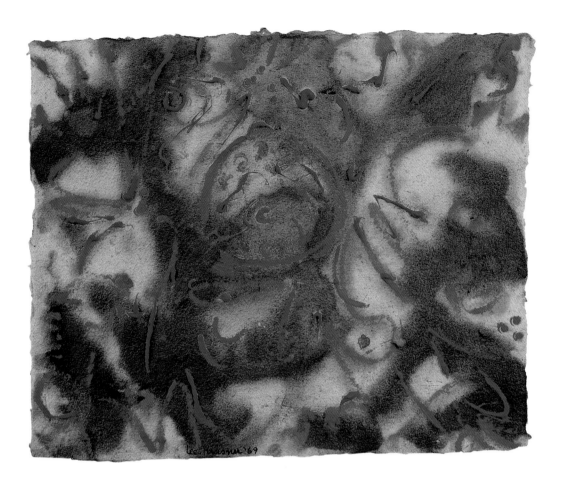

30. **Hieroglyphs No. 3**, 1969. Gouache on Howell paper, 17 ½ x 21 ½ inches.
Pollock-Krasner Foundation, Inc., courtesy Robert Miller Gallery, New York

Because writing is only able to refer back to the originary and ontological
state of speech, it is already reduced to the position of a supplement or
surrogate and "thus becomes the explanation for the divine absence and
compensation for it."[84]

This differentiation between the powers of speech and writing is
important for understanding Lee Krasner's emphasis on the latter, since
it underscores a subtle but crucial distinction of her work that separates
it from those Abstract Expressionist works, including Pollock's drip paintings
and Barnett Newman's zips, that are intended as inaugural forces. Krasner's
allusions to ancient languages imply a far less heroic yet still meaningful
desire to reestablish connections with the past in order to celebrate the
longevity and continuity of language itself. In reference to the Little Image
series, Krasner remarked, "I merge what I call the organic with what I call
the abstract. . . . What they symbolized I have never stopped to decide.
You might want to read it as matter and spirit and the need to merge as
against the need to separate."[85]

Her references to those languages that can be associated with ancient
Hebrew signify an additional need to reaffirm the life force of the Jewish
people at a time of almost overwhelming odds. Made in the late 1940s

31. **The Mouse Trap**, 1949. Oil on canvas, 30 x 25 inches.
Private collection

after the Holocaust and at a time when Jews were still struggling with waves of anti-Semitism in Stalinist Russia and were fighting to establish a safe haven for themselves in the Middle East, Krasner's Little Images, with their formal references to archaic languages—particularly cuneiform, with its wedge-shaped letters—can be considered concerted efforts to keep the faith of Jewish solidarity while still remaining resolutely modern and avant-garde. In terms of their multifaceted ramifications, these works strive for the liberal, unaffiliated, yet still Jewish identity that Rosenberg himself had tried to construct.

In the 1930s, the preeminent position that Christian Europeans had for centuries accorded Hebrew as the language in which God addressed the first man, Adam, had seemed at last confirmed by a series of archaeological discoveries at the ancient city of Ras Shamra on the coast of Syria, opposite Cyprus.[86] On August 8, 1930, a French archaeological team discovered the oldest extant dictionary, consisting of six languages on fired clay tablets.[87] The next year, this group found more large terra-cotta tablets, inscribed with several columns of cuneiform writing believed to date from 1400 B.C. One tablet judged to form part of another dictionary contains words divided into syllables as a guide to pronunciation.[88] Other tablets were believed to represent humanity's first known attempts at literature, a hypothesis confirmed two years later with the discovery of a poem written in Phoenician cuneiform that details the life and times of the father of the Old Testament prophet Abraham.[89]

Later that year, during a visit to the United States, British archaeologist Sir Charles Marston gave a series of talks about the city and temple complex at Ras Shamra; he agreed first to be interviewed and then to write about these discoveries for the *New York Times*.[90] According to Marston, some of the tablets in cuneiform present a twenty-seven-letter alphabet, and thus represent the first cuneiform alphabet ever found. Marston points out that techniques learned from reading Edgar Allan Poe's short story "The Gold Bug" were used to discover that these letters were an archaic form of Hebrew, and that the tablets themselves date from approximately 1400 to 1350 B.C., at least 600 years before the earliest known Hebrew inscriptions.

Part of the excitement generated by the cuneiform tablets from Ras Shamra is due to the fact that they were believed to have been written only a few years after Moses's death by a group of Arabs who had fled the neighborhood of the Dead Sea soon after the destruction of Sodom and Gomorrah and had settled on the coast of Asia Minor, where they became known as Phoenicians. The rituals and ceremonies described in these tablets are of such antiquity that they predate Moses and contain a number

32. **Continuum**, 1947–49. Oil and enamel on canvas, 53 x 42 inches.
Private Collection

33. **Composition**, 1949. Oil on canvas, 38 x 28 inches.
Collection Philadelphia Museum of Art; gift of the Aaron E. Norman Fund, Inc.

of remarkable passages, almost identical to biblical texts, that anticipate Mosaic law. The divine name "E" and its plural form "Elohim," which are used several thousand times in the Old Testament for God, appear in these texts, as do the names Jehovah and Yahweh, which similarly connote the Old Testament Deity. Marston concluded his essay by noting, "So far as the bearing these archaic Hebrew tablets have upon the early books of the Old Testament, they go far to authenticate the Pentateuch, or at any rate a large portion of it, as the actual work of Moses,"[91] thus legitimizing an early date for the first five books of the Bible, which are crucial for Judaism.

On the same day that Marston wrote so positively about the importance of these ancient Hebrew cuneiform tablets and the knowledge they provide of the Phoenicians, who were distant cousins of the Hebrew tribes, the *New York Times* ran a brief story about Nazi objections to Christianity.[92] Under the leadership of General Ludendorff, the National Socialists revealed their ideological prejudices that German Christianity's associations with Hebrew texts had made people weak. However, their initial efforts to replace Christianity with the *Nibelungenlied*, and Abraham and Christ with Arminius and Siegfried, had already been curtailed by the Reich bishop. Deciding that he could fight battles on only so many fronts at one time, Hitler either abandoned or postponed the problems Christianity posed for his thoroughgoing anti-Semitism, allowing the contradictions between the two to remain in limbo.

The ironic juxtaposition of these two newspaper articles—one lauding Hebrew's antiquity and the formative role it may well have played in innovating the alphabet, and the other recounting Nazi abhorrence of Judaism for enervating the alleged strengths of the German people—must have seemed strange to many New Yorkers, including possibly Krasner and Rosenberg. This same disparity between the beauties of ancient scholarship and the calumnies of modern prejudice was to be dramatized again in the post-World War II era, when the Dead Sea Scrolls, one of the greatest caches of ancient biblical texts to be retrieved, were found in 1947.

The first scrolls to be discovered were contained in sealed jars in one of the many caves near the western shore of the Dead Sea, where a pietistic sect of Jews known as the Essenes had withdrawn from the world's temptations to meditate and practice celibacy several centuries before the birth of Christ. At the end of 1948, Dr. E. Sukenik published a book on the scrolls; and beginning in February of the next year these texts became mainstream news when the *New York Times* published articles on their retrieval.[93] On March 19 of that year, a *Times* article called the scrolls "the greatest

manuscript discovery of modern times"[94] and confirmed that these Old Testament texts were now the oldest known. Judged to be at least 1,000 years older than the Leningrad copy of the books of the Prophets, written in 916 A.D., which had been considered the earliest dated manuscript of the scriptures in Hebrew, the Dead Sea Scrolls represented a remarkable find since they comprised an extensive library that included almost all the books of the Bible, a number of apocryphal works, and the literature of the early Essene sect.

To post-Holocaust Jewry, these texts would have had a special resonance, since they bespeak a tradition of Jewish survival against seemingly overwhelming odds going back to biblical times. Apparently, the texts were hidden in caves before Roman troops attacked and destroyed the temple where they had been stored.

To independents like Krasner and Rosenberg, uncommitted to either Judaism or Christianity, the Dead Sea Scrolls would have been particularly meaningful since they included copious writings by the Essenes, who anticipated Christianity in terms of ritual bathing (baptism), practiced a form of communism similar to the early Christians, and even honored their Teacher of Righteousness, a martyred prophet, as the Messiah. Since he died circa 65–53 B.C., and Jesus of Nazareth died circa 30 A.D., the Teacher of Righteousness may have served as a model for Jesus of Nazareth. These Essene texts were also important for showing the flexibility and dynamism of ancient Judaism, which was able to tolerate a splinter group like the Essenes that, through several generations, evolved doctrines leading to Christianity.

The Dead Sea Scrolls initially met with a great deal of resistance from various religious constituencies: some Jews feared that these newly discovered sources might question the authority of the Masoretic texts; traditional Christians were reluctant to give up the idea of a unique Christ; and liberal Christians, committed to the idea that Christianity developed several generations after the death of Christ, did not wish to have their theories overturned.

But in spite of the challenges that the scrolls posed to members of organized religious groups, they provided Krasner with an almost miraculous instance of Jewish continuity after a proto-Holocaust—the destruction of the Essenes by the Romans—which correlated well with the abstract notational schemes that she used in the first two groups of works in the Little Images series and may have served as a catalyst for the development of her third series, which she called Hieroglyphs.[95] The connection with the early texts represented by the Hieroglyphs and Krasner's return to this

34. **Untitled (Little Image)**, 1950. Oil on canvas mounted on Masonite, 45 x 11 inches.
Collection of Halley K. Harrisburg & Michael Rosenfeld

subject in 1969 (see *Hieroglyphs No. 3* [plate 30]) gives credence to her later statement, "I am never free of the past. I believe in continuity. I have made it crystal clear that the past is part of the present which becomes part of the future."[96]

Krasner left a telling clue to her ambitions in the form of the title *The Mouse Trap*, 1949 (plate 31), which she wrote on the stretcher of this Little Image painting. The origin of this title was later recounted by the artist's longtime friend John Bernard Myers, who helped her name paintings first in the 1940s and then again in the late 1970s and early 1980s.

In an article published in *Artforum* in 1984 Myers describes the episode that inspired this title:

> *Our first collaboration began in 1946, when I suggested the title* The Mouse Trap *for one of the Little Image paintings. We were sitting in the kitchen; her husband, Jackson Pollock, was with us, when suddenly a wood rat scampered into the room. Pollock grabbed a broom; the rat headed toward the doorway to the living room, across which was placed the painting we had been looking at. The painting stopped the creature, down came the broom, and the rat was exterminated. I was reminded of a picture Meyer Schapiro had lectured on, a 15th-century triptych called* The Mouse Trap, *by Robert Campin. It had something to do with Christ and the trapping of souls. Since it wasn't a big rat we decided 'mouse' would be more appropriate for the title. Perhaps the picture would 'trap' the imagination of viewers.*[97]

Myers's suggestion may have resonated with Krasner, a devoted fan of Meyer Schapiro, who was an art historian at Columbia University and a sometime contributor to *Partisan Review*. From the 1930s until the end of her life, she would attend any lecture he gave no matter what the subject. And she possibly had even heard the lecture by Schapiro that Myers mentioned. In this lecture, Schapiro addressed *The Mérode Altarpiece* in the Cloisters (Metropolitan Museum of Art) and the problematic iconography of the right wing of this triptych depicting Joseph making a mousetrap.

Schapiro's essay entitled "'Muscipula Diaboli,' the Symbolism of *The Mérode Altarpiece*," later published in his selected papers,[98] dates from 1945. Because it provides special insight to Krasner's Little Image series, it requires a brief summation. In this essay, Schapiro attemps to account for the important position assumed by Joseph and also for the unusual motif of the mouse trap. He shows that Joseph was regarded in the late Middle Ages as a decoy intended to deceive the devil into thinking Christ's paternity was earthly and not supernatural. To explain the mousetrap, Schapiro points to the following reference by St. Augustine:

The devil exulted when Christ died, but by this very death of Christ the devil was vanquished, as if he had swallowed the bait in the mousetrap. He rejoiced in Christ's death, like a bailiff of death. What he rejoiced in was then his own undoing. The cross of the Lord was the devil's mousetrap; the bait by which he was caught was the Lord's death. [99]

Since Christ was a Jew, it takes only a little imagination to see how this passage might resonate with post-Holocaust Jews who, in putting their lives together, might begin trying to find ways to understand the meaninglessness of the Nazi exterminations. In addition to this justification of Christ's sacrifice, Schapiro's piece might have proven useful to Krasner because it pointed to the conjunctions of domesticity, intimacy, and intense meaning that parallel her own Little Image paintings, which were antipodal to Pollock's contemporaneous wall-sized pictures. [100] Since the painting that Krasner chose to name *The Mouse Trap* contained colored fragments caught in a delicate web, this configuration may have seemed to her to support the metaphor of entrapment, an idea that Myers underscores in a letter written subsequent to the above-related incident, in which he refers Krasner to a recent essay by Rosenberg on Shakespeare's *Hamlet*, which appeared in the only published issue of *Possibilities* (winter 1947–48), which was in the Pollocks' library. Myers notes, "There is a marvelous discussion about the mouse trap in the play within the play." [101] In Shakespeare's tragedy, Hamlet uses the play within the play as a ruse for discerning Claudius's guilt, and thus he calls it "the mouse trap."

Critic Barbara Rose, in her early retrospective catalogue on Krasner, separated Krasner's Little Image paintings into three principal groups, beginning with the mosaic (divisionist) pieces, continuing with the webbed works, which might be referred to as Traceries, [102] and concluding with the grids, or Hieroglyphs. Although there are a fair number of overlappings between each of these series, the first group, which can be dated circa 1946–47, culminated in two mosaic tables made from tesserae scavenged from materials left from Pollock's WPA days as well as old pieces of Krasner's costume jewelry. This work paved the way for the Hieroglyphs. [103] The Traceries evidently begin in late 1947 and continued until 1949, while the Hieroglyphs seem to have been initiated in 1947 and were sustained into 1950. The dates of the Hieroglyphs parallel both the discovery of the first Dead Sea Scrolls and the widespread dissemination of information about them, beginning in 1949. Among the mosaics are *Abstract No. 2*, 1946–48 (plate 23), *Noon*, 1947 (plate 24), and *Untitled*, 1947 (plate 25). A late Tracery that appears to anticipate aspects of the Hieroglyphs is

Continuum, 1947–49 (plate 32), while prominent Hieroglyphs include *Composition*, 1949 (plate 33), two works, both *Untitled*, from 1949 (plates 28 and 29), and *Untitled (Little Image)*, 1950 (plate 34).

Composition is characteristic of a number of other works from 1949 that introduce an overall scaffolding of cryptic writing suggestive of cuneiform letters. Since the "tetragrammaton" is the indirect reference to the name of God, which is so awesome that it is referred to in the Dead Sea Scrolls in archaic Hebrew (i.e., Phoenician cuneiform characters), one wonders if Krasner similarly wished to refer to painting as a sacred pursuit through her allusive signs and the occasional appearance of the letter "E," which, as we have seen, signified God's name. Following Egyptian hieroglyphics, the ancient Semitic language depended on the acrophonic principle of representing sounds in terms of pictures of things whose names begin with that particular sound. Aspects of this principle recur in Krasner's work. For example, the hieroglyphic sign of an undulating line, which connotes waves of water, representing "n," which is the beginning sound in the word "water," is found in a number of Krasner's paintings of 1949. For the most part, however, the signs in these paintings are abstract notations that recall, but do not replicate, early forms of writing.

Krasner's Emphasis on Language as a Primary Constituent of the Self

Krasner's emphasis on language as a primary constituent of the self is a distinctly modern approach that has affinities with modern linguistics and its assumption that human beings can no longer be deemed autonomous entities. Instead of viewing individuals as the basic building blocks of culture, structuralist and poststructuralist linguistic theory attests that this significant role be reserved for language and that people must be subsumed under the category of speaking systems. In the early and transitional days of Abstract Expressionism, many artists would have been more open to this premise. Barnett Newman's epigram for his 1947 catalogue "The Ideographic Picture" begins with the following citation from The Century Dictionary, "Ideographic . . . applied specifically to that mode of writing which by means of symbols, figures, or hieroglyphics suggests the idea of an object without expressing its name."[104] As Kristeva has observed,

> *Perhaps we could say that while the Renaissance substituted the cult of Man with a capital M for that of the God of the Middle Ages, our era is bringing about a revolution of no less importance by effacing all cults, since it is replacing the latest cult, that of Man, with language. . . . Considering man as language and putting language in the place of man constitutes the demystifying gesture par excellence.*[105]

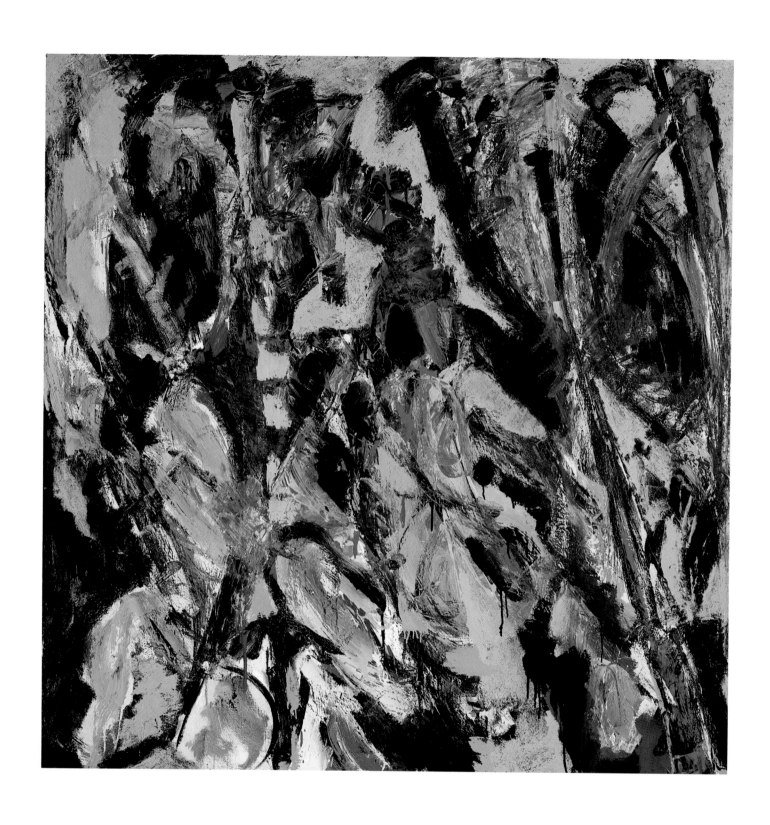

35. **Volcanic**, ca. 1951. Oil on canvas, 48 x 48 inches.
Pollock-Krasner Foundation, Inc., courtesy Robert Miller Gallery, New York

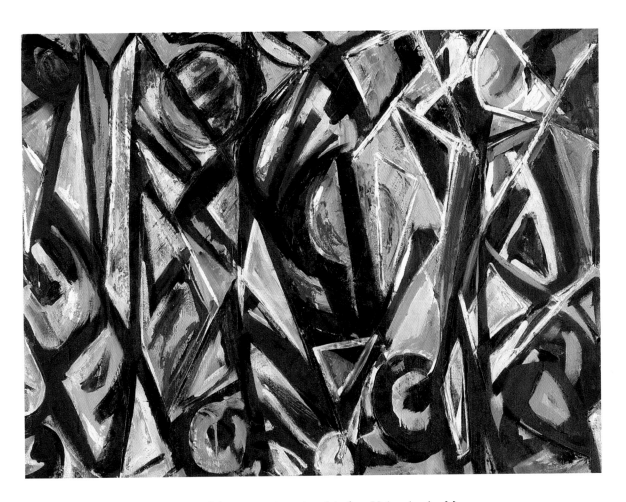

36. **Gothic Frieze**, ca. 1950, Oil on masonite, 36 x 48 inches. University Art Museum, California State University, Long Beach; gift of the Gordon F. Hampton Trust, through Katherine H. Shenk, Wesley G. Hampton, and Roger K. Hampton

Created at a time when general Abstract Expressionist rhetoric was moving away from an early, transitional phase and was beginning to make extravagant claims for artistic individuality and autonomy, Krasner's Hieroglyphs celebrate continuity over originality and longevity over innovation. In doing so, they posit a paradigm of a language-originated culture that differs from most of the contemporaneous Abstract Expressionist art that was starting to focus on the artists themselves and their individually intuited sensibilities. Considered in relation to the Holocaust and the subsequent discovery of the Dead Sea Scrolls, Krasner's Hieroglyphs offer the positive and reassuring message of perpetuity and resiliency through knowledge of one's cultural heritage. In many of these works she took Pollock's all-over compositions in a different direction by refusing to settle for basically centralized images—as he tended to do even in his most advanced drip paintings—and instead emphasized the

fragmentary nature of compositions that look as if they might once have extended far beyond their boundaries.

The small scale employed for many of these paintings reinforces their content, making their allusions to ancient languages and indecipherable sign systems appear as if miraculous survivals from a distantly unfamiliar world. The Little Image paintings are thus homages to archaeology and the prolonged labor involved in sorting through piles of ancient detritus for those fragments of past cultures deserving recognition. The signs incorporated in them are comparable to shards carefully assembled on the picture plane—a means of reclamation and an effort to find meaning. They return to origins not to create a new beginning, but to understand the past.

Although definitely related to Adolph Gottlieb's Pictographs, the Little Image paintings have a different emphasis. While Gottlieb placed a high premium on his role as consolidator of an eclectic array of primitivistic and biomorphic signs, Krasner focuses more on language itself. The admittedly subtle difference posited here is crucial for comprehending Gottlieb's role as synthesizer of diverse directions in order to point to the future, while Krasner undertakes the less august yet still significant task of establishing links with the past. After the Holocaust, these poetically evoked traces of past civilizations may have been more comforting than a new synthesis, suggestive of a new beginning, because they bespeak continuity, endurance, and the act of remembering.[106] They also allude to the priority of Jewish cultural contributions since Hebrew was considered to be part of the Semitic language group that originated the first alphabet, and thus they also serve as worthy, though humble, monuments to the six million Jews who died such senseless deaths.

Existentialism, Abstract Expressionism, and Krasner

In the late 1940s and early 1950s Abstract Expressionists proclaimed themselves a means for distilling a chaotic world into meaningful universals. As David Smith said pointedly, "Art . . . comes from the inside of who you are when you face yourself. . . . The nature to which we all refer in the history of art is still with us, although somewhat changed. It is very often the simple subject called the artist."[107]

In the process of defining themselves, these artists often took refuge in heroic allusions and mythic terminology. Gottlieb, for example, poetically suggested that his work evolves from the deep strata of primordial memory that Jung articulated as "archetypes," which are genetic predispositions to a hypothetical universal image bank situated in the unconscious of each individual and indirectly available through dreams and free association.

"I disinterred some relics from the secret crypt of Melpomene [the Muse of Tragedy] to unite them through the pictograph," Gottlieb wrote in 1944, "which has its own internal logic. Like those early painters, who placed their images on the grounds of rectangular compartments, I juxtaposed my pictographic images, each self-contained within the painter's rectangle, to be ultimately fused within the mind of the beholder."[108]

Gottlieb, together with Rothko and Newman, subscribed to the idea of a universal and ultimately static art that transcends time. In their collaboration "The Romantics Were Prompted . . . ," they wrote, "Since art is timeless, the significant rendition of a symbol, no matter how archaic, has as full validity today as the archaic symbol had then."[109] Instead of looking outside themselves to nature as had the romantics, these artists looked within and found "inscapes" (to use Gerard Manley Hopkins's term[110]) that connected them with the very beginnings of human culture.

This enterprise was glorified by Barnett Newman in his essay, "The First Man Was an Artist":

> *Man's first expression, like his first dream, was an aesthetic one. Speech was a poetic outcry rather than a demand for communication. Original man, shouting his consonants, did so in yells of awe and anger at his tragic state, at his own self-awareness and at his own helplessness before the void.*[111]

Written in 1947, Newman's essay bespeaks the important role that personal engagement was to play in resuscitating the romantic cult of the individual. This emphasis on the role of the individual parallels French existentalism's emphasis on the need to choose oneself, but in the late 1940s, one Abstract Expressionist after another, with the notable exception of Krasner, superseded existentialism when they embraced the more old-fashioned definition of the self as an objective entity enduring through time.

The postwar importation of Jean-Paul Sartre's existentialist ideas, which regularly appeared in a substantial number of English editions in the late 1940s,[112] as well as his visits to New York where he was sometimes the house guest of Harold Rosenberg,[113] were crucial for Abstract Expressionism since Rosenberg established himself as one of this school's preeminent critics. In addition, de Kooning recommended to his friends the recent English translations of the writings of the Danish proto-existentialist Sören Kierkegaard in the early 1940s.[114] Moreover, the ready availability of the writings of Friedrich Nietzsche, another proto-existentialist, were of crucial importance to Gottlieb, Newman, and Rothko. They were particularly intrigued with his *Birth of Tragedy* (1871), because of its emphasis on the duality of the Apollonian and Dionysian realms that seemed in sync with their psychological predispositions for establishing dichotomies between

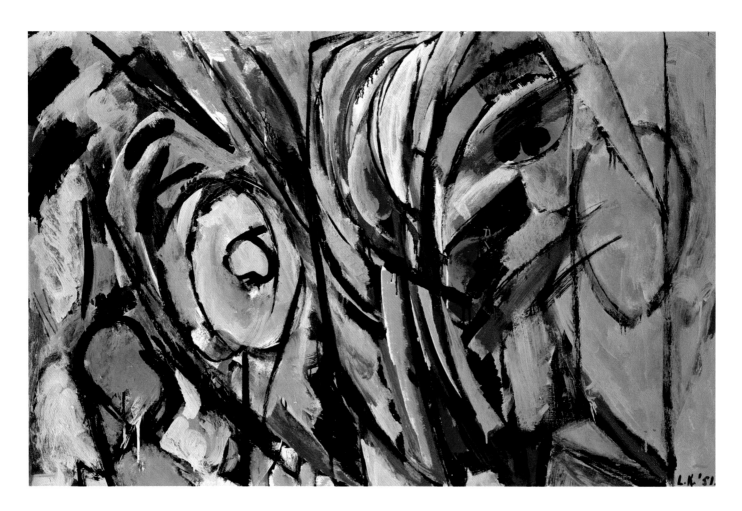

37. **Ochre Rhythm**, 1951. Oil on canvas, 37½ x 58 inches.
Private collection

an external, intelligible world and an intuited, ambiguous, and ultimately
sublime internal one. In addition to these primary sources, a substantial
number of secondary ones, appearing in journals often read by the
Abstract Expressionists, explicated the major tenets of this philosophical
movement. Among the most important are essays by Hannah Arendt,
Justus Buchler, and William Barrett in *Partisan Review* and *The Nation*
that appeared during the pivotal years of 1946 to 1948 when the Abstract
Expressionists were moving from mythic to personally intuited imagery.[115]

At this time there were a number of opportunities for Americans to
come in personal contact with existentialism. In 1945 the Office of War
Information invited to the United States seven French journalists, includ-
ing Sartre, who represented the Parisian publications *Le Figaro* and
Combat. While on this trip, Sartre, a former war correspondent who used
the French Resistance as a means for dramatizing his philosophic attitude,
became a celebrity, and existentialism an accepted topic of conversation
among intellectuals and artists. Sartre delivered a lecture at Carnegie
Recital Hall which was reported to have been half-filled with artists and

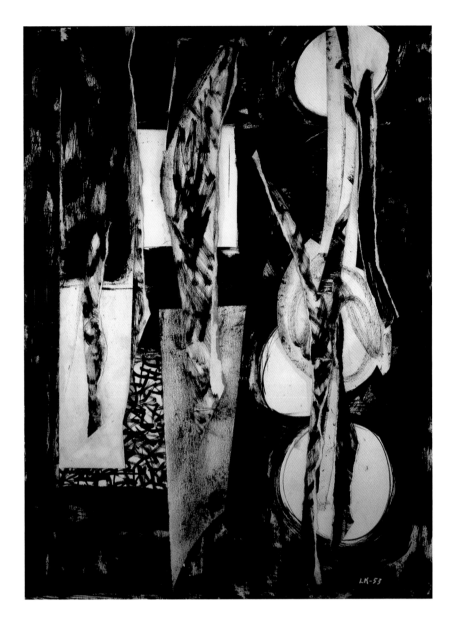

38. **Black and White**, 1953. Oil, gouache, and cut and torn printed
paper with adhesive residue on cream laid paper, 30 x 22 ½ inches.
The Art Institute of Chicago

dealers.[116] In the late 1940s, de Kooning and Franz Kline were friends with
one of the most important existentialist apologists, William Barrett.

In addition, de Kooning, Motherwell, Pollock, and Krasner were closely
associated with Rosenberg whose writings, including his famous essay
"The American Action Painters," evidence his immersion in key existential
ideas, particularly those of Sartre, who wrote, "there is no reality except
in action."[117] As a parallel to this famous phrase, Rosenberg wrote, "Art as
action rests on the enormous assumption that the artist accepts as real only
that which he is in the process of creating."[118] In fact, this essay, presenting
the artist's canvas as an "arena" and the act of creation as a "battle," which
has become such a crucial document of Abstract Expressionism,[119] was

originally commissioned by Sartre and his fellow editor Maurice Merleau-Ponty for their existentialist periodical *Les Temps Modernes*.[120]

Even though existentialism was definitely a subject of discussion among the Abstract Expressionists, their amalgam of it depended on both their prior reading of John Dewey's 1934 book *Art as Experience* [121] and their understanding of the Surrealist method of psychic automatism, which Motherwell and the young Surrealist Matta Echaurren proselytized to them under the name "plastic automatism."[122]

While plastic automatism provided a working method for enriching one's understanding of oneself and for breaking out of conventional ways of working, it needed the intensity of existentialism to transform it from an old-fashioned vanguard method associated with Surrealism, which was called in its first manifestation "pure psychic automatism" and regarded as thought's actual mechanisms,[123] into a persuasive means for manifesting an emancipated postwar self.

In his 1946 essay "Existentialism and Humanism," which briefly summarizes the tenets of this school of thought and which was available in English translation in the form of a book soon thereafter, Sartre describes artmaking as an open-minded process:

> *does anyone reproach an artist, when he paints a picture, for not following rules established* a priori? *Does one ever ask what is the picture that he ought to paint? As everyone knows, there is no pre-defined picture for him to make.* [124]

He continues by pointing out a similar need in both art and morality to prioritize "creation and invention," without deciding beforehand what course should be taken.[125]

A major proponent of the "death of God" theory, Sartre believed that without a god, humanity no longer had recourse to first principles and was forced to take responsibility for the incredible amount of freedom incumbent on it—a freedom so immense and terrifying that it caused the inner revulsion giving rise to the title of Sartre's highly acclaimed novel *Nausea*, 1938. His main character Roquetin explains, "I understood my Nausea, I understood it perfectly. . . . The essence of it is contingency . . . existence is not necessity. To exist is simply *to be here*." [126]

Following Sartre's often-quoted phrase "existence precedes essence" that appears in "Existence is a Humanism," [127] the Abstract Expressionists found plastic automatism a means for realizing a plenitude of formal possibilities identifiable with spontaneously conceived, open-ended selves, but, with the exception of Krasner, they refined them into forms intended to signify what they considered to be universal and static essences.

Krasner subscribed to her own version of this improvisational approach:

I make the first gesture, then other gestures occur, then observation. Something in the abstract movement suggests a form. I'm often astonished at what I'm confronted with when the major part comes through. Then I just go along with it; it's either organic in content, or quite abstract, but there's no forced decision. I want to get myself something via the act of painting....I sustain my interest in it through spontaneity.[128]

As outlined by Motherwell, plastic automatism is a three-step method in which artists begin freely improvising with doodles or puddles of paint to create images resembling Rorschach tests.[129] According to Motherwell, after an initial period of unrestricted activity (step one), the artist studies his or her improvisatory images (step two) to see if they suggest meanings or structures that can then be cohered into a completed work of art (the third and final step). Similar to the phenomenological system employed by some existentialists, including Sartre whose *Being and Nothingness*, 1943, was subtitled "A Phenomenological Ontology," plastic automatism at the outset is intended to be assumption-free.[130]

To recapitulate: After a get-acquainted period, which phenomenologists would consider an effort to focus attention on what is immanent in consciousness itself (i.e., an exercise designed to discover one's innocent eye, what we know intuitively), an artist begins to weigh possible meanings and relevant structures found in his or her doodles—a process phenomenologists would term "intentional acts." Here it is important to note Edmund Husserl's claim that ultimately all mental acts are intentional and all objects of consciousness are intentional objects.

Sartre's ideas are particularly applicable to plastic automatism since he emphasizes that self-understanding begins first with a series of acts before one can deliberate on them and their means of defining oneself. Instead of following the Cartesian dictum, "I think, therefore I am," he reverses its order by asserting that no self can be thought except in reflected consciousness. At this state in the plastic automatist operation, artists, who begin with the "I am" before arriving at the "I think" level, hope to come to terms with the possibilities of their own being and choose the one configuration that they believe comes closest to representing an inherent part of themselves at that particular time.[131] In their search for truth, the Abstract Expressionists emphasized the chaotic or ambiguous nature of experience, their own risk-taking decisions that willed themselves into being, and the resulting originality of their artistic endeavors.

Abstract Expressionists began evolving in the early and mid-1940s formal signs for communicating the open-endedness of the self, which can

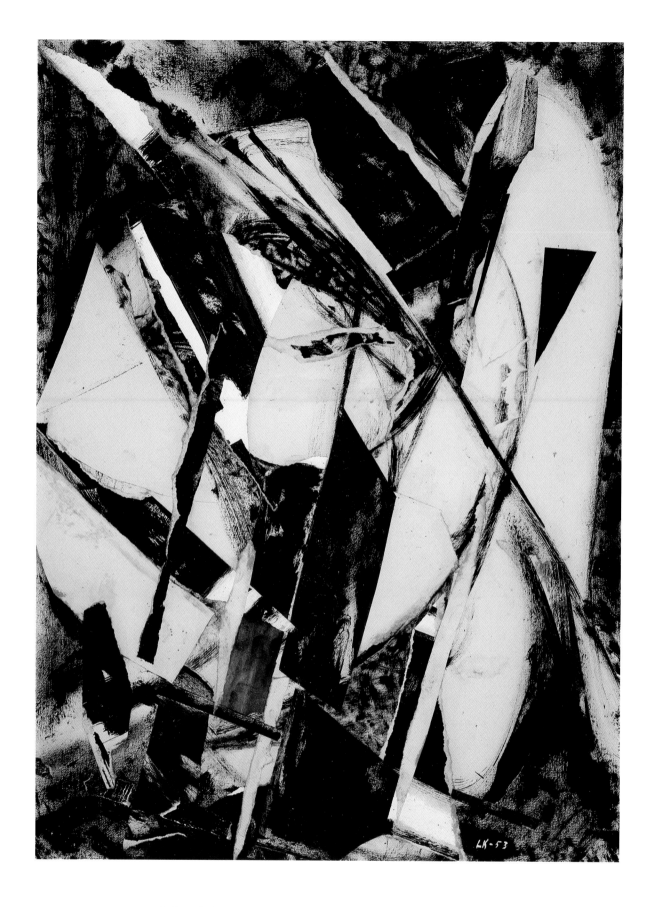

39. **Black and White Collage**, 1953. Oil and paper collage on paper, 30 x 22 ¼ inches.
Des Moines Art Center's Louise Noun Collection of Art by Women, Iowa

Opposite: 40. **The City**, 1953. Oil and paper collage on Masonite, 48 x 36 inches.
Private collection

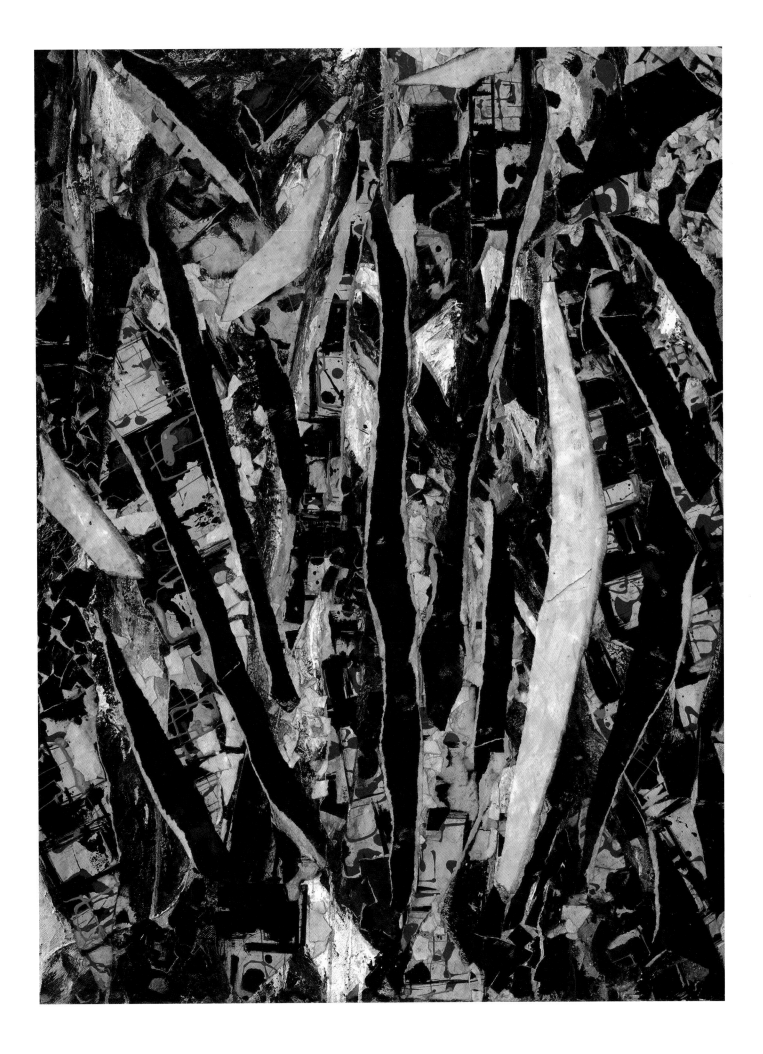

never resemble the clearly established static identity of mere things. These formal devices include pentimenti, fragmentation, radical overlapping of forms, extension beyond the limits of a given surface, and lack of finish, which can be communicated by liberal drips and splashes of paint. Of course, the irony of their art is that once these formal codes become part of the stylistic apparatus recognized as Abstract Expressionism, they cease to communicate an open-ended self and become merely the conventions of a reified self, thus cancelling out risk in favor of aesthetics. While this irony becomes the mainstay of Jasper Johns's and Robert Rauschenberg's works which are pastiches of this school's excesses, it is also evident in the so-called one image art of many Abstract Expressionists who replicate schemas serving as hallmark styles rather than originate new ones.

From the perspective of the late twentieth century, this quest to manifest an essential self in a work of art seems hopelessly romantic and surprisingly naive. This modernist assumption of a monolithic self that can be directly transcribed into art has become highly suspect in recent years when art historians conversant with the poststructuralist theories of Jacques Derrida, Michel Foucault, and Jacques Lacan have decentered the self and looked at ways this now highly improbable construct became naturalized in art historical discourses. But fifty years ago, the legacy of romanticism was still so strong that artists believed in a seamless self that could be actuated in their art. They subscribed to an expressive aesthetics which has its origins in William Wordsworth's externalization of his internal thoughts and intuitions in his poetry. According to literary theorist M. H. Abrams, Wordsworth's program is as follows:

> The first test any [romantic] poem must pass is no longer, "Is it true to nature?". . . but . . . "Is it sincere? Is it genuine? Does it match the intention, the feeling, and the actual state of mind of the poet while composing?" The work ceases then to be regarded primarily as a reflection of nature, actual or improved; the mirror held up to nature becomes transparent and yields the reader insights into the mind and heart of the poet himself. [132]

Expressive theories assume communication between creators and observers to be direct and unmediated. Both surrogates for their creators and direct conduits to their feelings, works of art become "objective correlatives," to use T. S. Eliot's terminology, "a set of objects, a situation, a chain of events which shall be the formula of that *particular* emotion; such that when the external facts, which must terminate in sensory experience, are given, the emotion is immediately evoked." [133] Eliot considers poetry to be universally intelligible because its language corresponds to a unique intellectual and emotional experience which

it in turn is capable of communicating, a belief that is consistent with the principles of New Criticism, which he helped to formulate.

Robert Motherwell was fond of referring to Eliot's "objective correlative" when discussing painting.[134] He enjoyed proselytizing his favorite theories to many Abstract Expressionists, including Pollock and Krasner with whom he spent time in both New York and the Hamptons where he had a house. He believed painting to be such a pliable medium that it was capable of directly responding to his feelings and then conveying them to viewers. "You must understand," Motherwell wrote, "that, as far as I can see, an artistic medium is the only thing in human existence that has precisely the same range of sensed feeling as people themselves do . . . as rich, sensitive, supple, and complicated as human beings themselves."[135] He adds that "an artistic medium, . . . [is] not an inert object . . . but a living collaboration, which . . . reflects every nuance of one's being."[136] Motherwell's extraordinary involvement with his artistic medium was shared by many other Abstract Expressionists who believed their art to be extensions of themselves. Though many subscribed to this idea, none described the process as poetically and in as great detail as does Motherwell in the above quotation.

The temptation inherent in this improvisatory mode of communicating through a given medium is for an artist to develop such innovative images during these plastic automatist sessions that he or she is reluctant to abandon them. In the late 1940s and early 1950s, this Surrealist/existentialist procedure for coming to terms with the self began, in fact, to culminate in identifying images and/or processes such as Pollock's drips, Rothko's lambent fields, Newman's zips, Motherwell's awkward cuts and tears, de Kooning's primordial women, and Kline's black and white swathes. Like Narcissus, some of these artists became enamored with these reified images of themselves and consequently relinquished the burden of freedom that, according to Sartre, obliges human beings to create their essence anew throughout every moment of their existence. He wrote, "[the existentialist] thinks that every man, without any support or help whatever, is condemned at every instant to invent man."[137] Despite the heroism of this quest for a perpetually unresolvable self, most Abstract Expressionists, with the exception of Lee Krasner and, on occasion, Pollock,[138] eventually left this Edenic hell of perpetual self-contingency for the comfort and stability of distinct images or styles that achieved a brand-name identifiability for them. Sartre would have pronounced this flight from the anxiety of freedom and its responsibilities, "bad faith." But such deviations from an existential program also bespeak new ambitions and ways of conceiving the self that are too varied and far-ranging to be analyzed here.

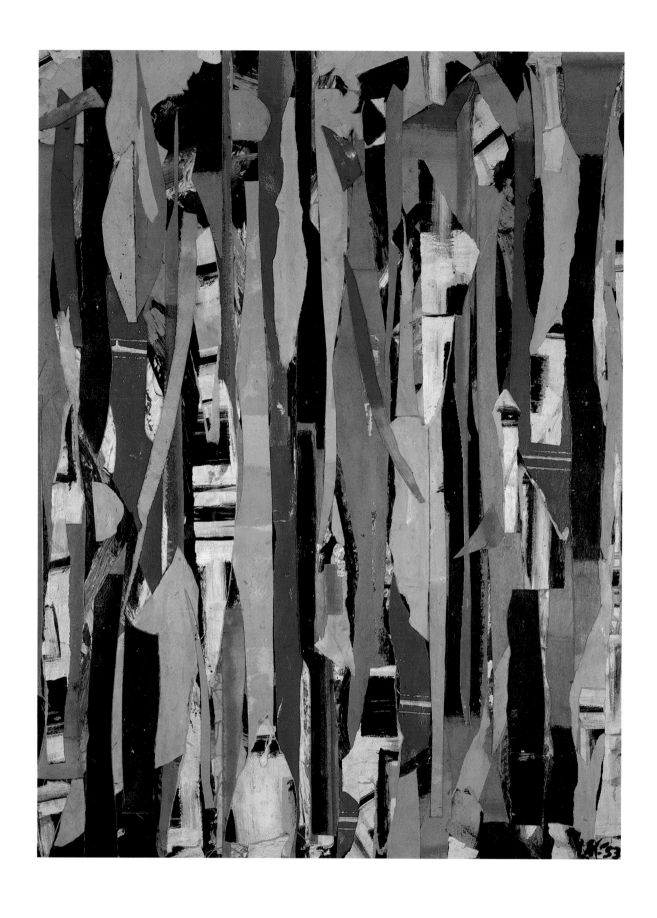

41. **City Verticals**, 1953. Oil, paper, and canvas on Masonite, 41¼ x 31⅛ inches.
Collection of Mr. and Mrs. Graham Gund

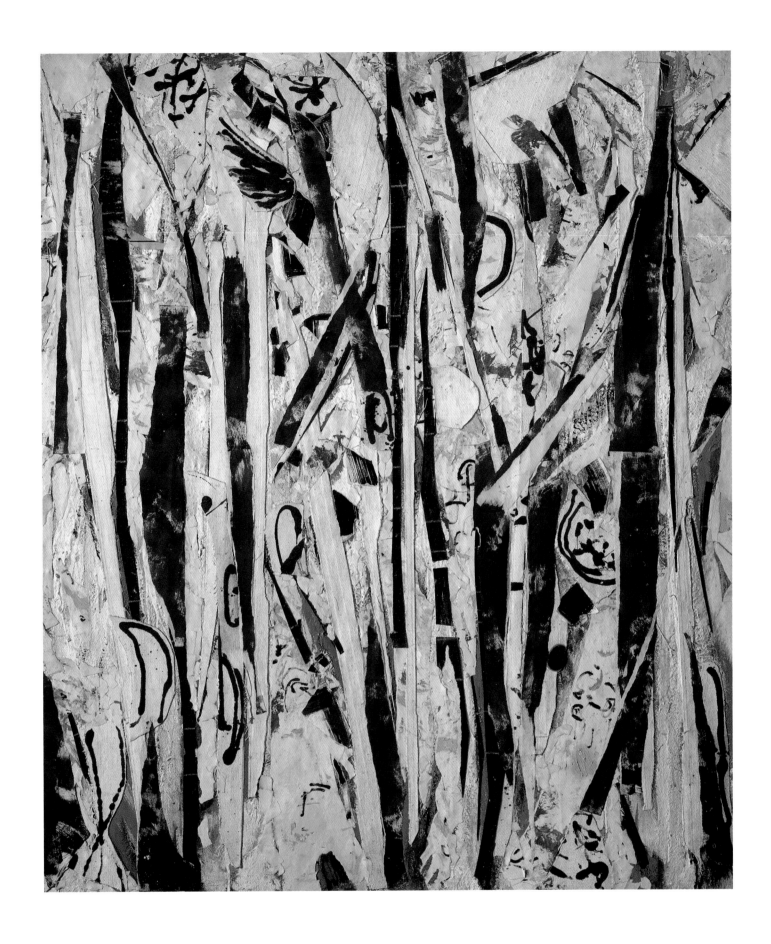

42. **Untitled (Vertical Sounds)**, 1953–54. Oil and paper collage on canvas, 56 x 48 inches (framed).
Deutsche Bank AG, New York

Although critic Lawrence Alloway intended to distinguish Abstract Expressionism from the 1960s systemic painting developing from it, his characterization of "one image art" in his 1966 essay for the Solomon R. Guggenheim Museum exhibition *Systemic Painting* describes a comforting teleology that transforms Abstract Expressionist existential angst into its opposite: "A possible term for the repeated use of a configuration is One Image art. . . . The artist who uses a given form begins each painting further along, deeper into the process, than an expressionist, who is, in theory at least, lost in each beginning."[139] Even though Alloway generously points out that the expressionist is "lost in each beginning" and although the Abstract Expressionists who settled on readily identifiable images or techniques may have felt their work to be open-ended, their acceptance of such signature images as drips, zips, and colored fields severely limited their freedom. In a word, they reduced the terrifying freedom outlined by Sartre to aesthetics, making their images of the self conformable to clearly established idiosyncracies and enduring personality traits.

Lee Krasner, however, avoided succumbing to the myth of a unitary self. Her work never settled for long into a distinct style. Her reluctance (or inability) to settle on a single defining image serves in retrospect as a cogent critique of Abstract Expressionism. In refusing to settle for long on such a limiting tactic, she presents an understanding of the problematics of a contingent self that is particularly germane today.

The Unresolvable Question of the Contingent Self

In many ways Krasner's art is in accord with Anne Wagner's conclusion that this artist does not produce an essentialized self in painting. In her often cited essay "Lee Krasner as L.K.,"[140] Wagner opines that Krasner refused to let her real self emerge in her art for fear that it would betray her femaleness. According to Wagner, Krasner used the name "Lee" and signed her works with the nongendered "L.K." in an effort to establish an otherness for herself as a male. In addition, Wagner believes that Krasner would not permit herself to indulge in either Pollock's evocations of mythic and primitivizing imagery or his involvement with psychologically loaded symbols because she needed to distance herself from him. In her more recent "Krasner Fictions" Wagner maintains that Krasner's "identity—above all, when she is a woman, and because she is a woman—cannot be pried apart from the other roles she is customarily asked to play. . . . Although Krasner's art is 'that of a woman,' the autobiography it inscribes invents its subject (its 'self') as the bearer of a fictional masculinity."[141]

Although I agree with Wagner that Krasner mined her otherness in her

art, I do not believe that she attempted to reject myth, primitivism, or her feminine gender to do so. While one or a number of her fictive roles might well be as macho as Wagner claims, I propose that Krasner's construction of her otherness was an ongoing process that is remarkable for its lack of closure. In her work she forges a number of constructed selves that she considered likely candidates for an ultimately indeterminable and hypothetical "real" self. Relying on the insistent open-endedness of existentialism, Krasner's constructed image of herself in her art is always exceeded by a superfluity of new choices necessitating her determination of yet other selves, becoming a never-ending cycle lasting throughout her life.

Lee Krasner was unable to accept the Abstract Expressionist's essentially romantic definition of the self as an original, the first of its kind that must be identical with itself.[142] In line with the Sartrean claim that existence is both prior and beyond one's commitment to a contingent self, Krasner viewed herself as constituted through choices involving both the past and the present. Even though she acknowledged the mandate to determine new courses for herself, she never appears to have been totally comfortable with Sartre's extraordinary assumption that human beings can totally create themselves through their free choices. Her early reading of Arthur Schopenhauer's *The World as Will and Representation* (1819) left a lingering doubt as to how decisions are actually made. And her embracement in the 1940s of an intuitive approach to making art in line with Pollock's free-associative mode of working suggests an adoption of Schopenhauer's will, which makes the real decisions that the intellect places before it. A non-rational and capricious force without ultimate purpose or design, ready to be led from the satisfaction of one set of goals to an entirely new and different set, the will dismantles the stability of the self by making it a mere servant.

Whether from Schopenhauer or from his intellectual offspring, Arthur Rimbaud, Krasner came to appreciate this reckless otherness within that vies for supremacy, making existence a ceaseless internal struggle and the self an unresolved question. We might say that her art represents an internal battle between the intellect and the will, between the desire to choose and the fatalistic sense that one has already been chosen. Her emphasis on this other "I" that Rimbaud's writings confirmed heightened the existential dilemma, making the terrifying contingency of the self and the need to choose a continuous, ongoing debate. Rather than lessening her affinities with existentialism, this connection with Schopenhauer's irrational will intensified it.

Krasner never succumbed to the temptation to regard her work as a recommencement of human culture from its very beginnings. Instead

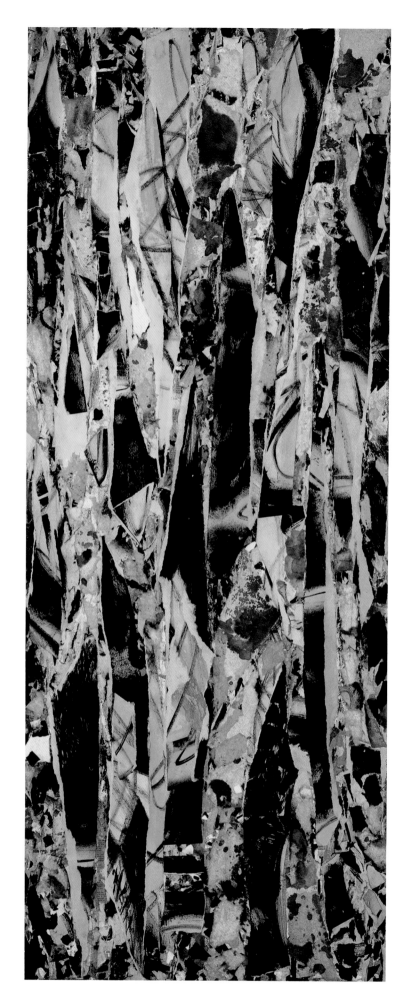

43. **Forest No. 2**, 1954. Collage and oil on panel, 59 ⅞ x 24 inches.
Kunstmuseum Bern, Switzerland

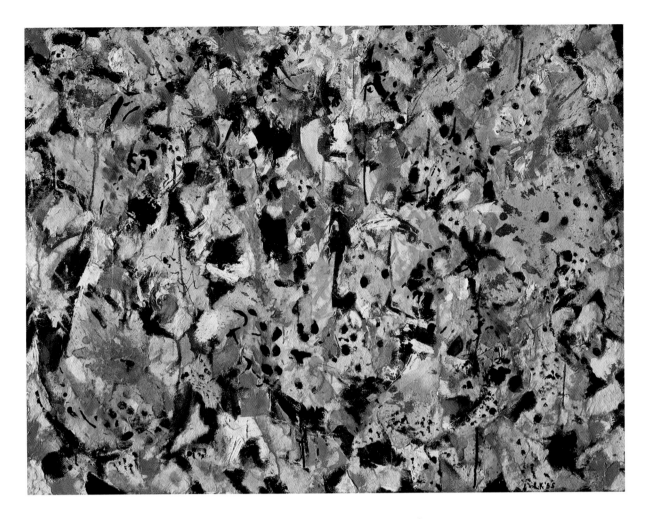

44. **Collage**, 1955. Collage of oil and paper on board, 30½ x 40½ inches.
Pollock-Krasner Foundation, Inc., courtesy Robert Miller Gallery, New York

of seeking in her art a tabula rasa that would enable humanity, at least
symbolically, to go back to absolute origins, (i.e., Newman's first man)
and to dispense with its enormous baggage of tragic misdeeds (including
the recent horrors of the Holocaust), she recognized the necessity of
working within an established, if embattered, culture as well as the need
to reestablish and rework traditions rather than dispense with them as
many other Abstract Expressionists did in their mature phase. In this
respect, she differed significantly from Sartre, who believed in the pure
presence of a work of art and who dispensed with information anterior
to its creation. Although she understood the burden of freedom incumbent
on her, Krasner was reluctant to refer to each work as an absolute begin-
ning. When she gave viewers, including her friends who helped her title
works of art, great latitude in creating, and even recreating, her art through
their suggestions, she showed an understanding of the constraints that a
given culture places on the dissemination and reception of artistic ideas.

In contrast to Krasner, Rothko dispenses with the impediments of
contexts that might interrupt either the artist's connection with the works
or the viewer's direct apprehension of art, as he explained in 1949:

The progression of a painter's work, as it travels in time from point to point, will be toward clarity: toward the elimination of all obstacles between the painter and the idea, and between the idea and the observer. As examples of such obstacles, I give (among others) memory, history or geometry, which are swamps of generalization from which one might pull out parodies of ideas (which are ghosts) but never an idea in itself. To achieve this clarity is, inevitably, to be understood. [143]

Although tragedy is unavoidable for Rothko, he wishes to purge it of particulars so that it will stand as a universal and timeless human condition and a sublimation of the artist into his work. This universality transmutes the tragedy, making it strangely comforting due to its dependability and constancy as a constituent human situation.

In a similar vein, Clyfford Still writes of works of art that are intended to evade the entanglements of history by maintaining the authority of an everpresent original state:

I held it imperative to evolve an instrument of thought which would aid in cutting through all cultural opiates, past and present, so that a direct, immediate, and truly free vision could be achieved, and an idea be revealed with clarity. [144]

Both Rothko and Still, as well as many of their contemporaries, believed that the encumbrances of time can be erased by fiat. Working in concert with Newman's description of the first man, they accepted a national ideology of an eternal return to untrammeled beginnings by positing in their post-World War II art a new dawn on a par with primordial acts of consciousness. This contradictory longing for both new and ultimate origins, however, is out of step with Sartre's Resistance-influenced existentialism that differs significantly from Still's belief in art's ability to transcend time by forging an identity through confronting imposed circumstances and choosing a contingent self from a daunting array of options. The Abstract Expressionists' emphasis on a static and primordial human condition consonant with their understanding of their unconscious selves would have been regarded by the existentialists as an inability to uphold the rigors of personal freedom.

The Abstract Expressionist poetic connection with the distant past represents a classical view of the world in which first principles need to be periodically reaffirmed so that people can slough off the husks of mere personality in order to forge commonalities through their universal and timeless essences. [145] This position is evident in the postwar art of most Abstract Expressionists in which they invoke the theory of Jungian archetypes, which must be discovered anew by succeeding generations looking deep within themselves.

Coupled with this existential necessity to reframe the past rather than out-of-hand dispense with it is Krasner's ongoing investigation of herself as other—an insight that develops in the 1930s, as we have seen, from her immersion in the poetry and thought of Rimbaud. Consonant with the high premium Sartre placed on consciousness and its ability to come to terms with the void within each person is Krasner's regard for herself as an unknowable or perpetually deferred other. Rather than accepting individuality as a God-given right or as a Holy Grail that must be either found or proclaimed, Krasner internalized alienation and made it an ongoing subject of her work.

Deemed other in America by virtue of being the child of Russian Orthodox Jewish immigrants, Krasner assumed during her first thirty years a number of new identities documented by the changes in her name from Lena Krassner to Lenore, later to Leah, and finally, in the 1930s, to Lee Krasner, which sometimes, as we have seen, in her work was abbreviated to the initials L. K. Later, her role as the single female member of the first generation Abstract Expressionists, known for their macho posturing and often misogynist outlook, reinforced her alterity without allowing it to congeal into a comforting stable entity. Years later, she referred to herself as a "survivor" and emphatically stated, "the women's revolution is the only real revolution of our time."[146]

Viewing Abstract Expressionism first as a heightened form of self-anointed individualism predicated on the existential angst of choosing oneself from a plethora of possibilities, and then seeing it quickly evolve into the solid comforts of an easily recognizable singularity (i.e., the drips, zips, etc.), helps one appreciate the persistent open-ended quality of Lee Krasner's art, which continued to develop in new and unpredictable ways until her death.

Among the first generation of the New York School, Krasner should be considered its preeminent existentialist proponent because her sense of self remained iterative and protean. In conversation with Barbara Novak, Krasner first disclaimed affinities with one image art and then attacked it. "I've never understood the fixed image," she stated. "I've never experienced this state of being where you fix an image and this becomes your identification. . . . It's rigid. Its purity is alarming, so to speak. It terrifies me in a sense." To make sure her point was clearly understood, she enunciated, "It's rigid, as against being alive."[147] In addition to referring to one image art as an aesthetic rigor mortis, Krasner emphasized the intuitive receptivity to change that she believed was essential to her work, "I think that matter is as important as spirit and once these things are separated, then comes

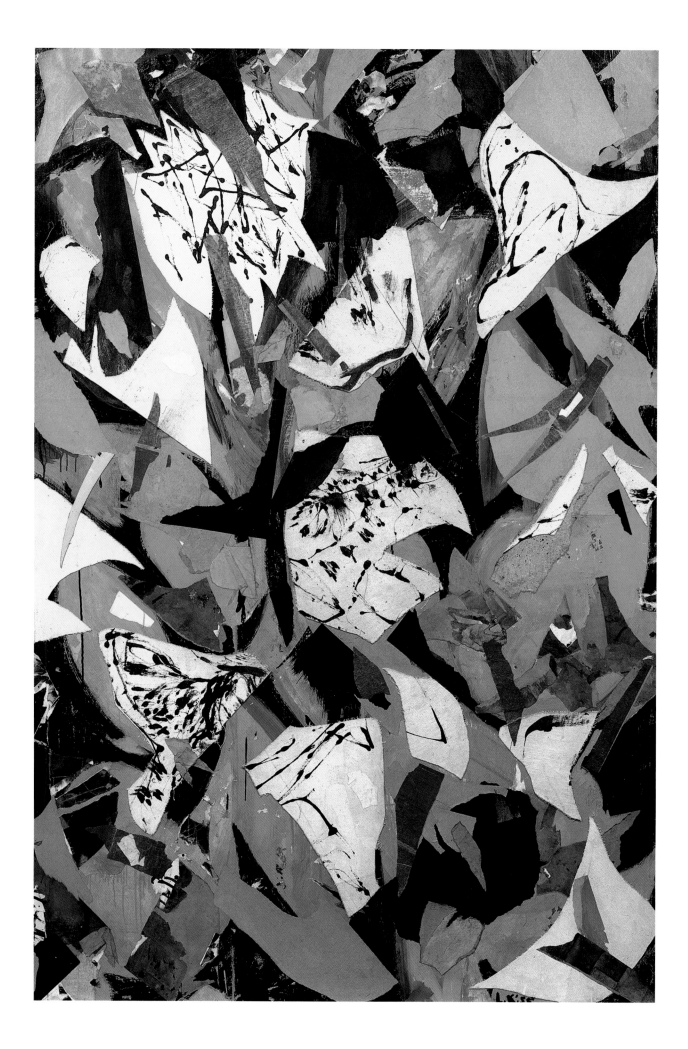

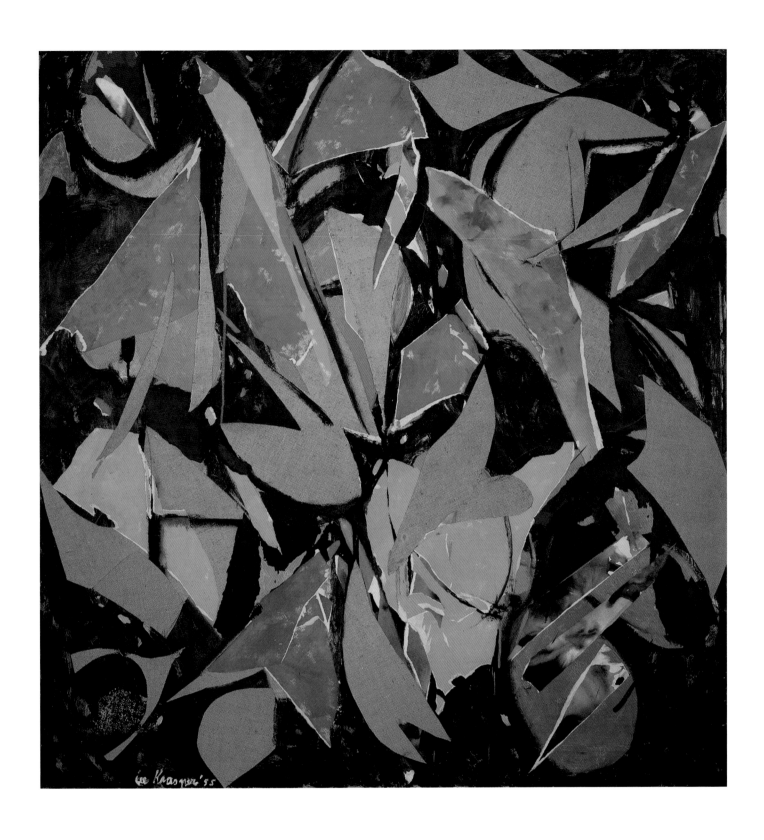

Opposite: 45. **Bald Eagle**, 1955. Oil, paper, and canvas collage on linen, 77 x 51 ½ inches.
Collection of Mrs. Audrey Irmas

46. **Bird Talk**, 1955. Oil, paper, and canvas collage on cotton duck, 58 x 56 inches.
Collection of Mr. & Mrs. Jerome Zimmerman

what I call the fixed image, which I don't understand."[148] At another time, she affirmed, "The one constant in life is change. I have regards for the inner voice."[149]

Krasner recognized the continued difficulty of remaining open and being unable to settle on a distinctive mode for very long. To Tucker, she admitted that, "my own image of my work is that I no sooner settle into something than a break occurs. These breaks are always painful and depressing but despite them I see that there's a consistency that holds out, but is hard to define."[150] Her resignation to these changes that seemed imposed on her rather than readily assumed, coupled with her recalcitrance regarding the accepted pattern of Abstract Expressionist development, made her a formidable if isolated member of this group of self-proclaimed individuals, who often paralleled one other. "I believe in listening to cycles," Krasner told Munro. "I listen by not forcing," she asserted. "If I am in a dead working period, I wait, though those periods are hard to deal with. For the future, I'll see what happens."[151] Toward the end of her life she took a grudging pride in the amazing direction in which this perpetual open-endedness had taken her when she admitted to critic Barbara Cavaliere, "Not having been a giant success in my life has been, in the end, a blessing. I can afford now to do as I wish. . . . So I'd like to take advantage of the situation and not predict what my next paintings will be."[152]

Destruction as a Form of Creation

Krasner was unable to maintain for long the reassuring synthesis of primordial references and personal écriture constituting her Little Image series. The same year that she perfected this body of work with her magnificent *Untitled (Little Image)*, 1950 (plate 34), she began to experiment in a number of competing directions, creating painterly equivalents of her pre-Pollock American Abstract Artists period, the Bauhaus art of Joseph Albers, and even such pre-Little Images works as *Image Surfacing*, ca. 1945 (plate 22). From the many biographies written on Jackson Pollock, we know that he was veering away from the classic synthesis represented by the drip paintings after he started drinking again. His bouts with alcohol no doubt affected Krasner, upsetting the balance she achieved in the Little Image series. Even with these difficulties, Krasner was able to undertake a retrospective stocktaking in *Volcanic*, ca. 1951 (plate 35), and several adventurous forays such as *Gothic Frieze*, ca. 1950 (plate 36), and *Ochre Rhythm*, 1951 (plate 37), in which she initiated a style based on abstracted embryonic forms. Particularly important to these works are the overlapping of forms, brusque handling, and embedded organic shapes that begin to resemble

body parts, including incipient eyes in *Ochre Rhythm*. Because this style anticipates a way of working that Krasner begins to explore more fully in 1956, the discussion of these stylistic characteristics will be delayed until those works are analyzed.

After moving away from the great abstract drip paintings (the last was completed in 1950), Pollock returned in 1951 to the ambiguous and conflated imagery of his pre-drip period in a series of black-and-white works that culminated in an exhibition at the Betty Parsons Gallery. From that time until his death he oscillated between figuration and abstraction, occasionally achieving in such a later work as *Blue Poles: Number 11*, 1952 a power and resolution comparable to the best drip paintings. His problems with his work as well as his drinking affected Krasner and resulted initially in a similarly difficult time for her.

Beginning in 1953, however, she found a way to deal with her frustration regarding Pollock's drinking through alternate destructive and reconstructive acts in which she ripped or cut apart either her own or Pollock's works and then recombined them into a series of important collages that began with such pieces as *Black and White* and *Black and White Collage*, both 1953 (plates 38 and 39). She has recalled the intensity of her first self-destructive act that was followed by sessions of reclamation and recreation:

> it started in 1953—I had the studio hung solidly with drawings . . .
> floor to ceiling all around. Walked in one day, hated it all, took it down,
> tore everything and threw it on the floor, and when I went back—it was a
> couple of weeks before I opened that door again—it was seemingly a very
> destructive act. I don't know why I did it, except I certainly did it. When I
> opened the door and walked in, the floor was solidly covered with these torn
> drawings that I had left and they began to interest me and I started collag-
> ing. Well, it started with drawings. Then I took my canvases and cut and
> began doing the same thing, and that ended in my collage show in 1955.[153]

Held at Eleanor Ward's Stable Gallery, this collage exhibition was later referred to by Clement Greenberg as one of the most important exhibitions of the decade.[154] From 1953 until this exhibition in 1955, Krasner created a number of notable collages, including *The City*, 1953 (plate 40), *City Verticals*, 1953 (plate 41), and *Untitled (Vertical Sounds)*, 1953–54 (plate 42), focusing on urban themes; a related series of congested thickets, such as *Forest No. 2*, 1954 (plate 43), followed by a particularly powerful series of monumental collages, including *Collage*, 1955 (plate 44), and *Bald Eagle*, 1955 (plate 45), which contain pieces of Pollock's 1950s ink drawings on paper, and *Bird Talk*, 1955 (plate 46), which incorporates fragments of out-of-focus photographs. Recycling portions of Pollock's discarded works in her collages suggests a complex series of responses, varying from the Depression-era frugality for which she was renowned, to a long tradition

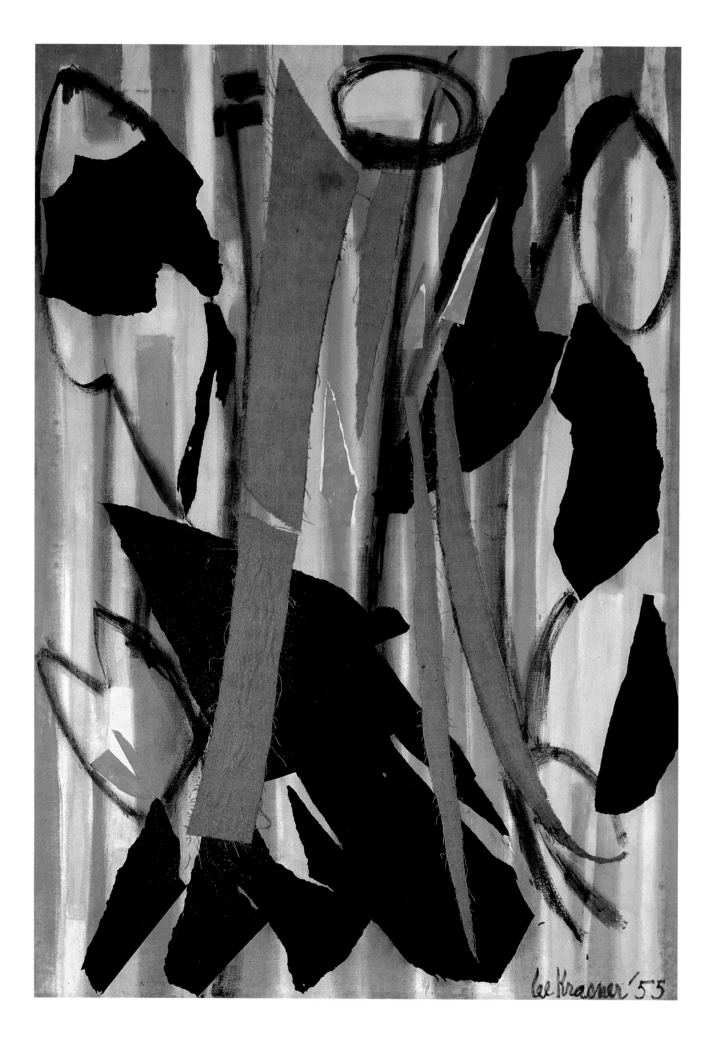

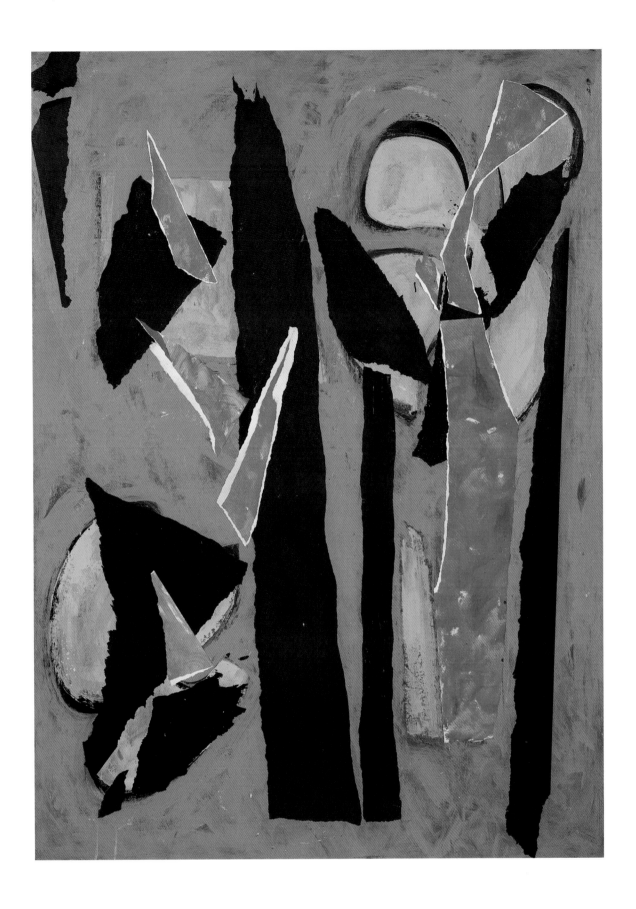

Opposite: 47. **Shooting Gold**, 1955. Oil, paper, and burlap collage on canvas, 82 ¼ x 58 ½ inches. Collection of Fayez Sarofim

48. **Desert Moon**, 1955. Collage of oil and paper on cotton duck, 58 x 42 ½ inches. Courtesy Robert Miller Gallery, New York

of women creating quilt patterns from scraps of family clothing, to a means of triumphing over her husband's inadequacies by succeeding where he had failed, and finally to a Sullivanian understanding of the self as formed through an ongoing discourse with others.

Sullivanian Therapy

The significance of a discursive definition of the self was confirmed by Krasner's decision in 1952 to work with the psychotherapist Dr. Leonard Siegel because his approach was in line with Sullivanian therapy.[155] In the early 1950s the ideas of Harry Stack Sullivan (1892–1949) were so widely accepted by members of the New York art community[156] that Krasner would have had many opportunities to become familiar with this approach before deciding to work with Siegel. Her familiarity with the Sullivanian interactive system can be documented by the fact that Pollock had chosen to work with the Sullivanian therapist Dr. Ralph Klein in 1951. Pollock later consulted with Krasner's analyst regarding problems with their marriage, thus indicating that both artists were aware of the significance Sullivanians attribute to interactive patterns.

Sullivan was highly critical of Freud for isolating human beings in a nineteenth-century fashion, for not fully appreciating the fact that psychology must be involved with interpersonal relations, and for not recognizing personality as, at best, a hypothetical entity that can never be isolated from specific contexts.[157] In addition, he believed that Freudians improperly understood individuality because they tended to regard it as static and monolithic rather than dynamic and interactive. Instead of focusing on the individual in his therapy, Sullivan looked for the envelope inclusive of all the roles, both actual and imaginary, that a person has learned in the course of his or her life. Moreover, he emphasized early interpersonal patterns that people first learn, then develop and change, as significant clues to their behavior.

Sullivan's view of people as dynamic constellations of forces would have been particularly meaningful to Krasner in the early and mid-1950s when Pollock's alcoholism was creating enormous tensions in their lives. Viewing herself and her art as a series of ongoing social dynamics also freed her from mounting pressures exerted by the one image styles of the other Abstract Expressionists to create one of her own. Rather than succumbing to this means of self-definition, Krasner chose the diametrically opposite position of an interactive art that carries on a discourse with her own earlier work, with Pollock's painting, and at times with the art of other Abstract Expressionists such as Motherwell, whose *Elegies to the Spanish*

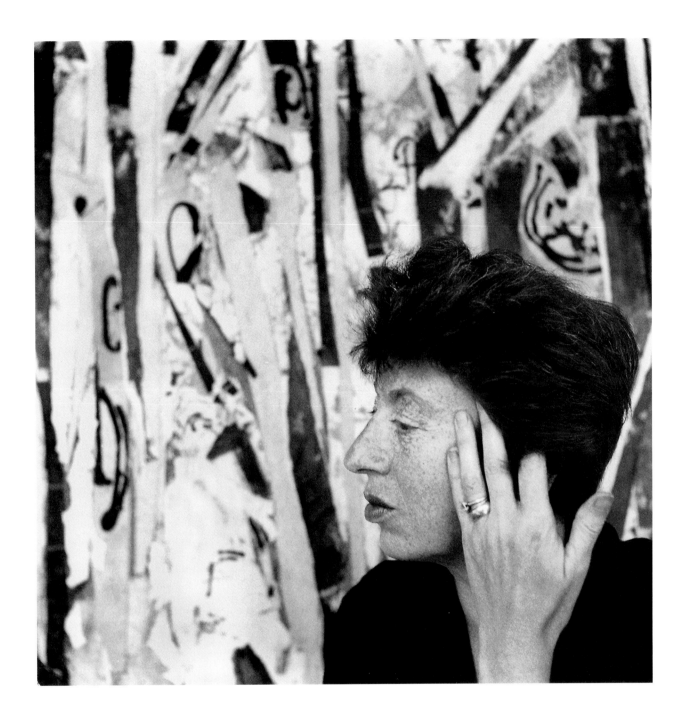

Lee Krasner, 1957

Republic are both referenced and deflected in the collages *Shooting Gold*,
Desert Moon, and *Milkweed*, all 1955 (plates 47, 48, and 49), as well as with
de Kooning, whose work joins Pollock's in becoming part of an ongoing
dialogue framing *Bird Talk* and the series of paintings she undertook
beginning in 1956 and continued intermittently until the early 1960s.
Her essentially Sullivanian sense of self parallels literary critic Irving Howe's
later definition of the necessary contingency of existence. "The self entails
a provisional unity of being," Howe states, "yet this occurs, if it does at all,
during transformation and dissolution. For the self, as a felt presence, is
inescapably dynamic, at once coming into and slipping out of being."[158]

Sullivanians reject the tradition of an essentialized self and also repudiate
theories of self-expression predicated on the unfolding of an inner essence

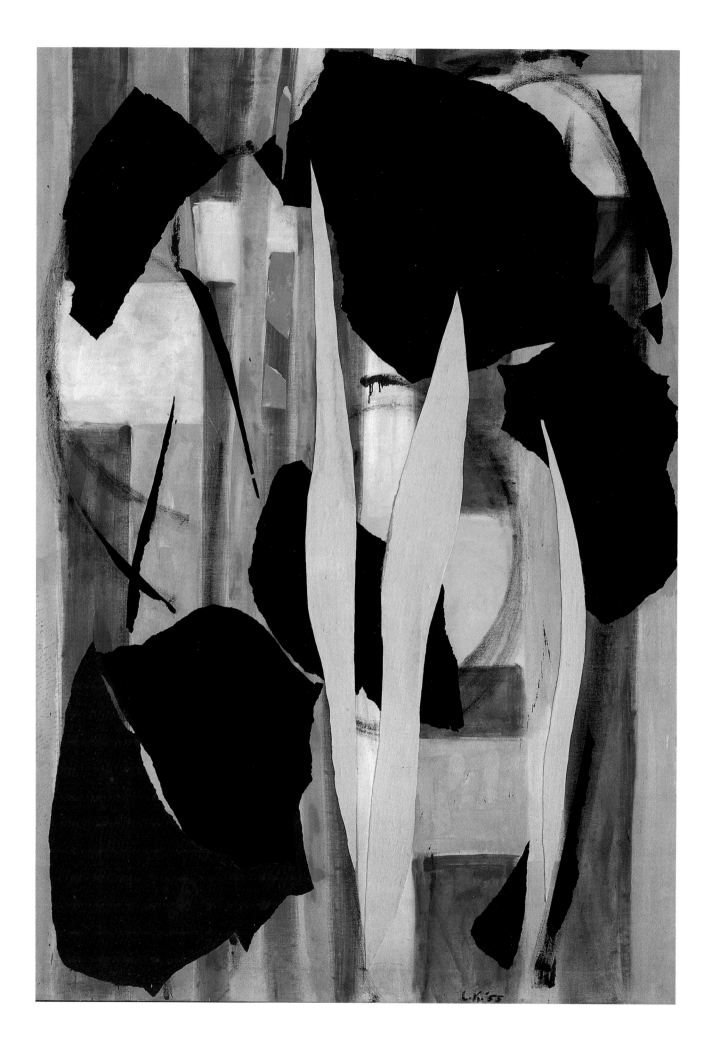

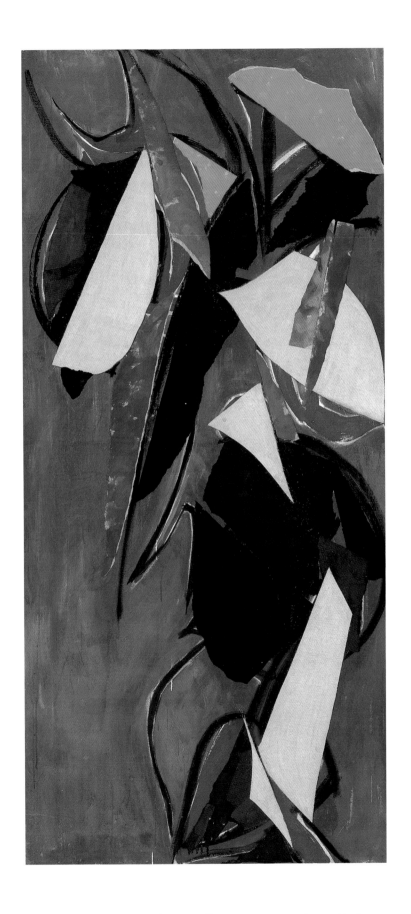

Opposite: 49. **Milkweed**, 1955. Oil and paper collage on canvas, 82 ⅛ x 57 ¼ inches.
Albright-Knox Art Gallery, Buffalo; gift of Seymour H. Knox

50. **Jungle Green**, 1955. Oil and collage on canvas, 82 ¾ x 39 inches.
Meredith Long & Co., Houston

through one's life. According to these traditional theories, the self already exists as a potential ready to realize itself in its relationships with others. In contrast with this outlook, Sullivanians dispense with beliefs regarding each individual's unique inner essence. Along with their rejection of this idea, they also view self-exploration and self-expression as complex interactive processes involving both internal and external conversations among the various interpersonal roles that have been "naturalized" as the self.

This discussion regarding a "naturalized" self as opposed to the post-modern preference for the term "subject" is important for the dialogic work of Krasner. Instead of "naturalizing" herself in her work, she posits her art as an integral component of an ongoing artistic conversation with herself and others that supports a given culture and advances it.

Her work differs from the empiricism promoted by such Abstract Expressionists as Motherwell who accord primary importance to their knowledge of their essentially private and inaccessible feelings that they try to communicate to others through the culturally conditioned language of painting. She departs from them in believing that her feelings are always mediated, always subject to the interpersonal patterns forming her nature. Although she might at times vent her strong emotions—and many contemporary accounts agree that she did—in her art she came to regard these feelings as topics of discussion and even censorship from a partially disembodied consciousness represented by the staring eyes that began appearing in her works in the 1950s, which might symbolize a dislocated consciousness emerging from the realm Rimbaud termed the "there where I is another." Instead of evidencing trust in the stabilizing and regulatory ability of the ego to serve as an infallible guide to creativity, Krasner's work was more in line with Lacanian notions of the "fragmented body" and the alienating and imaginary ego that Lacan theorized children assume during the so-called mirror phase. Although it is most likely tha Krasner was unaware of Lacan's important work from the 1930s on the alienating effects of a borrowed ego, her embrace of Sullivanian theory and Rimbaud's ideas enabled her to form similar conclusions regarding the divided self.

Prophecy

The transformation from such occasional pieces as *Ochre Rhythm*, and from the collages *Bald Eagle*, *Bird Talk*, and *Jungle Green*, (plate 50), all 1955, to the paintings known as the Earth Green series, which were begun in 1956, appears in retrospect to constitute a logical yet giant step for Krasner. But at the time, this move seemed to her to constitute a virtual sea change of attitudes. After the Stable Gallery show in 1955, which had

impressed a number of people including Pollock who "was at the opening, proud as a peacock,"[159] Krasner returned to painting. She appears to have first created *Easter Lilies*, 1956 (plate 51), a work that carries on a dialogue with both *Ochre Rhythm* and Pollock's *Easter and the Totem*, 1953. In her next painting, *Prophecy*, 1956 (plate 52), she moved back to such Pollock works as *The Key*, 1946, with its conflated forms, bold outlines, and mysterious figures. But *Prophecy* was not simply an academic exercise or a ploy intended to redirect Pollock's floundering style to a source of strength. For Krasner, it assumed the force of a nightmare. "The image was there," she later told Munro, "and I had to let it come out. I felt it at the time. *Prophecy* was fraught with foreboding. When I saw it, I was aware it was a frightening image, but I had to let it come through," she reiterated. "Some people might not have been afraid, but I was. So I allowed it to happen, but I didn't pursue the meaning at the time."[160] Most terrifying to her was the eye in the upper-right corner incised into the black background. Pollock suggested that she paint it out, but she resisted.

She decided to leave the work as it was on her easel when she departed for her first European trip. The vacation was a trial separation from Pollock. Their situation had deteriorated, and he was having an affair with the young painter Ruth Kligman. Krasner was gone for only a few weeks when she learned that Pollock had killed himself and Kligman's friend Edith Metzger in a car accident. She returned to face Kligman's clothes in her closet, a husband to bury, an estate to settle, and the premonitory painting *Prophecy* still on her easel with its unsettling accusatory eye.

Instead of settling into grief, Pollock's death, the relief of no longer being his caretaker, and the new responsibilities and power involved in managing his estate energized her. Believing that her own house was haunted, she invited two young writers, Sanford Friedman and Richard Howard, to live in the old smokehouse, which had functioned as a small guest house.[161] Both men became lifelong friends. During their time on the Krasner-Pollock compound, they would read to Krasner in the evening and would help her when she needed to title specific bodies of work.

When she returned from Europe, but before she took over Pollock's studio, she felt the need to face *Prophecy* once again. Years later, she confided to Richard Howard:

> I got back from Europe and this painting—once more I had to look at it and deal with it: Prophecy *still frightened me enormously. I couldn't read why it frightened me so, and even now would be hard put to do so. And so in that sense the painting becomes an element of the unconscious, as one might bring forth a dream.*[162]

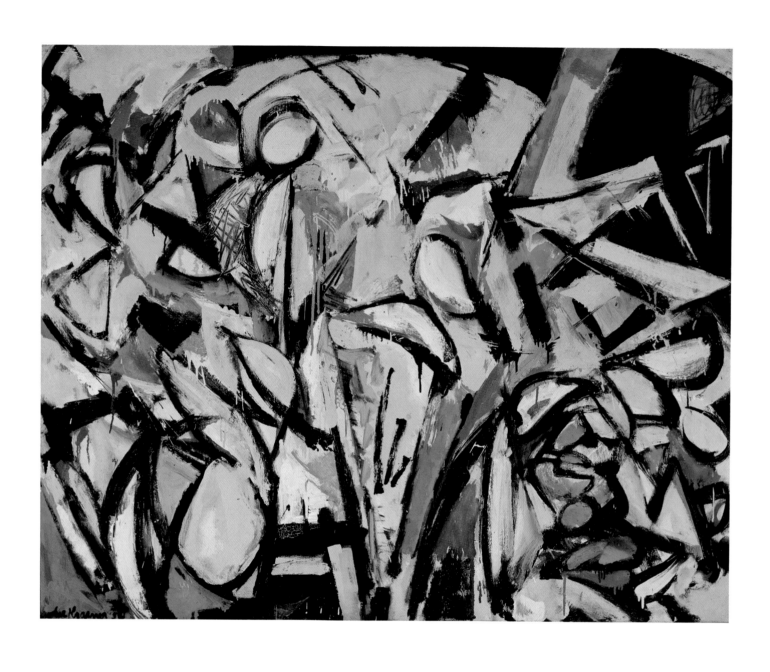

51. **Easter Lilies**, 1956. Oil on canvas, 48 x 60 inches.
Collection Mr. & Mrs. Jeffrey Brotman

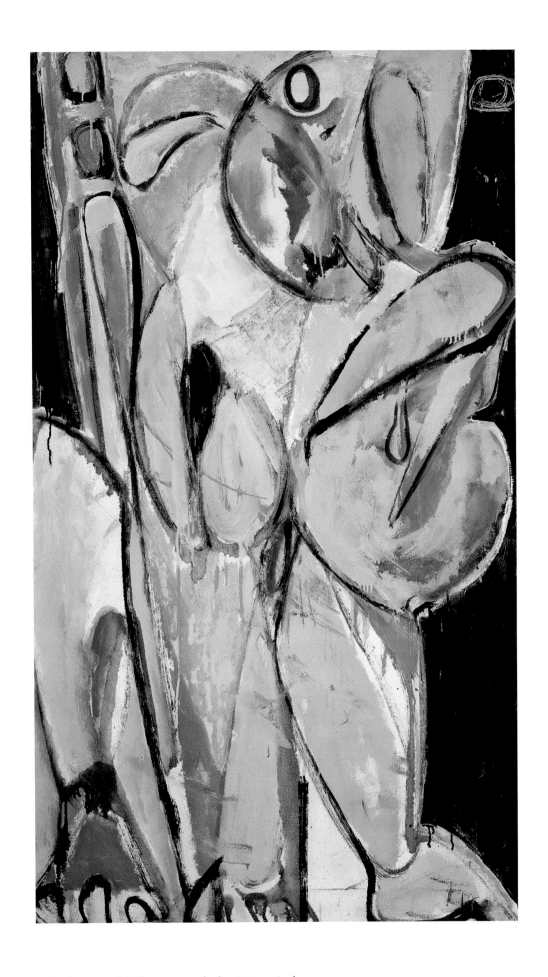

52. **Prophecy**, 1956. Oil on cotton duck, 58⅛ x 34 inches.
Collection of Mr. & Mrs. Jerome Zimmerman

While in analysis some time later, she recalled a terrifying experience that occurred when she was about five years old. She remembered feeling some apparition leap over the banister in the dark hall where she was standing and mumbling in a petrified voice, "Half man, half beast."[163] The enormous impact of this event on her psyche is not surprising, considering the ambience of superstitions and fears surrounding her in her youth. She remembered that her father, Joseph, told her wonderfully frightening stories.[164] Her mother, Anna, was renowned in the family for her ability to rub a pregnant woman's belly and correctly determine the sex of the child.[165] And Krasner's Russian grandmother, Pesah, was legendary for her ability to wield the evil eye.

The Evil Eye

Although Pollock had made many references to eyes in his early figurative works and used them thematically in *Eyes in the Heat* from his 1946 Sounds in the Grass series and in *Ocean Greyness*, 1953, where they are caught up in a maelstrom of gray surging paint, they never seem to have assumed for him the malevolent force they did for Krasner. She was both intrigued and repulsed by them, and yet felt compelled to use them as key elements in many paintings in the late 1950s and early 1960s and even returned to them occasionally after that time. A possible clue to the eyes in her paintings might be the innocent conflation of sight and self occurring in a letter that her former art-school classmate, George Mercer sent her on July 15, 1940, in which he used the picture of an eye in place of the vertical pronoun signifying himself.[166] Mercer's humorous connection suggests a widespread intragroup appreciation for the homonymic "eye/I" since he could joke about it with Krasner, knowing that it would be understood. But even though Krasner would have appreciated Mercer's wit, the disembodied eye assumes a troubling and at times sinister role in her art.

Krasner said, "I had to confront myself with this painting [*Prophecy*] before I was able to start work again. I went through a rough period in that confrontation."[167] To understand the terror invoked by the eye in this painting, it is helpful to look at the tradition of the evil eye. Following long-established usage, some provincial Jews in Hungary, Poland, Rumania, and Russia, according to folklorist Aaron Brav, attributed great power to this sign.[168] In this respect, they resembled many other European groups and tribal peoples throughout the world.

Known in Yiddish as "En Horah," the evil eye was believed by some Talmudists to be so pernicious that it accounted for ninety-nine percent

of deaths, only the remaining one percent being attributable to natural causes. So ingrained in the Jewish religion is the evil eye that one section of a well-known morning prayer asks for protection against it. And the often-used expression "Nicht kein en horah," said after giving a compliment, means "Don't give an evil eye." While the evil eye is most often intentionally invoked against an enemy, it is thought so insidious that it can unconsciously emanate from people wishing only to do good. The eye is, however, most effective when it is consciously directed, and the most productive way to effect this power is to close one eye in order to concentrate one's full strength on the evil one. In Krasner's *Prophecy*, the figure's central blank eye seems, in fact, to be blind, while the seeing and perhaps evil one looms out of the darkness. The fear aroused by the evil eye is supported by the traditional pity felt for the blind as opposed to the anxiety, recorded in Edgar Allen Poe and others, about those who are without sight in one eye. There is even a tradition regarding the host of evil spirits existing in a single eye: some Judaic scholars have pointed to the belief that each eye contains a thousand evil spirits, making a grand total of two thousand pernicious ghosts with which the sighted must contend.

Evil eyes are part of a larger superstitious world in traditional Judaism that is inhabited by external and internal demons who are just as liable to represent threats from other people as from oneself. For immigrant Jews the concern with the evil eye multiplies in an English-speaking context where it lurks behind every "I." Since the pronoun "I" is a shifter, using the term of the twentieth-century Russian linguist Roman Jakobson that requires an indexical or contextual relationship to determine exactly who the "I" is, its homonymic relationship with the eye of vision makes it both ambiguous and unreliable because it implicates oneself as well as others. Being on the lookout for this indexical "eye/I" must have required enormous vigilance from believers and would no doubt have occasioned considerable distrust of others as well as oneself.

Reared in a simple immigrant atmosphere in which such ideas as the evil eye were discussed and invoked, since the alien and dynamic world of Brooklyn in which the Krasner family found itself was no doubt threatening, Lee Krasner first reacted to her family's superstitions by staunchly rejecting such fancies, only to find herself decades later subject to them once again. The ferocity and irrationality of these fears that had seemed to forecast Pollock's tragic death not only haunted Krasner but also provided her with a tremendous need to work through them—a need that resulted in the completion of seventeen large paintings during the first year-and-a-half after Pollock's death.

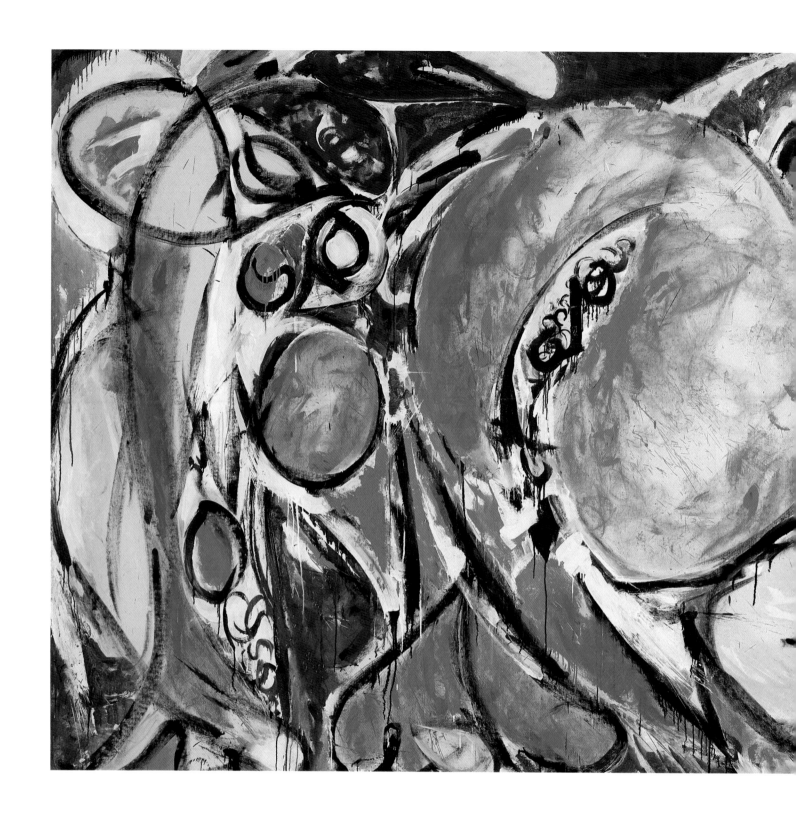

53. **The Seasons**, 1957. Oil on canvas, 92⅞ x 203¾ inches.
Whitney Museum of American Art, New York;
purchased with funds from Frances and Sydney Lewis (by exchange),
The Mrs. Percy Uris Purchase Fund, and the Painting and Sculpture Committee

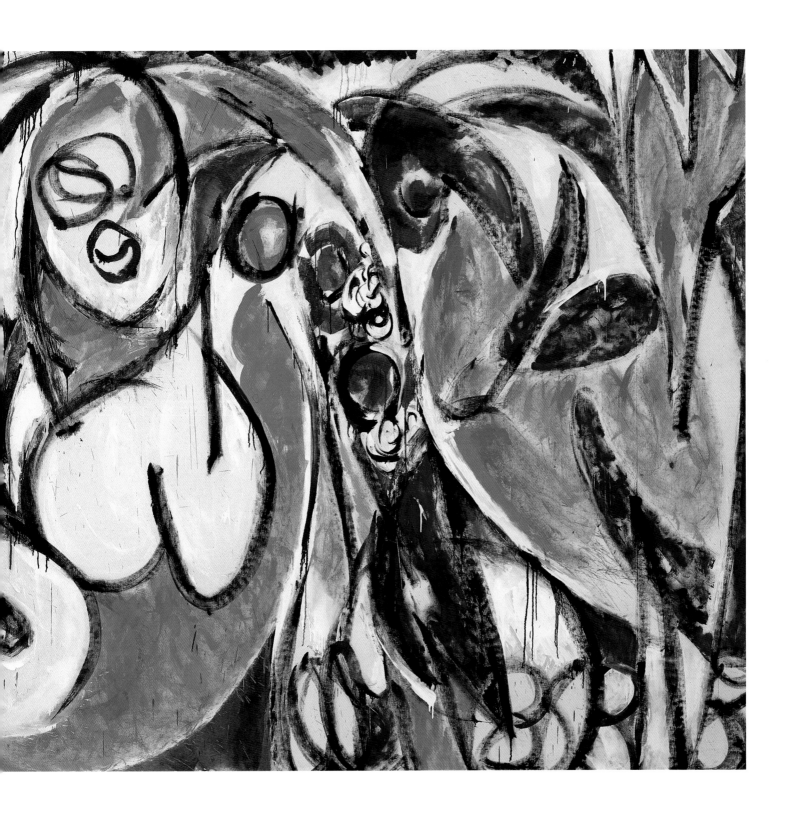

A similar anxiety regarding the evil eye was exhibited by Harold Rosenberg in his "Four Poems," 1932, in which he wrote, "I have whitened to a hideous egg the eye/ that pleaded; I have slashed the brown."[169] Considered in light of evil-eye superstitions, this line connects blindness with a traditional image of fecundity, the egg, while striking out at the seeing or evil eye. This emphasis on the malevolent force of the evil eye may explain Rosenberg's fascination with the opening scene of Luis Buñuel's and Salvador Dalì's 1928 film *Un Chien Andalou*, in which the eye of an animal appears to belong to a woman and is sliced with a razor blade.[170]

Birth

Because women in childbirth were considered especially susceptible to the harmful effects of the evil eye, the term "Kein En Horah" ("No evil eye") was frequently pronounced as a way of warding off evil spirits when addressing a pregnant woman. In light of this custom, it is of exceeding interest to note that Krasner titled one of her first major works in the Earth Green series, *Birth*, 1956 (plate 54). In this painting a similarly threatening eye appears in the same place as the one in *Prophecy*. It is joined in this composition by many other eyes, as well as a series of fragments of body parts liberally dispersed throughout the work.

Psychologist Otto Rank describes how the death of a close relation might result in conflicted needs involving a reenactment of a person's primal birth trauma in which this individual tries to extract him or herself from an initial attachment to the mother by being reborn, while attempting at the same time to identify with the dead one who is returning to the mother's womb in a reversal of the birth process.[171] In addition, Rank conjectures that patients often signal the end of their psychoanalysis through birth symbolism. Rather than a regression, this rebirth fantasy is a step forward, enabling patients to reenact the primal separation and to free themselves both from their analyst and from the early birth trauma that has haunted them throughout their lives.[172] Whatever the reasons for this emphasis on rebirth and regeneration in Krasner's art, it was an important subject in these increasingly monumental paintings making up the Earth Green series (the largest, *The Seasons*, 1957; plate 53, is a little over sixteen feet in width) and a motivation to work at full speed so soon after Pollock's death. Compositionally related to *The Seasons* and approximately two feet smaller in width, *Celebration*, 1960 (plate 58), is a partial repainting of the Earth Green work *Upstream #2*, 1957.

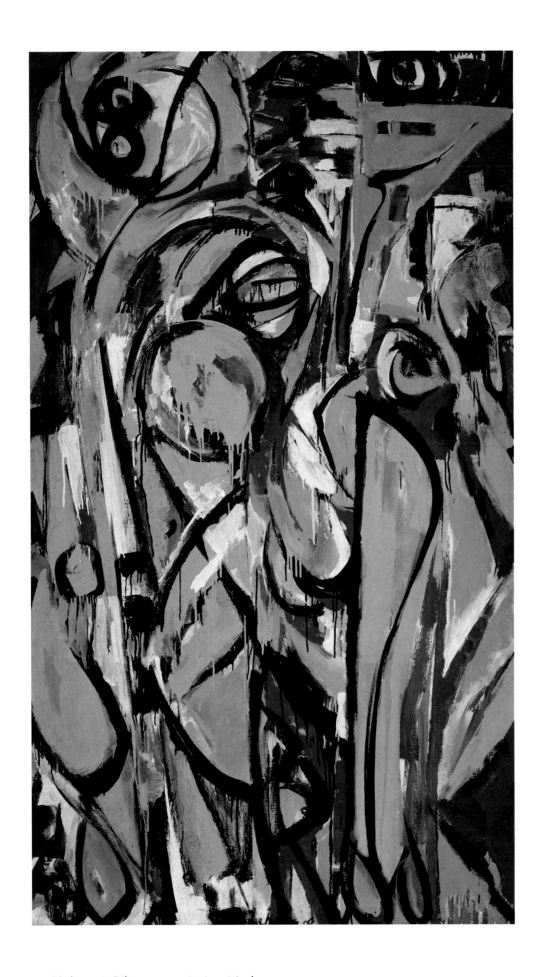

54. **Birth**, 1956. Oil on canvas, 82 ¾ x 48 inches.
Private collection

Krasner's Signature Image as Compositional Device

Beginning in 1957 with the painting *Listen* (plate 55), which B. H. Friedman helped name,[173] Krasner elaborates her signature to the point that it expands to become the armature for the entire painting. This emphasis on her name occurs in a number of other contemporaneous works, including *Sun Woman I* (plate 56), *Sun Woman II* (plate 57), and *The Seasons*, as well as *Black, White and Pink Collage*, 1958–74 (plate 59) which was begun at the same time as the other but was completed in 1974. This emphasis on the artist's signature as a compositional device may have a source in John Graham's *System and Dialectics of Art*. Starting with the self-evident, Graham writes:

> *Signature is the art of signing an object of art. In itself it is a difficult art. Man who knows it best is Picasso. It is said that he can take a mediocre painting and entirely by signing, convert it into a work of art. Spontaneous faultless placing of signature, attuned to the pattern of the painting, injects life into a dead corpse. Therefore—magic.*[174]

But contrary to Graham's conclusion, the artist's signature is far more than the act of affixing a name to a work of art. Received wisdom suggests that it be evident in every brushstroke of a painting so that the painter's individuality is readily apparent throughout a work and not confined to a mere name. So strongly did Abstract Expressionist Richard Pousette-Dart believe that the signature is an inextricable part of a given work, evident both in its conception and execution, that he refused to sign the front of his paintings. Withholding a signature might enable artists to feel that they are maintaining an external and autonomous position in relation to their art.

At the time Krasner created *Listen*, many Abstract Expressionists had already settled on a self-defining schema that became known as their "signature image," as discussed earlier. In consideration of this fact, we might conjecture that on one level Krasner's extended signature in *Listen* could be considered a parody of one image art. But the signature had other meanings for her, as we shall see.

Starting in the lower right, her sprawling name appears either to have initiated or concluded the initial phase of outlining the composition with an umber imprimatura. Whether undertaken at the beginning or reinforced at the end of this process, the integral use of the artist's name allies the overall work with her identity and helps to explain the intense emotional reaction she felt while making it. "I can remember," she later told Richard Howard, "that when I was painting *Listen* which is so highly keyed in color— I've seen it many times since and it looks like such a happy painting— I can remember that while I was painting it I almost didn't see it, because

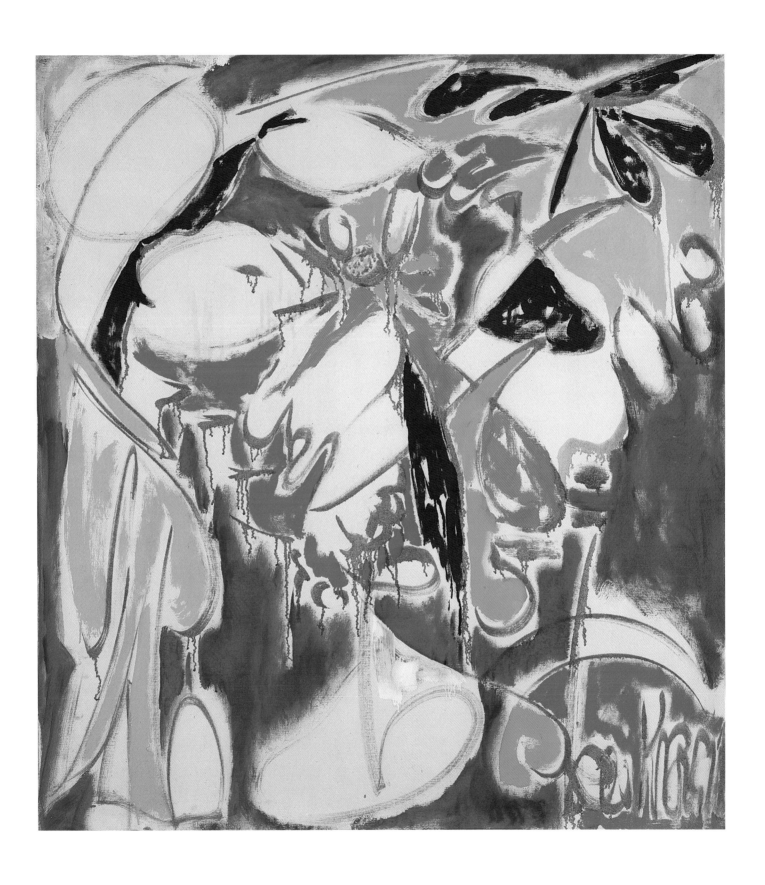

55. **Listen**, 1957, Oil on cotton duck, 63 ¼ x 58 ½ inches.
Private Collection

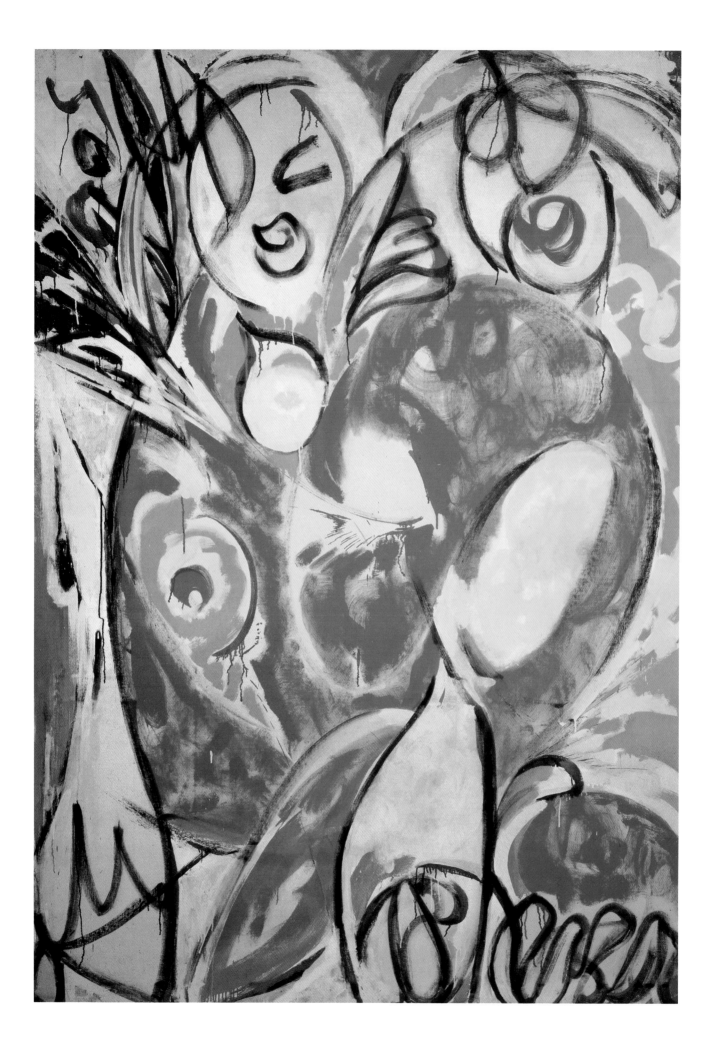

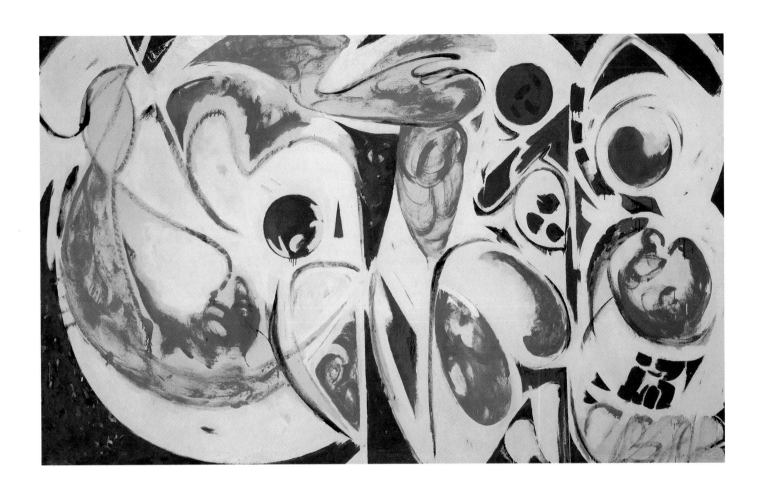

Opposite: 56. **Sun Woman I**, 1957. Oil on canvas, 97 ¼ x 70 ¼ inches.
Private collection

57. **Sun Woman II**, 1957–ca. 73. Oil on canvas, 69 ½ x 113 ½ inches.
Pollock-Krasner Foundation, Inc., courtesy Robert Miller Gallery, New York

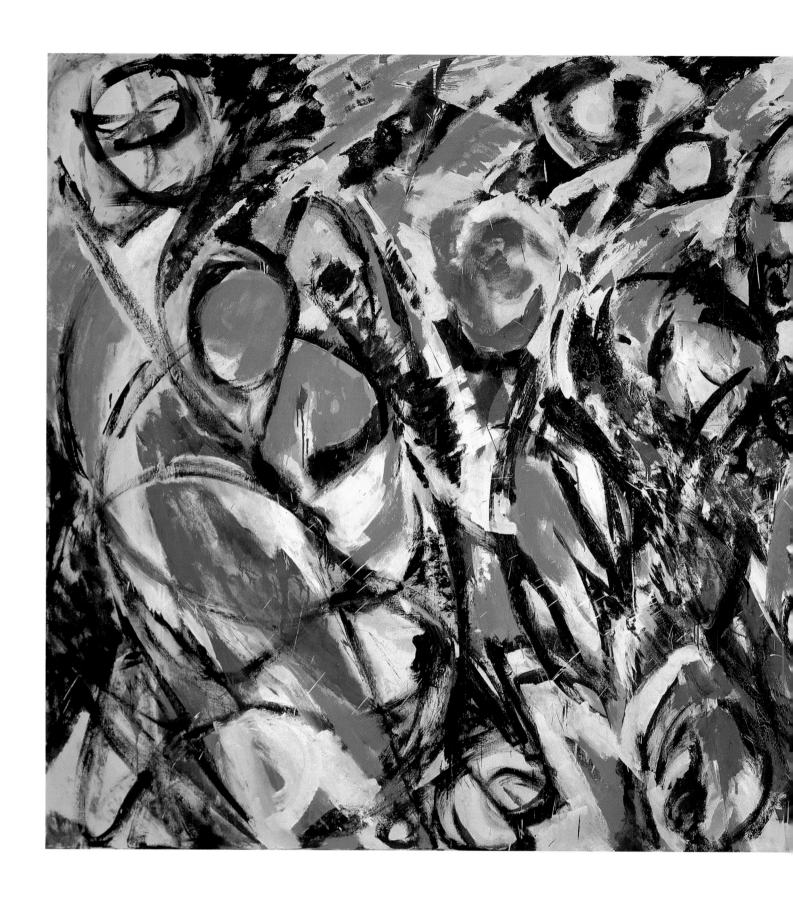

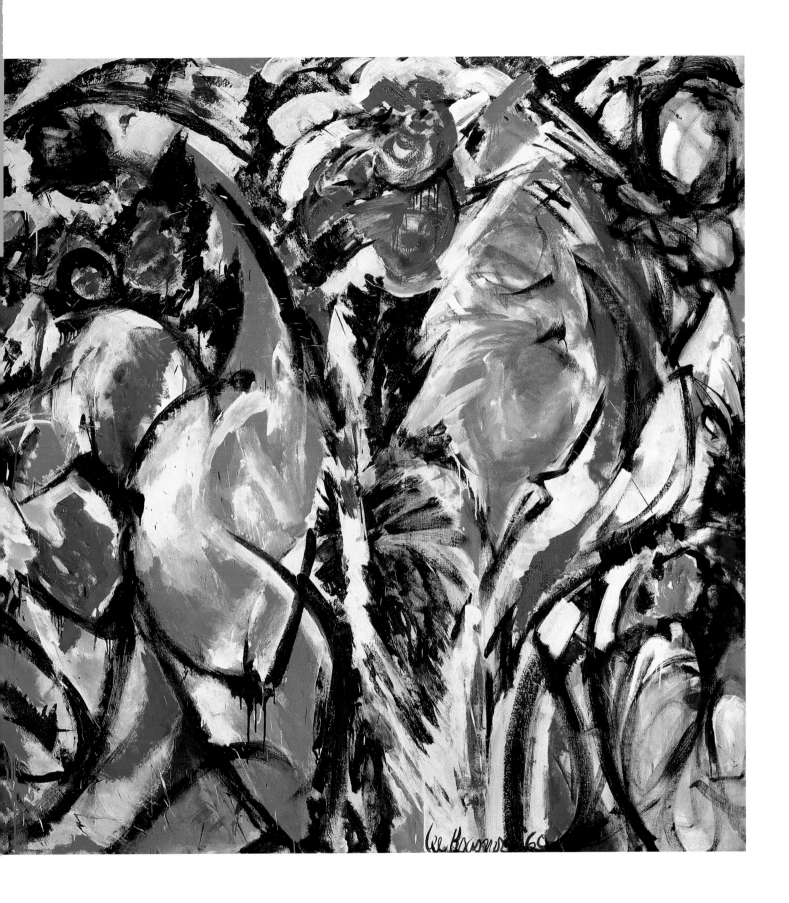

58. **Celebration** (formerly **Upstream #2**, 1957), 1960.
Oil on cotton duck, 92¼ x 184½ inches.
Private collection

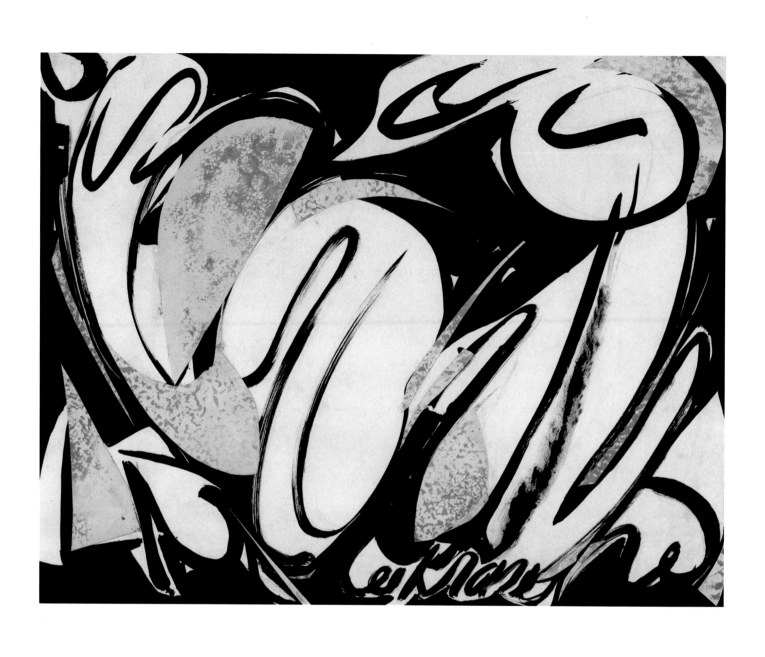

59. **Black, White and Pink Collage**, 1958–74.

Ink and collage on paper, 23 x 29 inches.

Pollock-Krasner Foundation, Inc., courtesy Robert Miller Gallery, New York

tears were literally pouring down."[175] Instead of invoking a holistic sense of self in this painting, Krasner presents fragmented images of herself in terms of (1) the signature and (2) the breastlike forms that occupy the position traditionally accorded flowers in a vase comprised partly of her signature. The artist's nature, which may be synecdochically connoted by the leaflike forms in this painting, is equated with the same scraggly indoor plant used for some of Krasner's circa 1940–43 Picasso-style still lifes (see *Untitled*, 1940; plate 12).

The fragmented realm of *Listen* is closely related to the Dionysian theme of self-sacrifice and dismemberment, coming before metamorphosis and rebirth. Despite its reduction to decoration, this still life correlates with Otto Rank's theory of creation through naming. As Rank explains:

> *the myths which deal with the creation of the world out of the human body are really speech-myths which represent man's conquest (that is, his creation) of the world by naming the objects (that is, by metaphorically expressing them through speech). This creative power of language . . . does not merely "tell" the myths, but forms them physioplastically . . . [since they] are only grand linguistic metaphors for this projection of the parts of the body onto the whole universe.*[176]

In *Listen*, however, Krasner's speech myth is transformed into a written myth: the creation of herself through her signature and breasts, but instead of comprising a new word and world, it conflates what is known, thus the imperative "[to] listen" as its title rather than the originary injunction "to name." A hybrid in this painting, Krasner must follow her own directive and respond to the voices of the acculturated selves comprising her. Although *Listen* might seem a "happy" picture as the artist suggests, it is not surprising that she cried when she considered the amputated breasts, the hothouse plant leaves, and the lack of connection with either an integral or self-sustaining nature that this work underscores.

Derrida conjectures that the incorporation of a signature in a work of art becomes a form of self-sacrifice in which a creative individual's identity loses its sovereignty as it is siphoned into the art. Although he describes a literary situation, his observation is equally applicable to art:

> *The law producing and prohibiting the signature (in the first modality) of the proper name, is that by not letting the signature fall outside the text any more, as an undersigned subscription, and by inserting it into the body of the text, you monumentalize, institute and erect it into a thing or a strong object. But in doing so, you also lose the identity, the title of ownership over the text; you let it become a moment or a part of the text, as a thing or common name.*[177]

Krasner's sadness in making *Listen* suggests an awareness of the necessary loss involved in consigning one's identity to a work of art. Once the work is finished, the umbilical cord is cut. Even when the painting is a constructed surrogate identity, as *Listen* evidently is, the new creation assumes an existence separate from the artist's.

Earth Green Series

Once posited as a compositional device in *Listen*, the artist's umber signature is abstracted even more in other Earth Green paintings where it serves as a subtext for potential meaning. This subtext is particularly important in such works as *Sun Woman I, Equation*, 1957 (plate 60), *Thaw*, 1957 (plate 61), *Cornucopia*, 1958 (plate 62), and *The Bull*, 1959 (plate 63).

In order to understand the interplay of language and imagery in these works, it helps to consider an ongoing discussion regarding the profusion of strange secular figures found in the marginalia of manuscripts dating from the first half of the fourteenth century that seem unconnected with the texts they decorate. As noted earlier, Krasner was a devoted follower of Meyer Schapiro, who wrote about these marginal figures on several occasions.[178] Her illumination of a poem by Frank O'Hara for the Museum of Modern Art publication *In Memory of My Feelings: A Selection of Poems by Frank O'Hara* (1967; plate 64), testifies to her own interest in manuscript marginalia and in the disjunction between words and images that can occur in such a genre, as does her later painting *Morning Glory*, 1982 (plate 65), which incorporates the title of Howard Moss's poem.

Krasner was particularly intrigued with manuscript illustrations as an art form.[179] In conversation with Munro, she reflected on the importance of the decorated sacred texts of her youth:

> *And then in the house there were plenty of Hebrew books. Bibles, the books you took to the synagogue. I was going to Hebrew school and working with those books. I don't remember clearly, but there may have been gold margins and big letters. Today, my orange and alizarin orange is my involvement with manuscripts and illuminations. Way, way back my involvement with them began.*[180]

Munro notes that "the love . . . [Krasner] felt for those compositions with streaks of color blazing through gray-black fields of handwriting would come out in her work."[181] Because of her great respect for Schapiro, coupled with her love of manuscripts, we may assume her familiarity with the debate regarding the role of secular imagery in sacred medieval manuscripts.

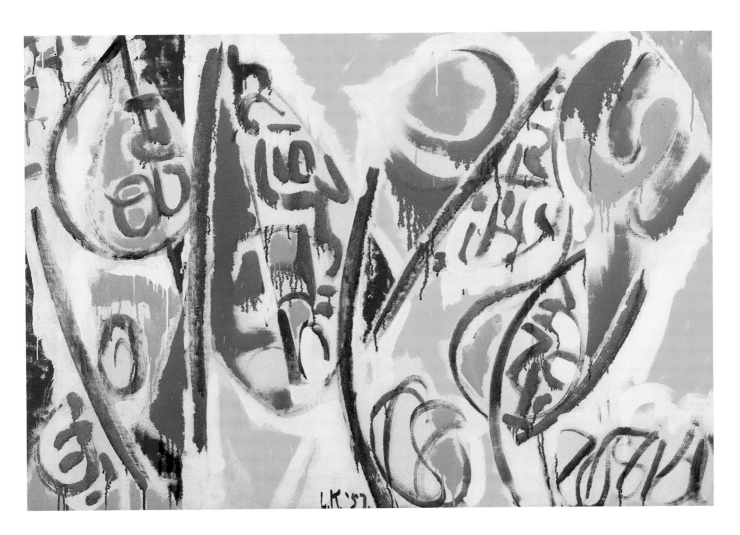

60. **Equation**, 1957. Oil on canvas, 39 x 58 inches.
Courtesy Robert Miller Gallery, New York

Schapiro believed that because the late Middle Ages had become
increasingly secularized, the often irreverent figures found along the
margins of important manuscripts reflected this new worldly attitude. A
confirmed formalist in spite of his Marxist sympathies, Schapiro pointed
out that sometimes medieval artists would incorporate in their work
portions of Arabic script that they found decorating Islamic objets d'art
"without consulting the possibly un-Christian sense of these inscriptions."[182]
On another occasion, when Schapiro tried to discover why Saint Bernard
of Clairvaux made such lucid and concrete denunciations against profane
images in sacred places (in his famous letter to the abbot of Saint-Thierry),
he concluded that Saint Bernard must have feared them because he was
susceptible to their power and beauty.[183]

While Schapiro may have laid out the problem for Krasner, her own
conflation of illuminated manuscripts in her paintings in which she joins

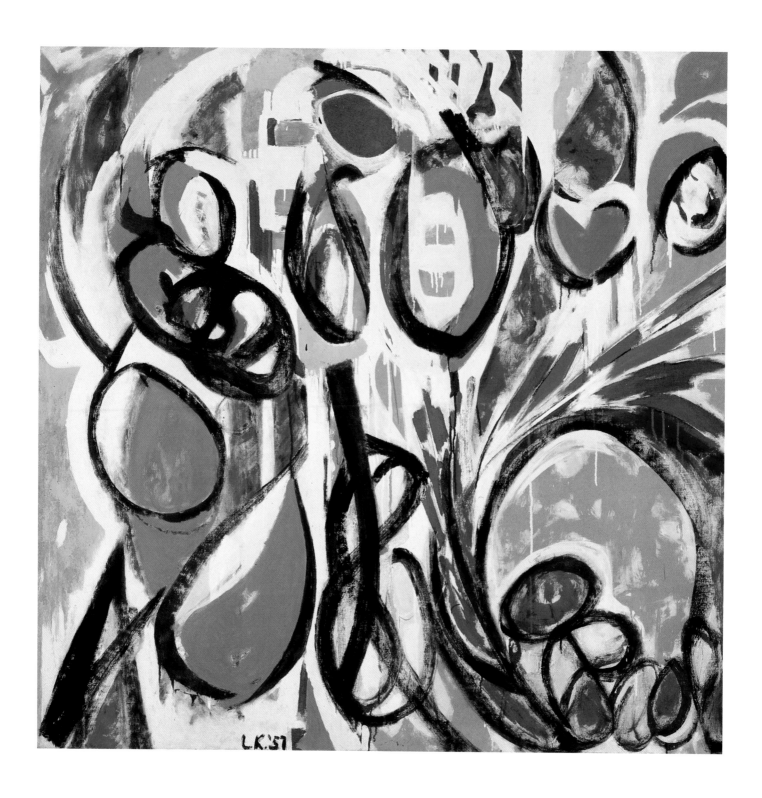

61. **Thaw**, 1957. Oil on canvas, 57 x 58¼ inches.
Collection of Roberta Rymer Balfe

Opposite: 62. **Cornucopia**, 1958. Oil on cotton duck, 90½ x 70 inches.
University Art Museum, California State University, Long Beach;
gift of the Gordon F. Hampton Trust, through Katherine H. Shenk,
Wesley G. Hampton, and Roger K. Hampton

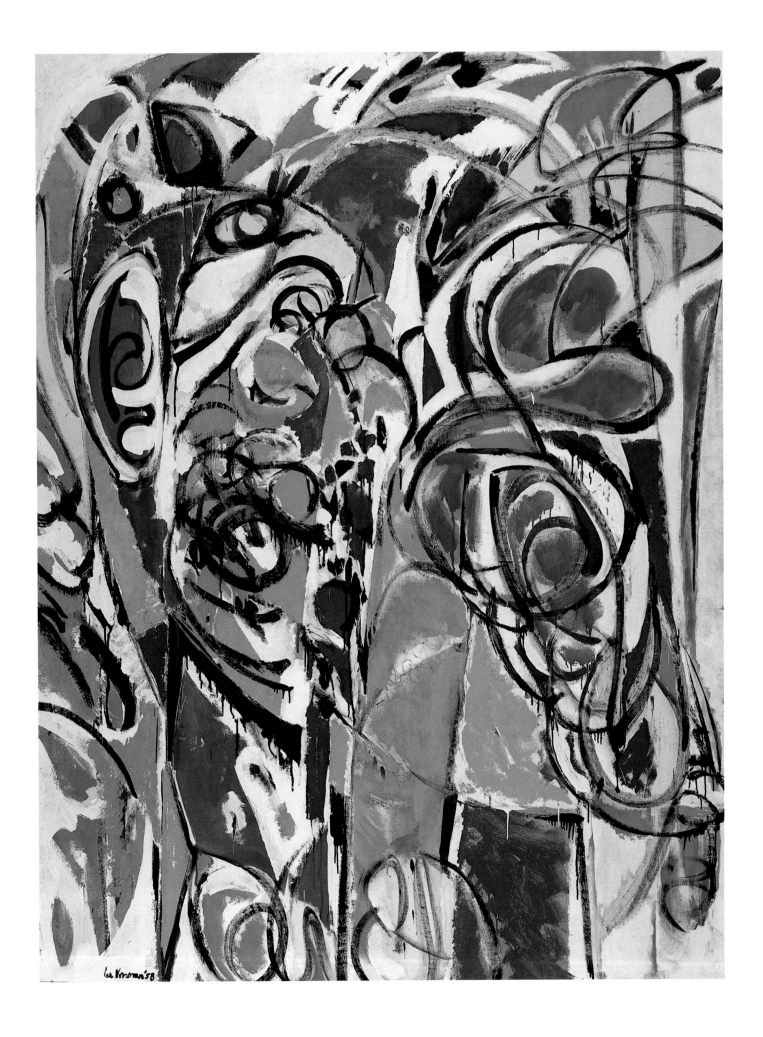

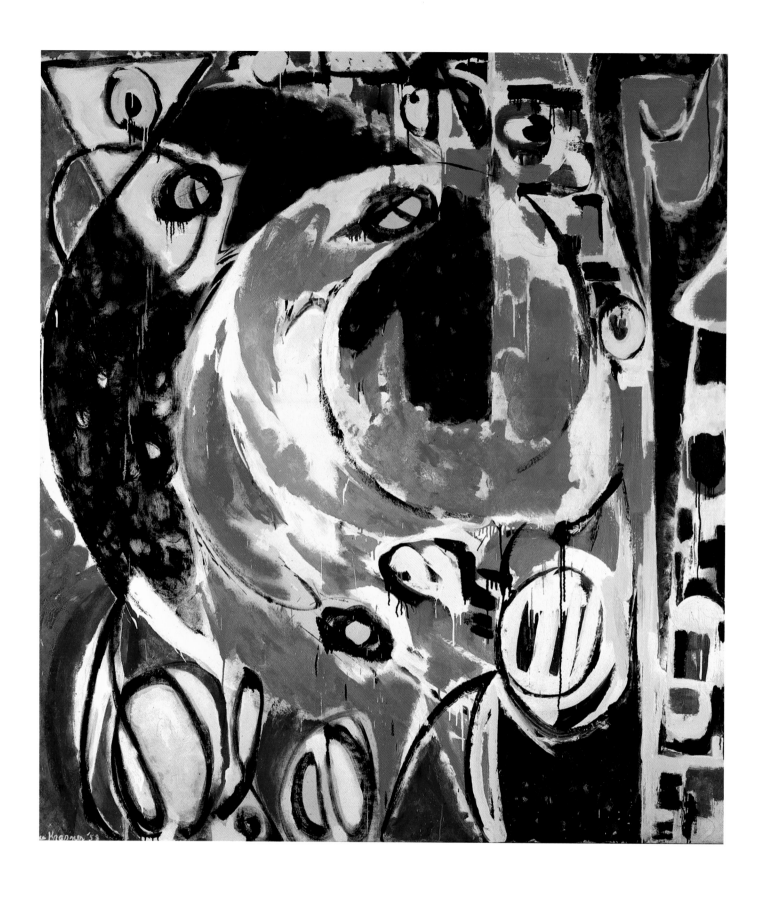

63. **The Bull**, 1959. Oil on canvas, 76½ x 70½ inches.
Collection Mr. & Mrs. Meredith J. Long

Poem

Light clarity avocado salad in the morning
after all the terrible things I do how amazing it is
to find forgiveness and love, not even forgiveness
since what is done is done and forgiveness isn't love
and love is love nothing can ever go wrong
though things can get irritating boring and dispensable
(in the imagination) but not really for love
though a block away you feel distant the mere presence
changes everything like a chemical dropped on a paper
and all thoughts disappear on a strange quiet excitement
I am sure of nothing but this, intensified by breathing

64. **In Memory of My Feelings**, 1967. Photolithograph on paper, 11 ¹⁵/₁₆ x 17 ¹⁵/₁₆ inches.
The Museum of Modern Art, New York; gift of the Museum of Modern Art
Department of Publications

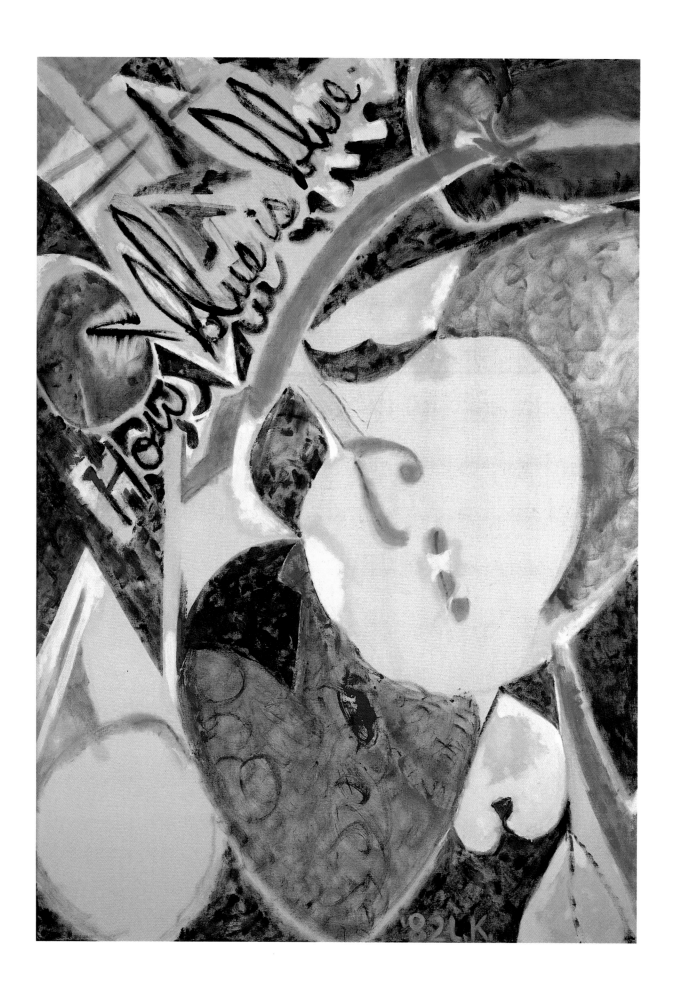

65. **Morning Glory**, 1982. Oil on canvas, 84 x 60 inches.

Pollock-Krasner Foundation, Inc., courtesy Robert Miller Gallery, New York

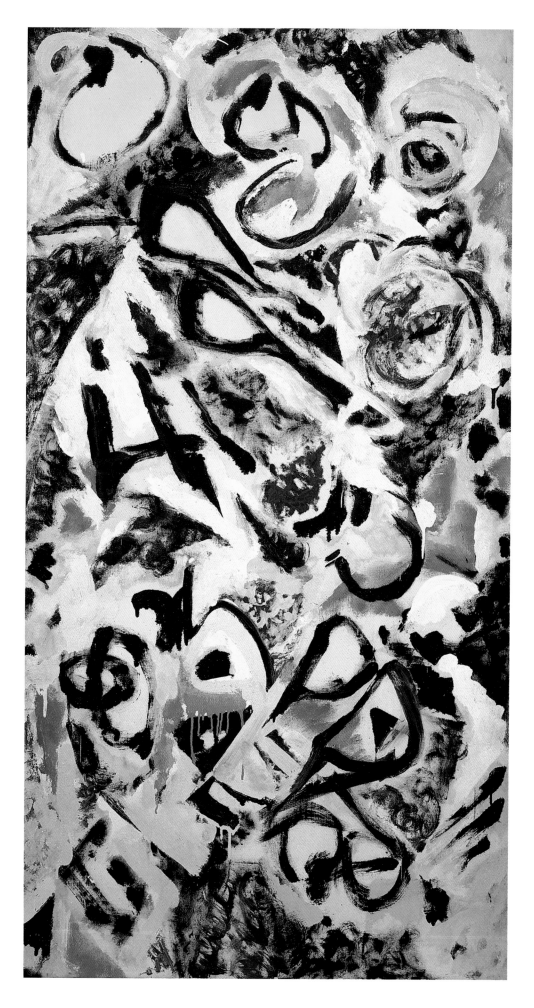

66. **Spring Memory**, 1959. Oil on canvas, 70 x 37 ½ inches.
Norfolk Southern Corporation, Norfolk, Virginia

words and images into new inextricable wholes similar to *Listen* may owe a much greater debt to Rimbaud's poetry than to Schapiro's art history. Soon after the death of Pollock, Richard Howard read aloud to her Rimbaud's *Illuminations* and *Season in Hell*.[184] Although he does not remember discussing the import of these works, Howard has recalled the intensity with which she listened to the poems.[185] Howard, who was beginning to establish an impressive reputation for himself not only as a poet but also as a premier translator of French avant-garde literature and key critical texts,[186] would have brought to his readings of Rimbaud as well as his discussions with Krasner an impressive erudition and breadth of knowledge that may well have contributed substantially to her rethinking of Rimbaud's theories, as her paintings of the late 1950s strongly suggest. Rimbaud had titled his collection *Illuminations* perhaps because of his background as a skilled Latinist, which had imbued him with a keen interest in the Middle Ages.[187] Consequently, he may have wanted his poems to be thought of in terms of the disparity between the inverted world of visual marginalia and the manuscripts that they decorated.[188] Others have treated these poems as only representing the colored plates his friend Verlaine suggested,[189] but we might see the discrepancy between the concrete descriptive adjectives Rimbaud preferred and the allusive incantations of phrases he permitted to surround them as a nineteenth-century poetic reworking of the improbable conjunctions of often licentious manuscript illuminations with sacred texts.

The obvious distinction between these concrete and abstract realms in Rimbaud's poetry creates a meditative and imaginative space analogous to the dissimilar universes presented in illuminated manuscripts.[190] Rather than describing the cosmological range from the heights of spiritual insight to the depths of the earth's lowest forms as Dionysius the Areopagite indicated, Rimbaud creates a disjunctive realm, full of gaps, that readers themselves must complete. Because of these breaks, texts never coincide with themselves, and a doubling of functions occurs whereby the lack of coherent images in Rimbaud's poems, coupled with the vivid and concrete images that he also provides, forces readers first to imagine a range of possible solutions and then to select from them a new interpretation that constitutes, in actual fact, a new poem. The new interpretation is then transferred back to Rimbaud's fragmented text and subsumes it, thus taking its place.

We might conjecture that, similar to Rimbaud's gap between concrete images and fleeting impressions, the gap between grotesqueries and the sacred texts they enframe provides spiritual adherents with the necessary space to create their own understanding of the relationship between earthly

and heavenly realms. After developing their own understanding of the universe, these worshipers then project it back on the illuminated manuscript and attribute their own interpretation to it rather than to themselves. This tripartite situation correlates with the breaks between writing and imagery in Krasner's work. Although entangled, they are never totally united, thus providing opportunities for imagining and then retroactively introjecting the products of these interpretive acts back on the work of art itself.

What this means in terms of Krasner's work is that unilateral interpretations are difficult to make and even such readings as the one proposed for *Listen* must remain conditional. Because disruption of traditional logic is crucial to the aesthetics of these works, they require an appreciation of dialectics without a desire to synthesize them into static wholes. Similar to a number of Krasner's best works, *Listen* seems poised between being made and starting to deliquesce. Its present status is conditional and almost miraculous, since change seems so much a part of its being. Its present alliance with the artist's name is a situation that appears on the verge of transformation, and thus one's interpretations also appear to be subject to change. We might say that instead of creating an art that only objectifies process, which it inadvertently does, Krasner creates paintings whose ostensible subjects are predicated on contingency, making both their current state and any ventured reading appear to be only momentarily applicable. Her means correlates with the definition of imagination provided by Samuel Taylor Coleridge who discussed the importance of creating images that are not easily verifiable. Emphasizing the importance of "hovering between images," Coleridge stated in his 1812 lecture on Shakespeare's *Romeo and Juliet*, "As soon as it [imagination] is fixed on one image, it becomes understanding; but while it is unfixed and wavering between them, attaching itself permanently to none, it is imagination."[191]

Krasner's thematized contingency is evident in the way she titled her works. Instead of beginning with a set idea, she waits until a given painting or group of paintings is complete and then sets out to title it or them in the company of a few trusted individuals, usually Sanford Friedman and Richard Howard. According to Friedman, Krasner would first talk about her work and free associate about it.[192] Howard has added that Krasner liked to see figures in her pictures almost as if she were looking at Rorschachs, and that Friedman too would find recognizable shapes in them.[193] After this period of free association, both men would suggest possible titles. Krasner liked hearing the possibilities; sometimes she would immediately close her eyes after hearing a suggestion and try to visualize it. If an idea clicked, she would accept it immediately, but just as often she would mull over a

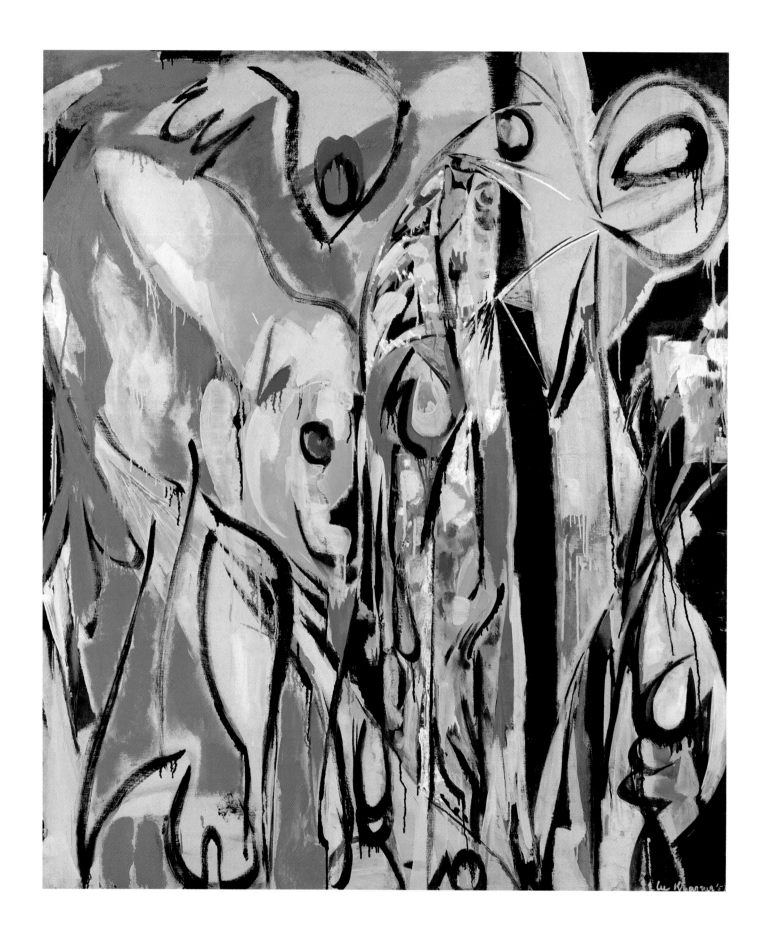

67. **April**, 1957. Oil on canvas, 68½ x 58¼ inches.
Private collection

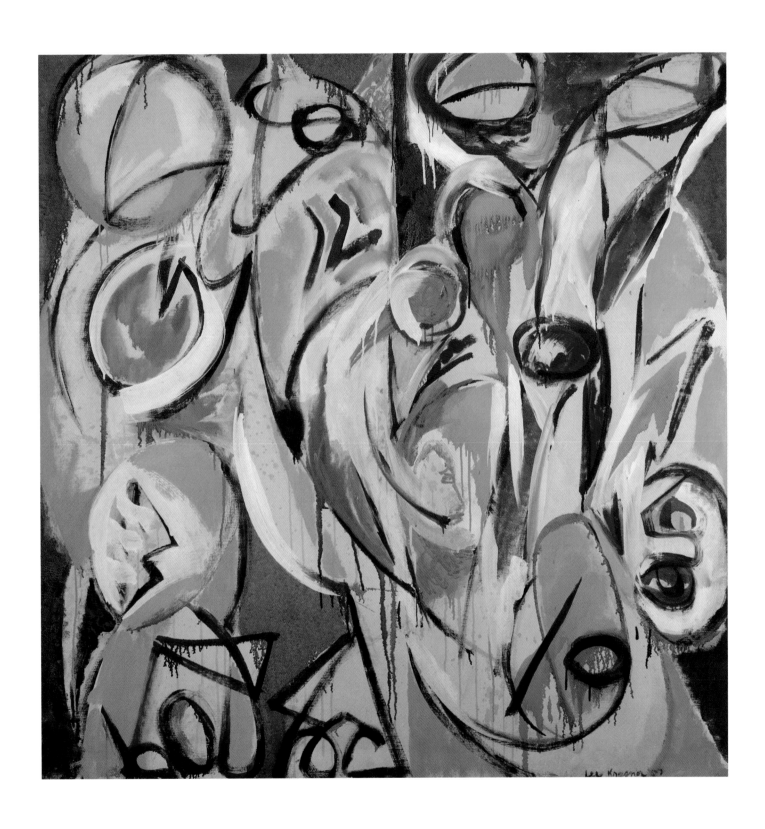

68. **Re-echo**, 1957. Oil on canvas, 59 x 58 ½ inches.
Collection of Michael Williams, The Ginny Williams Family Foundation, Denver

suggestion for several days. Not always reactive, Krasner sometimes came up with a title herself. The conversations were obviously important. Although Krasner later explained that "titling is never meant as an insight into the paintings. It's not a key for you, the observer, to enter the paintings,"[194] the seriousness with which she took the process of naming her works militates against such a statement, making it seem more a momentary lapse into formalist thinking than an ongoing, working premise for her art.

A substantial number of Krasner's Earth Green paintings, such as the two versions of Sun Woman, *The Seasons, Thaw, Cornucopia, The Bull,* and *Spring Memory,* 1959 (plate 66), were influenced either by discussions Krasner had with Sanford Friedman regarding Jane Ellen Harrison's book on Greek tragedy entitled *Ancient Art and Ritual,* which was part of the Pollock-Krasner library at The Springs, or by her own reading of it.[195] Friedman was fascinated with the book at the time, and remembers specifically using it as the basis for his suggested title *The Bull,* which Krasner readily accepted for a painting of 1959.[196]

In her book, Harrison sets herself the task of trying to understand why the Greek tragedies of Aeschylus, Sophocles, and Euripides were performed in Athens in early April at the Great Dionysian festival. Intrigued with Plato's passing reference that the birth of Dionysus is called a "dithyramb" and with Aristotle's observation that tragedy began with leaders of the Dithyramb, Harrison examines the meaning of this term and discovers that the Greeks of the classical period no longer knew that it referred to spring songs and frenzied dances. Puzzled also by Pindar's query in one of his odes, "Whence did appear the Graces of Dionysus/With the Bull-driving Dithyramb?",[197] she reasons that the Graces are the seasons, and that for the ancient Greeks the main season of the year is spring.[198]

She then explains that each year a bull is selected either in the fall or in the spring (Harrison is not sure when) to live a sanctified life in which he is entrusted with safeguarding the people's future. In early April on the day before performances of the tragedies begin, this special animal is sacrificed. As Harrison observes:

He dies because he is so holy, that he may give his holiness, his strength, his life, just at the moment it is holiest, to his people. The holy flesh is not offered to a god, it is eaten ... by each and every citizen, that he may get his share of the strength of the Bull, of the luck of the state.[199]

In Athens, this Bouphonia, or annual ox-murder, was followed by an additional ritual in which the hide of the bull was stuffed with straw, sewn up, and hitched to a plough as an image of resurrection and a symbolic means of ensuring continuity and fertility.[200]

Since the Dithyramb, according to Harrison, is the song of rebirth,[201] we might hypothesize that after Pollock's death, the Earth Green series became a form of willed rebirth for Krasner which she invoked through a series of titles referring to Harrison's text, including the cycle of *The Seasons*, especially *Spring [Memory]*, with an emphasis on *April*, 1957 (plate 67) [which is related to *Re-echo*, 1957 (plate 68)]. Spring is the season of the great *Thaw* when the resurrection festival begins. *The Bull*, the tragic hero, makes the new year possible. Tangential to Harrison's theories is her observation that the sun, which is reborn at the winter solstice,[202] initiated the seasons.[203] This concept may have been a factor in the naming of *Sun Woman I* and *Sun Woman II*.[204] And the title *Cornucopia*, which actually is associated with the horn of the goat symbolizing the infant Zeus's nurse, can be connected with the abundance provided through proper observance of spring rituals.

Umber and White Series (The "Night Journeys")

In 1959 Lee Krasner had reason to be exuberant about her career because she, together with her nephew Ronald Stein, completed two monumental mosaic murals for the front and back of 2 Broadway in New York City, designed by Emery Roth & Sons for Uris Buildings Corp.[205] Its vice president, B. H. Friedman, Sanford Friedman's brother, had commissioned the pieces. But that same year her mother died, and Krasner found herself moving in the new direction of her Umber and White series. Krasner consciously connected the first piece in the series, *The Gate*, 1959 (plate 64), with her mother's recent death.[206] The full-blown expressionist style of this piece and related works such as *Fledgling*, 1959 (plate 70), *Triple Goddess*, 1960 (plate 71), and *Primeval Resurgence*, 1961 (plate 73), moved counter to the newest art world trends that were heading in the direction of the Color Field painting Clement Greenberg was then championing.[207] So Abstract Expressionist were these works that many people remarked when they were first exhibited at the Howard Wise Gallery in successive exhibitions in 1960 and 1962 that Krasner was "being influenced by Jackson from beyond the grave, and that these paintings were very much dictated by the spirit of late Pollock work."[208]

In the course of painting the Umber and White series, Krasner suffered from insomnia:

> *I was going down deep into something which wasn't easy or pleasant. In fact I painted a great many of them because I couldn't sleep nights. I got tired of fighting insomnia and tried to paint instead. And I realized that if I was going to work at night, I would have to knock color out altogether, because I wouldn't deal with color except in daylight.*[209]

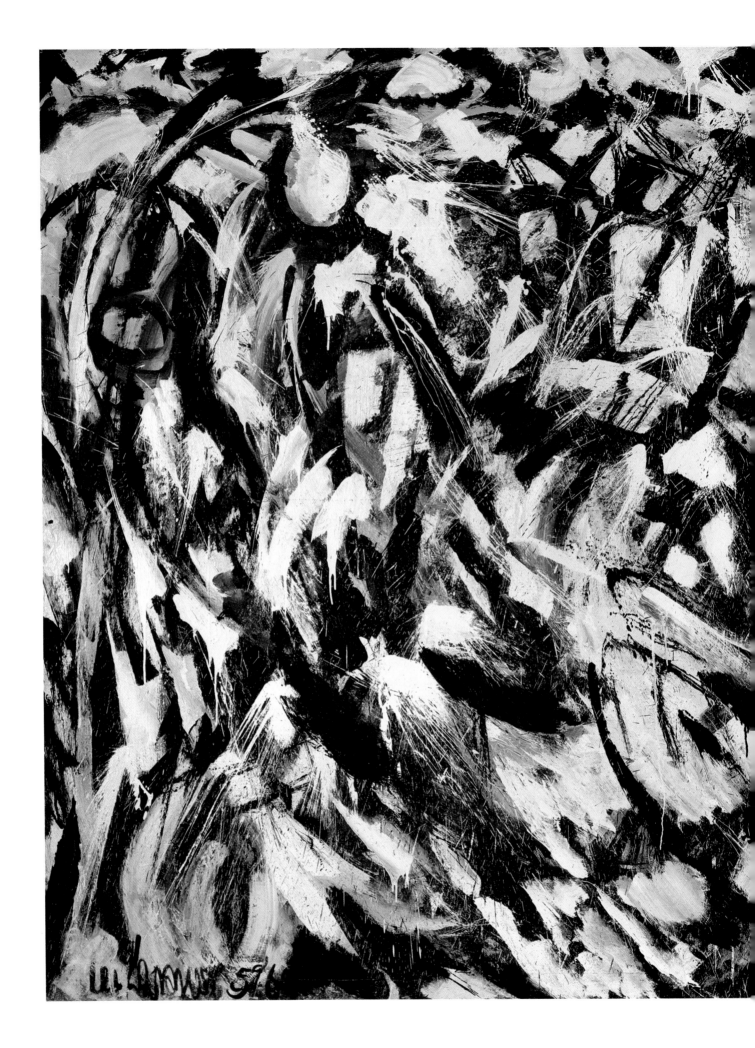

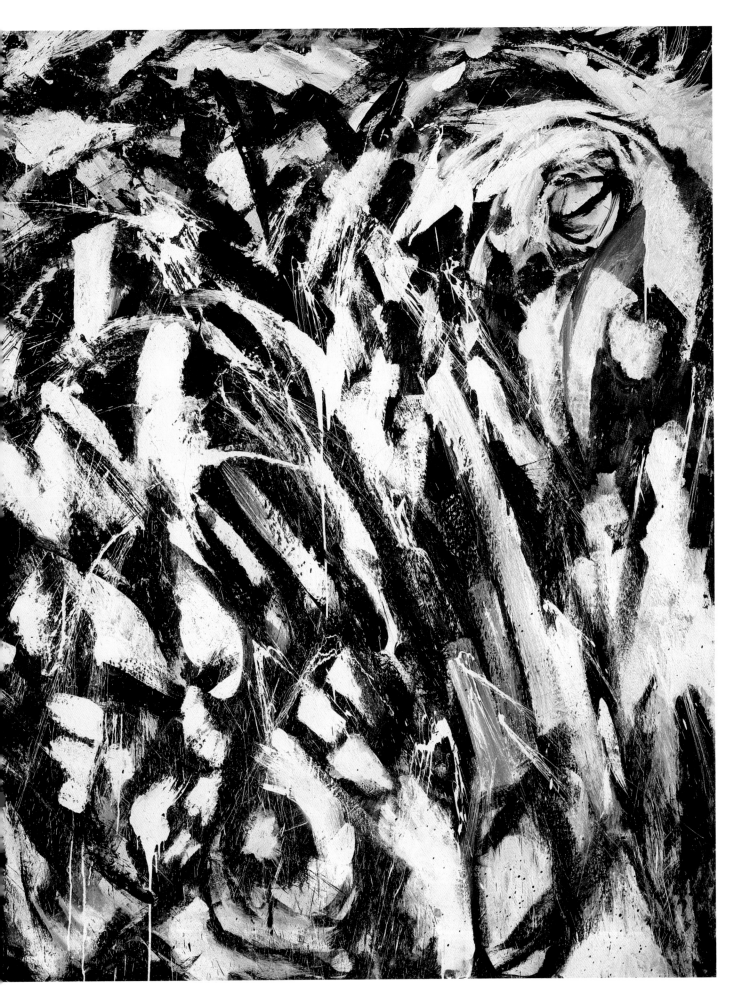

69. **The Gate**, 1959. Oil on canvas, 91⅞ x 145½ inches.
Private Collection

She reaffirmed this imagery of sinking into lower depths when she said to Howard later in this same interview, ". . . it's as though you were descending once more, bringing forth from the unconscious, subconscious, or whatever area you bring forth from, as one does in a dream."[210]

Seventeen years after completing the series, both she and Howard used the more apt appellation "night journeys" to refer to the Umber and White series.[211] Although Howard connects these paintings with the traditional biblical descent into hell, he might also have associated them with Rimbaud's *A Season in Hell* that he had recently read to Krasner. Rimbaud's biographer Enid Starkie elaborates on this symbolic opening of oneself to an internal underworld that the great hermetics made:

> *For alchemists the descent into Hell was symbolical for the descent into oneself. This is a terrifying experience and there is the psychological danger of the complete dissolution of the human personality, disintegration. Rimbaud's* Saison en Enfer *was the record of such a descent into himself and with him there was the danger of this disintegration of his personality, but he rose in the end victorious. According to the alchemists the Hermetic Philosopher makes this descent as a "redeemer."* [212]

"So they [Krasner's *Umber* paintings] are night journeys," Howard concludes, and then elaborates, "There is a category of experience that in Hebrew mythology is in fact called a night journey, a descent down into the darkness."[213] One of the titles, in fact, *What Beast Must I Adore?*, 1961, is taken from the line of Rimbaud's *Season in Hell* that Krasner had written on the wall in her East Ninth Street studio in the late 1930s.

Another literary title for the series comes from the first line of Ralph Waldo Emerson's "Circles." In this essay and the related "Self-Reliance," the optimistic New England transcendentalist regards even tragic human experiences as evidences of growth in which people are being asked repeatedly to break free of conditioned responses to life in order to enter ever increasing, wider spheres of understanding:

> *Every ultimate fact is only the first of a new series. Every general law only a particular fact of some more general law presently to disclose itself. There is no outside, no enclosing, no circumference.* [214]

Emerson's belief in life's necessary contingency would have resonated with Krasner. "There are no fixtures in nature," Emerson explains. "The universe is fluid and volatile. Permanence is but a word of degrees. Our Globe, seen by God, is a transparent law, not a mass of facts. . . Every thing looks permanent until its secret is known. . . . Permanence is a word of degrees. Every thing is medial. . . . The life of man is a self-evolving circle."[215]

Despite the optimistic tone of Emerson's writing, Krasner's use of his sentence, "The eye is the first circle," as the title for an Umber painting of 1960 (plate 72), should not be taken as simply an uplifting affirmation of the artist's essential quest to prioritize vision. Given the previous discussion of the evil eye, and the number of eyes emerging from the cascading waves of loosely brushed and flung paint making up this work that suggest a range of viewpoints, we might conjecture that the eyes, punning, the shifter "I," undermine a unitary self and also posit the work of art as a multifaceted consciousness that looks back at viewers, appraising and inter-rogating them. It is worth noting that the artist remembers only seeing the eyes after the painting was done [216] and thus was initially unaware that her work was appraising her.

In line with the Rimbaudian interpretation ventured earlier in which the poet provides openings for readers' projections, we might say that Krasner's painting establishes gaps between process and vision so that one is caught in a house of mirrors and sees oneself being seen. However, this mutual looking, caught up in whirlwinds of change, appears to be only an accident of chance, giving one a momentary glimpse of an ongoing mutually reflexive process whereby art and life mirror and interrogate one another. *The Eye Is the First Circle* could be an acknowledgment of the breakup of the *primum mobile*. Because of the act of consciousness, represented by the many eyes in the painting—the shifter-like positions of the seer and the seen, the artist and her work, as well as viewers and their self-conscious looking—observers are forced to acknowledge their assumed unity as merely a hypothetical construct that the many painted eyes begin to break up as they regard them from distinctly different perspectives. The result may well be a shattering of the ego as one's self is viewed as another. This breakup of the self exhibits definite affinities with the Sullivanian belief that one's personifications—the stereotypical views of oneself and others that regulate one's dynamisms (characteristic patterns of interaction)—must be periodically reevaluated and reframed.

Although Krasner excuses herself for limiting her palette to umber, black, and white in the Umber and White series because she was working at night under artificial light rather than during the day as had been her custom,[217] her restricted palette throughout the entire series appears to have been indebted to the heretofore unrecognized source of the first color publication of the Lascaux cave paintings in 1955 by Albert Skira for his series entitled *The Great Centuries of Painting*.[218] Skira's book, containing lavish hand-tipped color plates and titled *Lascaux or The Birth of Art*, featured a text by French theorist Georges Bataille. Although Howard

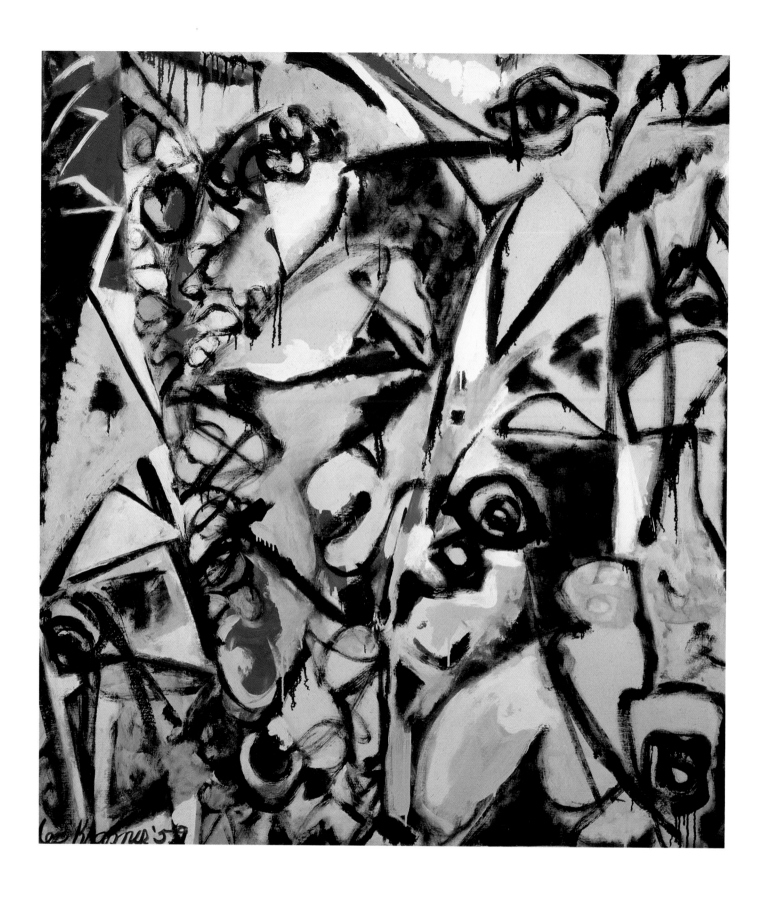

70. **Fledgling**, 1959. Oil on canvas, 64 x 58 inches.
Private collection

Opposite: 71. **Triple Goddess**, 1960. Oil on canvas, 86 x 58 inches.
Pollock-Krasner Foundation, Inc., courtesy Robert Miller Gallery, New York

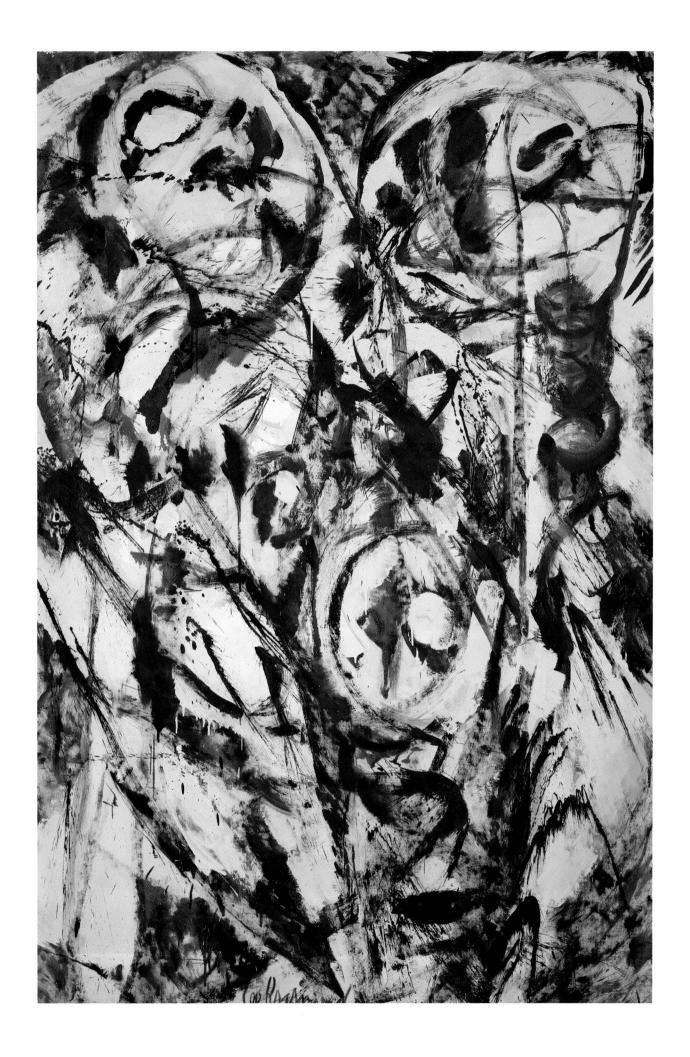

remembers Krasner owning a copy of this publication, he doubts that she read it.[219] But the internal evidence of the paintings themselves strongly suggests her familiarity with Bataille's text.

Discovered by four Montignac boys on September 12, 1940, the Lascaux cave paintings were soon heralded as the greatest known Paleolithic works. They date from the Aurignacian period, which is also known as the Upper Paleolithic, Leptolithic, or, more simply, Reindeer Age, and were created by Cro-Magnons.

In his text, Bataille builds a case for the cave paintings as the first evidence of the prototype of modern *Homo sapiens* and even conjectures that in modern dress Cro-Magnons would blend into a twentieth-century crowd of people.[220] This comparison with modern life is essential, since Bataille wishes to propose Lascaux as the absolute beginning of humankind as we now understand it:

> *"Lascaux Man"* created, and created out of nothing, this world of art in *which communication between* individual minds begins. *And thus Lascaux Man communicates with the distant posterity today's mankind represents for him—he speaks to us through these paintings, discovered only very recently and unaltered after that seemingly interminable space of time. . . .*
> *Following along the rock walls, we see a kind of cavalcade of animals. . . .*
> *But this animality is nonetheless* for us *the first sign, the blind unthinking sign and yet the living intimate sign, of* our *presence in the real world.*[221]

For Bataille, the significance of the cave paintings is that they provide us with the first view of humanity's inner life. He relates that the paintings broke away from the long night of *Homo faber* coming before the dawn of *Homo sapiens*, writing "the night of time through which it comes is pierced by no more than uncertain glimmers of faint light."[222] He discusses how the works were created in the semidarkness of lamplight. In line with his overall interest in life as a necessarily transgressive series of acts in which taboos must be broken, Bataille discusses the paintings of Lascaux as a "sunrise," a breaking with the "element of prohibition which, it seems, like the awareness of death, has its beginnings *in the night-time.*"[223]

No doubt impressed by Bataille's poetic evocation of the first *Homo sapiens* transgressing the dark night preceding their evolvement, Krasner's Umber and White series poetically and literally evokes this darkness coming before creation when she decides to work at night rather than during the day. But instead of hailing the daytime of humanity's inspiration, which Bataille connects with Greek art, Krasner opts for the liminality suggested in *The Gate*. In this work, she comes closer than she ever does before or after to subscribing to the conviction of some Abstract

Expressionists that they can return to a primal moment without either the trappings or the enormous baggage of civilization. What saves these works from becoming merely sentimental evocations of the dawning of human consciousness are the many eyes seeded throughout them, sometimes barely visible like the eye in the upper right of *The Gate*, but often unmistakably apparent as in *Night Watch*, 1960 (plate 74), a work no doubt named after the Rembrandt painting, which reappeared in the early 1950s in a fresh light due to its postwar conservation and cleaning. These eyes appearing at the threshold of consciousness reinforce the idea of an already populated world akin to the cities Adam and his family encountered soon after exiting Eden, thus establishing the actuality of entering Western civilization at a late date rather than invoking the myth of beginning.

On December 25, 1962, Krasner suffered a brain aneurysm that effectively concluded her Umber and White series even though she had already started to move in the new direction documented by *Untitled (White Light)*, 1962 (plate 75), which closely approximates Pollock's drip paintings. Despite a number of setbacks over the next two years, including a broken arm in the summer of 1964, followed by another serious illness that year, Krasner continued painting, even learning to work with her left hand. A number of works from 1963 belie the difficulties Krasner was experiencing since they are lyrical, abstracted visions of nature. The all-over painting *Eyes in the Weeds*, 1963 (plate 76), exemplifies this trend.

Dissonant Color and Lettuce Leaves

In 1965 Krasner regained the force of the Umber and White series when her health improved, and she helped curator Bryan Robertson complete his preparations for a major showing of her work at London's Whitechapel Gallery. During that year, her major works are predictably Janus-faced, recapping in *Combat*, 1965 (plate 77), the great sweeping energies of the Umber paintings and the limited palette of this group of paintings in *Kufic*, 1965 (plate 78), while initiating a new interest in dissonant hues in the former and an emphasis on calligraphy in the latter. Unlike most early twentieth-century avant-garde artists, who have preferred traditional color harmonies, a number of advanced musicians and writers have experimented with the aesthetic potentials of dissonance in their music and sound poetry. Krasner's analogous exploration of unsettling color combinations has placed her firmly in this highly innovative and experimental category that she shares with few other painters. Although liberal passages of white open the composition of *Combat* and relieve some of the intensity created by its overheated red and orange hues, they do not compromise Krasner's

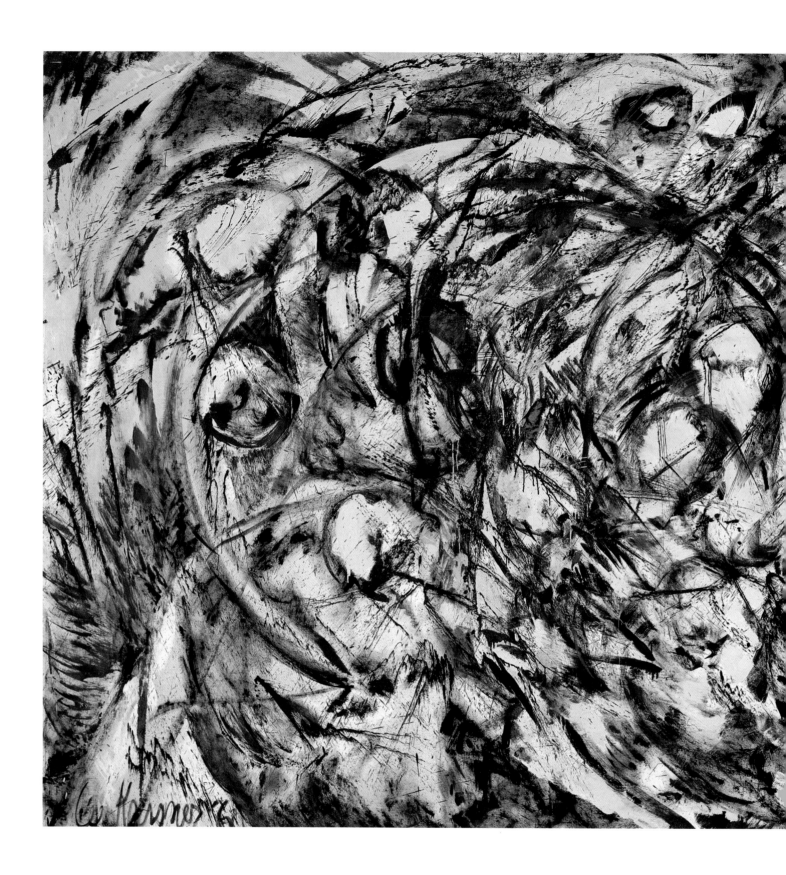

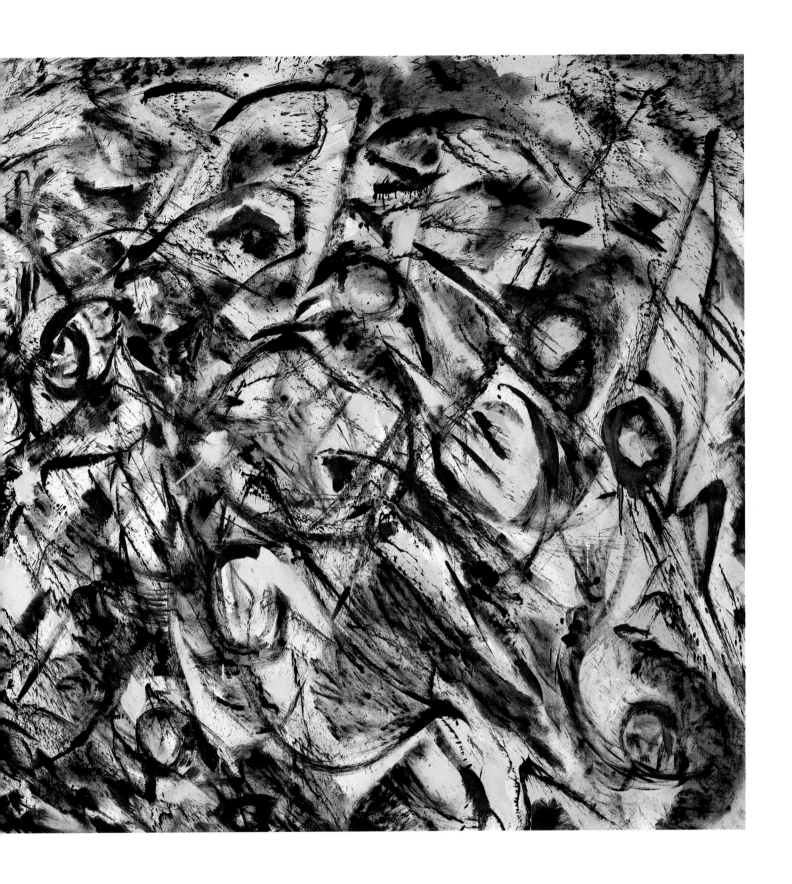

72. **The Eye Is the First Circle**, 1960. Oil on canvas, 92¾ x 191⅞ inches.
Courtesy Robert Miller Gallery, New York

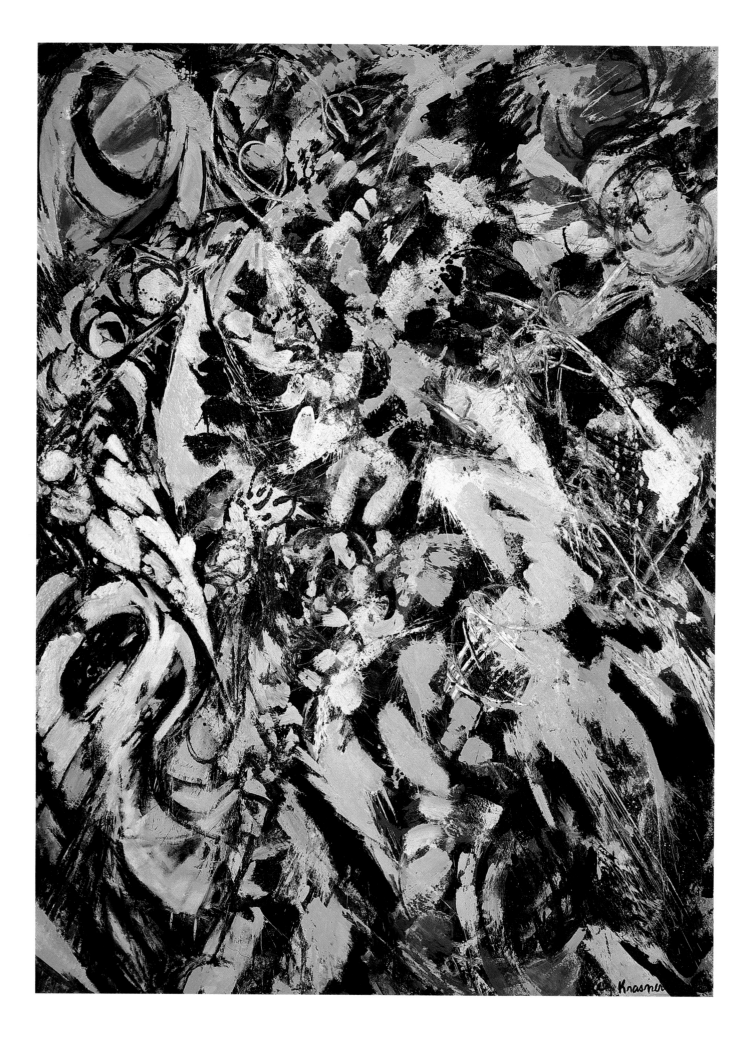

initial decision to make a more than thirteen-foot long painting with such a fierce combination of colors. Further experiments with cacophonous colors include *Gaea*, 1966 (plate 79), mother earth without the requisite green, and *Pollination*, 1968 (plate 83), while she continued to explore traditional color relationships in Towards One, 1967 (plate 80), and *The Green Fuse*, 1968 (plate 84).

For this first retrospective, Krasner provided a statement that poetically underscores her denial of both an essential self and an integral style even though on first appearance her analogy seems to support the opposite conclusion. Reproduced on a separate page beneath Charles Eames's photograph of her, Krasner's statement concludes this catalogue that represented a general stocktaking of her work. "Painting, for me," she began, "when it really 'happens' is as miraculous as any natural phenomenon— as say a lettuce leaf. By 'happens,' I mean the painting in which the inner aspect of man and his outer aspects interlock." She elaborated on her initial idea by stating, "One could go on forever as to whether the paint should be thick or thin, whether to paint the woman or the square, hard-edge or soft, but after a while such questions become a bore. They are merely problems in aesthetics, having only to do with the outer man.

But the painting I have in mind, painting in which inner and outer are inseparable," she emphasized, "transcends technique, transcends subject and moves into the realm of the inevitable—then you have the lettuce leaf." [224]

Taken on face value, the statement would appear to support a belief in an essential self in which inner and outer worlds reinforce opposite sides of a permeable membrane, representing the artist's inner and outer worlds. But if one considers a lettuce leaf as a fragile element of a larger entity, then each internally and externally consistent leaf, which might be construed as synonymous with one of Krasner's discrete styles, is broken away, one after another, over a period of time. Because Krasner's metaphor is so remarkable, one wonders about its source, and the most convincing candidates are the series of photographs of cabbage leaves that Edward Weston made in 1931 and exhibited in New York soon thereafter. [225] These sensuous, undulating shapes, looking very much like lettuce, are beautiful in their fragility and transience, each discretely unified and each self-consistently seeming to support an essence that differs, however, with each successive image in the series.

Opposite: 73. **Primeval Resurgence**, 1961. Oil on canvas, 77 x 57½ inches. The Museum of Contemporary Art, Los Angeles, gift of Gordon F. Hampton

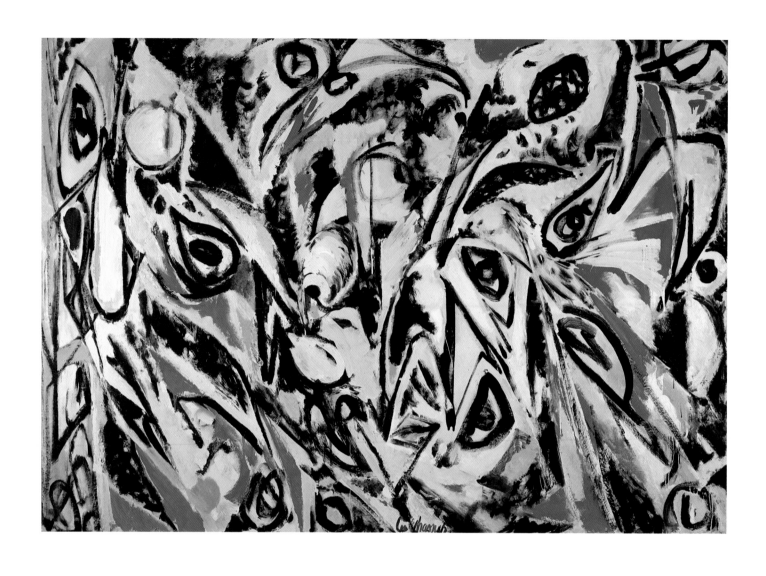

74. **Night Watch**, 1960. Oil on canvas, 70 x 99 inches.
Collection of Jane Lang Davis

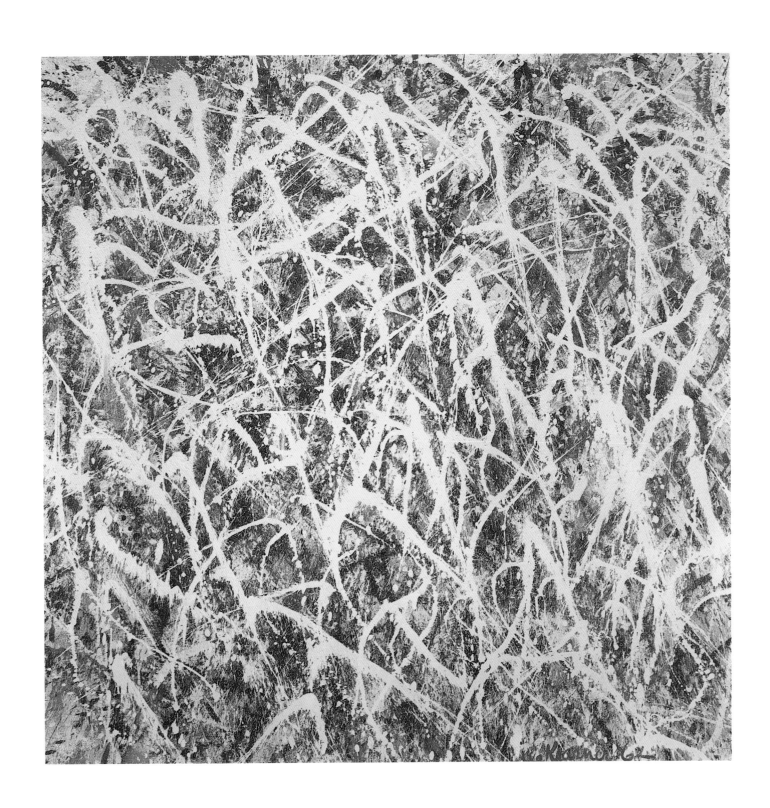

75. **Untitled (White Light)**, 1962. Oil on canvas, 57 ½ x 58 ½ inches.
Collection of Rena "Rusty" Kanokogi

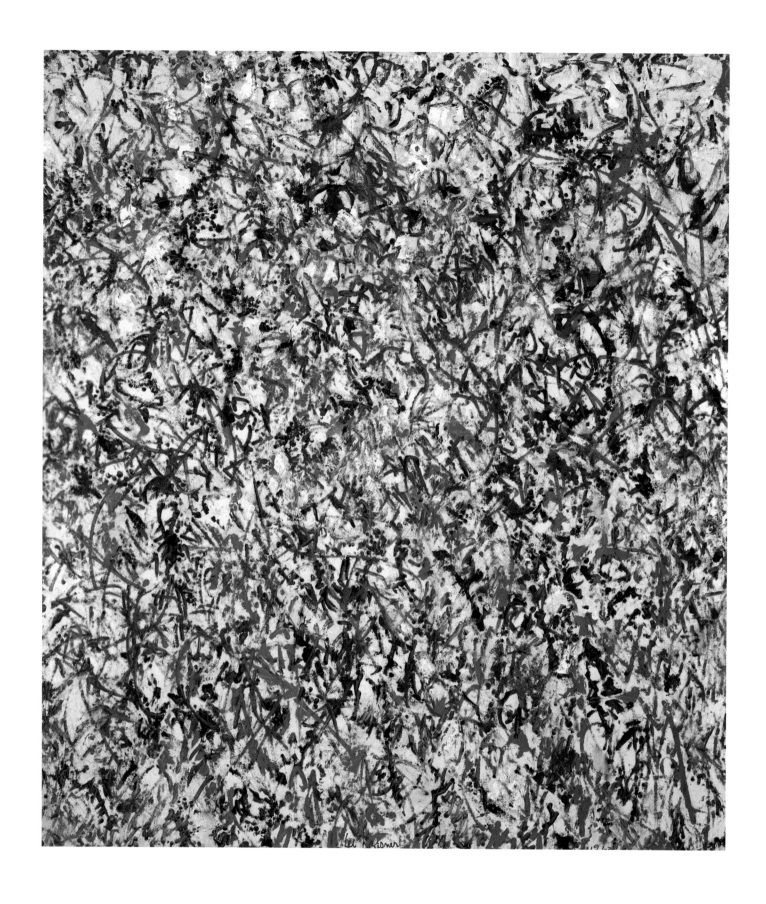

76. **Eyes in the Weeds**, 1963. Oil on canvas, 64 x 57 ¼ inches.
Pollock-Krasner Foundation, Inc., courtesy Robert Miller Gallery, New York

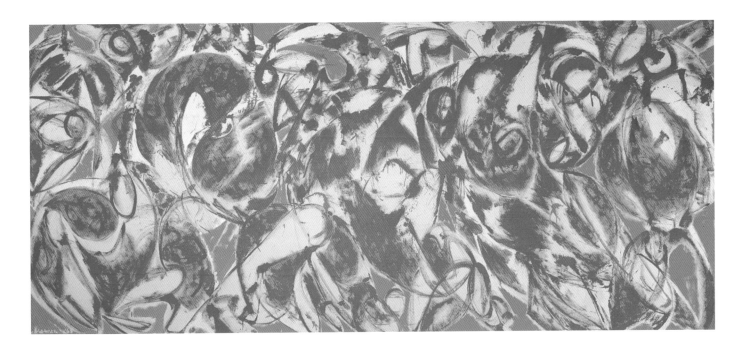

77. **Combat**, 1965. Oil on canvas, 70 ½ x 161 inches.
The National Gallery of Victoria, Melbourne, Australia

78. **Kufic**, 1965. Oil on canvas, 81 x 128 inches.
Pollock-Krasner Foundation, Inc., courtesy Robert Miller Gallery, New York

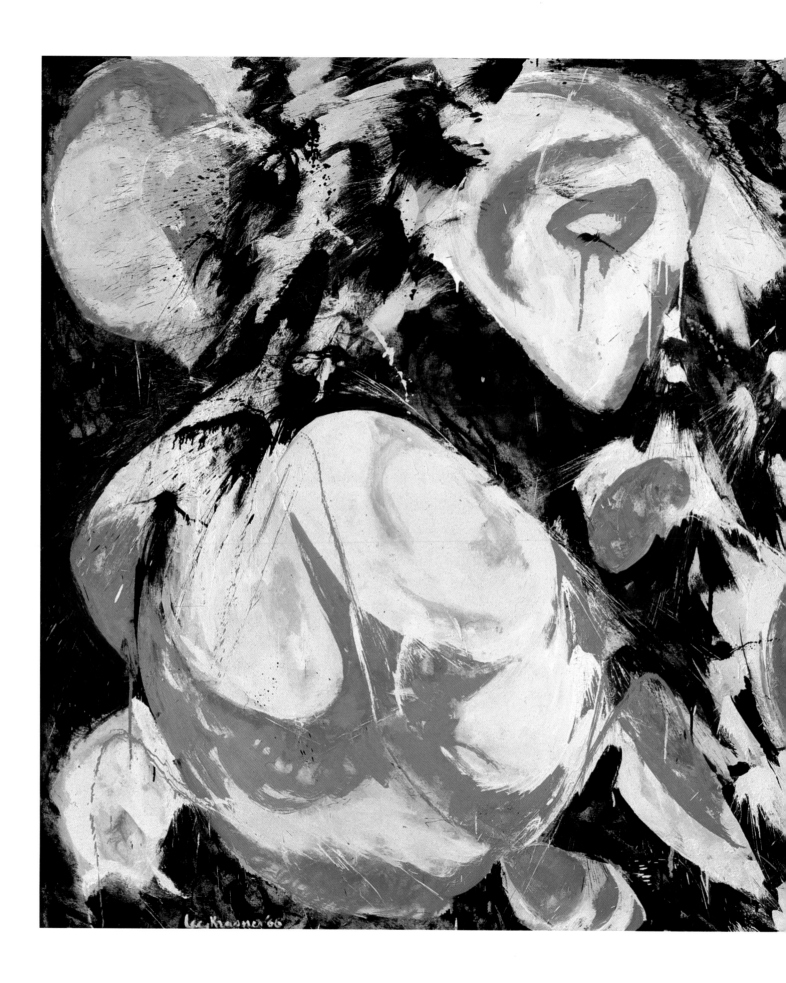

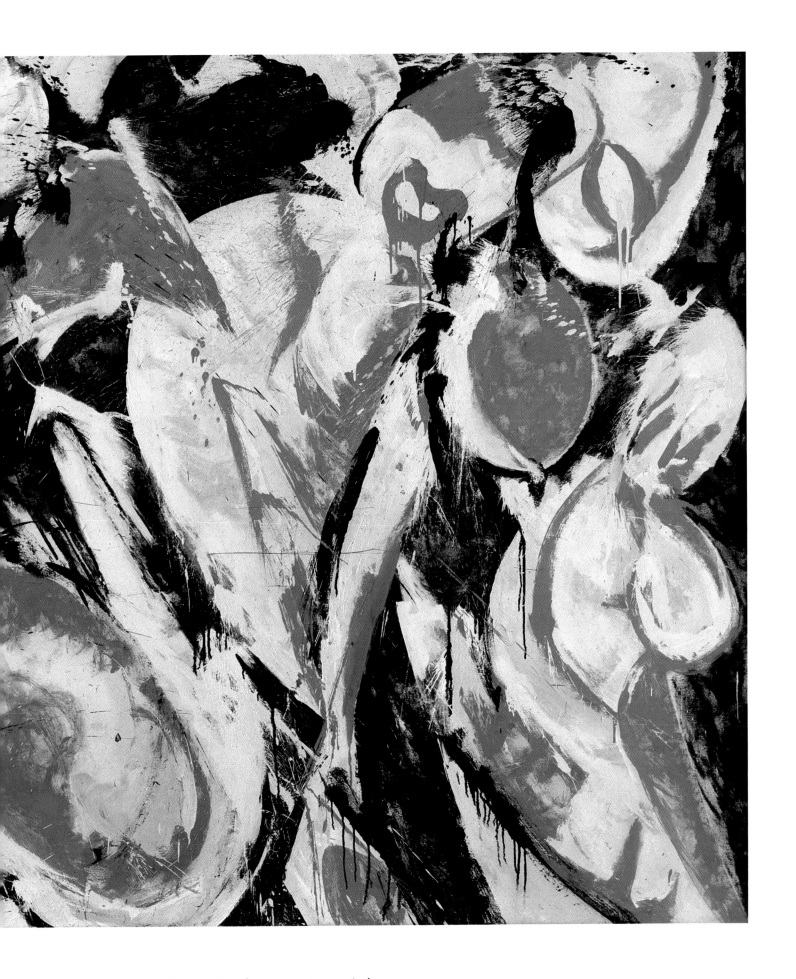

79. **Gaea**, 1966. Oil on canvas, 69 x 129 inches.
The Museum of Modern Art, New York, Kay Sage Tanguy Fund

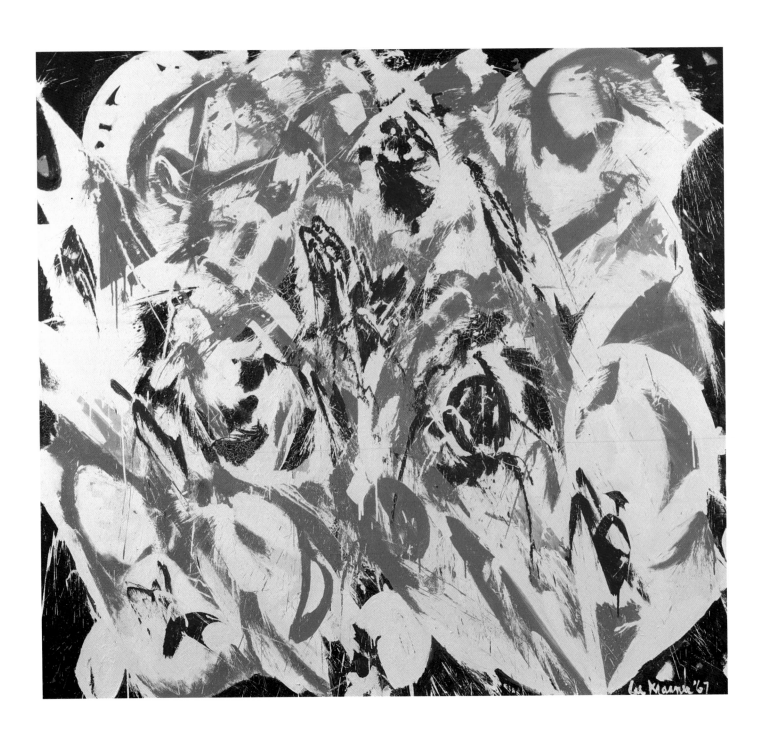

80. **Towards One**, 1967. Oil on canvas, 68½ x 74¼ inches.
Indianapolis Museum of Art; gift of the Herron Museum Alliance

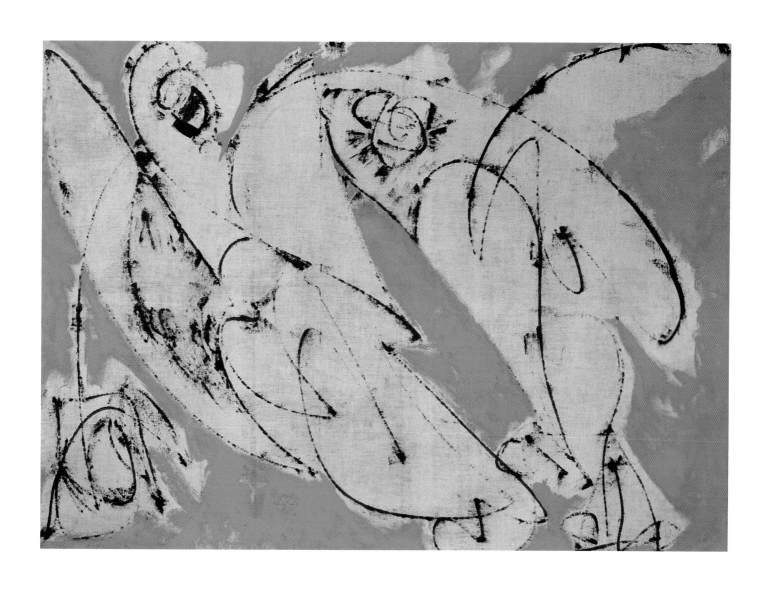

81. **Courtship**, 1966. Oil on canvas, 51 x 71 inches.
Private Collection

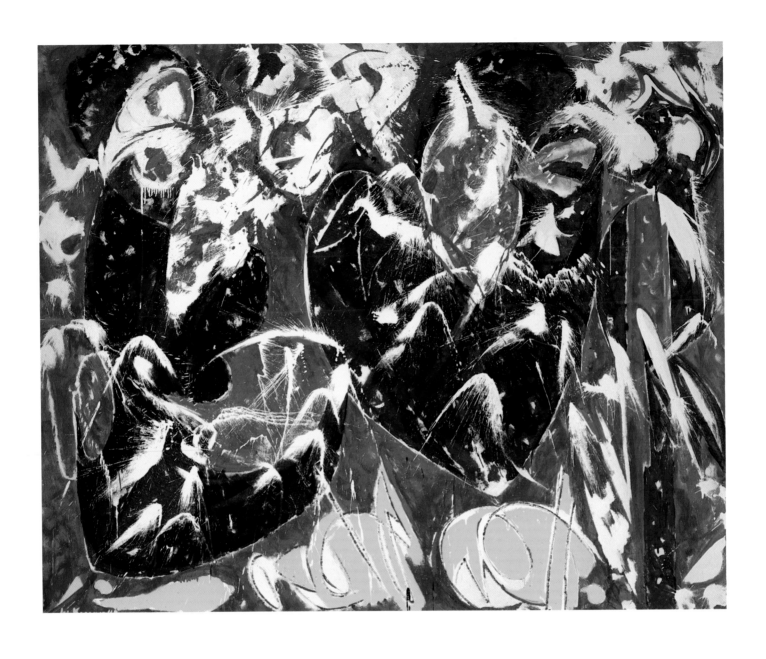

82. **Uncial**, 1967. Oil on canvas, 68 x 85 inches.
Collection of Dr. & Mrs. Jerome Hirschmann

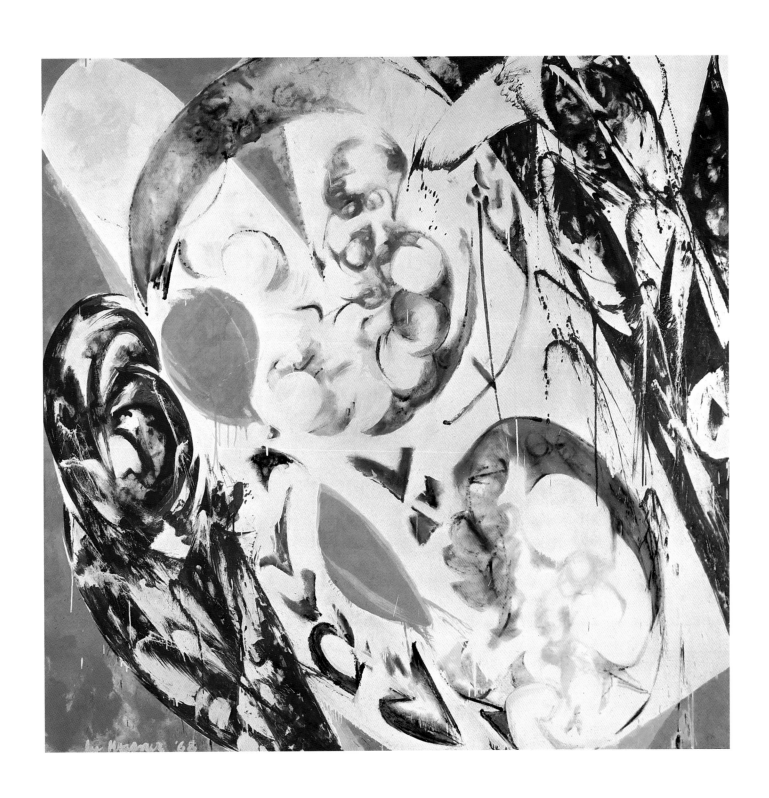

83. **Pollination**, 1968. Oil on canvas, 81¼ x 83 inches.
The Dallas Museum of Art; gift of Mr. & Mrs. Algur H. Meadows
and the Meadows Foundation, Inc.

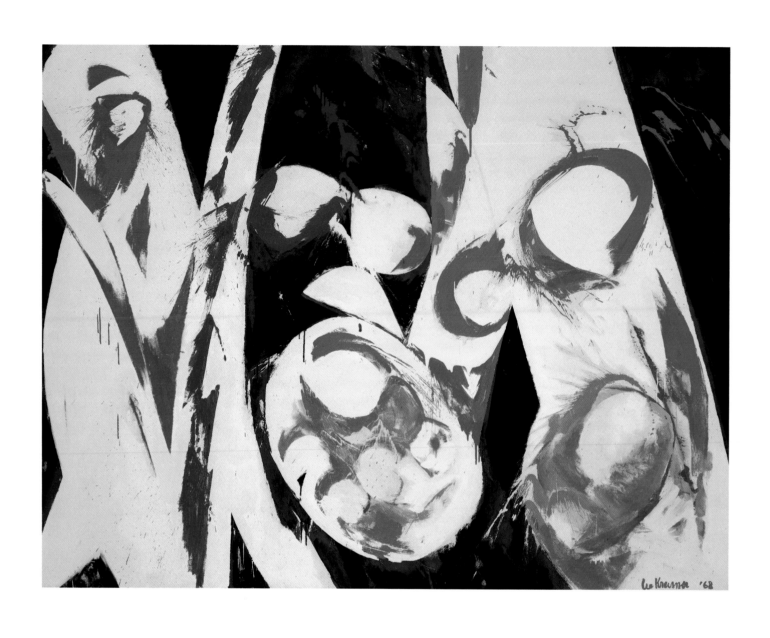

84. **The Green Fuse**, 1968. Oil on canvas, 60 x 90 inches.
Collection of Fayez Sarofim

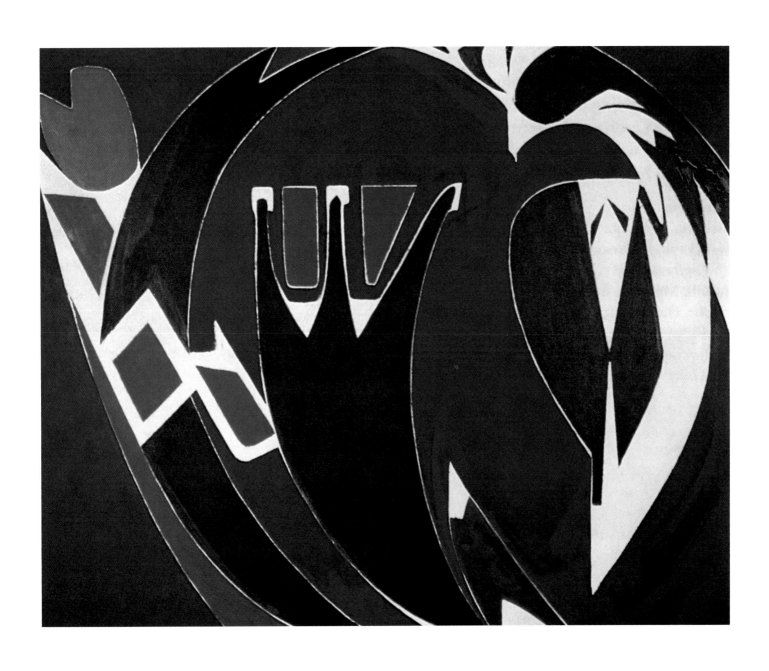

85. **Majuscule**, 1971. Oil on cotton duck, 69 x 82 inches.
Private collection

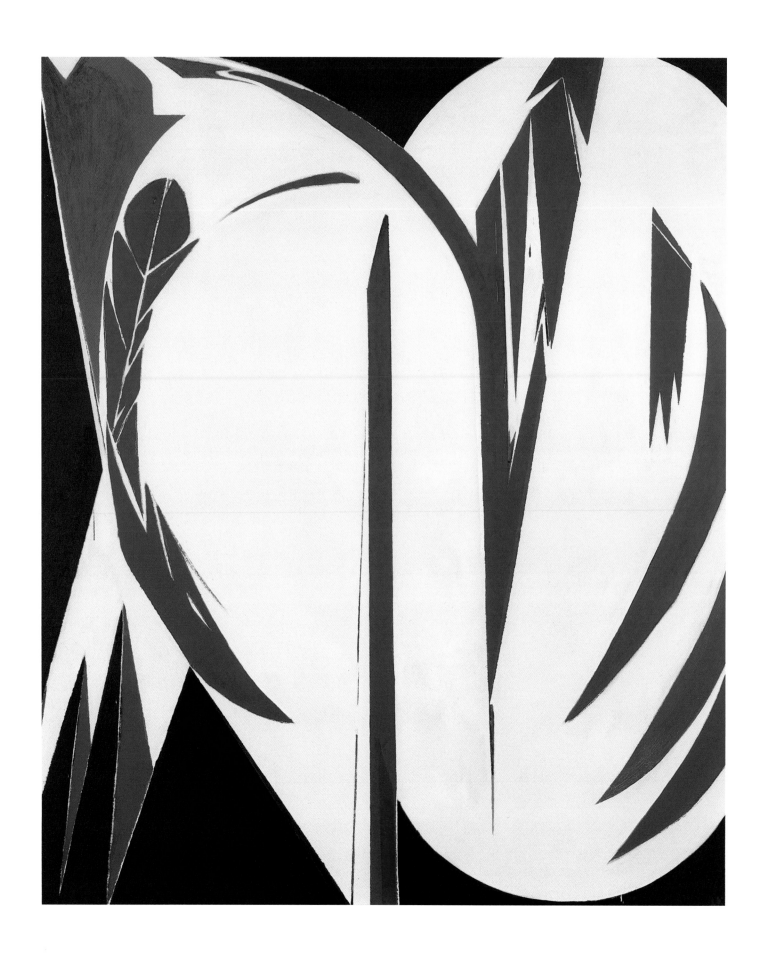

86. **Rising Green**, 1972. Oil on canvas, 82 x 69 inches.
The Metropolitan Museum of Art, New York; gift of Mr. & Mrs. Eugene Victor Thaw

Calligraphy: Tracing the Past

Perhaps as a compensation for the ferocity of the hues in *Combat*, Krasner embarked on the almost quiescent *Kufic*, whose title is intended to recall the earliest style of Islamic calligraphy, from which her marks deviate considerably. Stately and carefully calculated, the angular Islamic script was used for the Koran as well as for inscriptions on coins, tombstones, and buildings. Although the Islamic writing later proliferated into a number of offshoots, including foliated, plaited (or interlaced), bordered, and squared Kufic, none were as informal and improvisational as Krasner's cursive drawing, which works in counterpoint to the painting's title. This painting looks back to Little Image works at the same time that it anticipates the lassolike throws of paint that characterize a number of paintings of the next year including the impressive piece *Courtship*, 1966 (plate 81).

In the 1960s and 1970s, Krasner continued to plumb interactions between abstract painting and writing in a number of works, including *Uncial*, 1967 (plate 82), referring to an open script of capitals used from the fourth to the twelfth centuries, and *Majuscule*, 1971 (plate 85) used to designate the uppercase or large letters in most alphabets (as opposed to the lower-case "miniscule") that were particularly important for the elaborately decorated initials appearing in manuscript illuminations. Her *Rising Green*, 1972 (plate 86), a pared-down variation on *Majuscule*, looks as if one of these grand initials has been enlarged and reconceived by an Art Deco designer. Traces of the cursive script *ñaskhi*, which replaced Kufic around the eleventh century and has remained the most popular form of writing in the Arab world, informs the painting *Meteor*, 1971 (plate 87). The traditional form of picture making used by the six ethnographically distinct peoples of the Pacific Northwest Coast serves as a basis for the left sections of *Mysteries*, 1972 (plate 88). *Mysteries* also contains passages inspired by manuscript illuminations and Near Eastern calligraphy.

The references to established systems of writing in these works indicate Krasner's willingness to work within the constraints of conventional sign systems and deemphasize the impact of improvisational abstract marks that might recall her immediate presence, thus distancing her work yet again from the myth of direct and unmediated communication that seized the imagination of many other Abstract Expressionists. Her emphasis on acculturated signs and the traces of past and/or exotic cultures thus removes these works from myths regarding the artist's self-presence in his or her work.

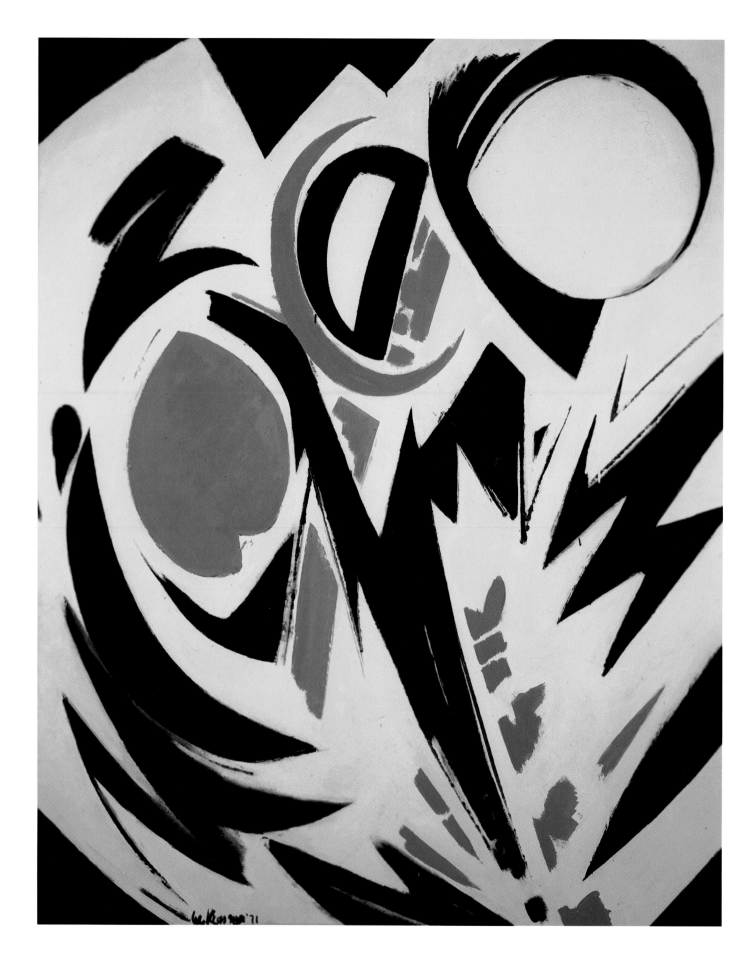

87. **Meteor**, 1971. Oil on canvas, 81¼ x 66¼ inches.
Pollock-Krasner Foundation, Inc., courtesy Robert Miller Gallery, New York

88. **Mysteries**, 1972. Oil on cotton duck, 69 x 90 inches.
Brooklyn Museum of Art, New York, Dick S. Ramsay Fund

89. **Palingenesis**, 1971. Oil on canvas, 82 x 134 inches.
Pollock-Krasner Foundation, Inc., courtesy Robert Miller Gallery, New York

Krasner's Minimalist Abstract Expressionism

Like other Abstract Expressionists, including Motherwell in his Open series,
Richard Pousette-Dart in his black and white paintings, and de Kooning
in his late paintings, Krasner responded to the ascendancy of minimalism
in the 1960s and 1970s by paring down her forms, disciplining somewhat
her exuberant brushstrokes and drips, and opening up her canvases to
more expansive passages of white and flat color as is evidenced by *Comet*,
1970 (plate 90), which is a radical editing of *Confrontation*, 1966. While
her works are never minimalist, this style did encourage her to look once
again at her American Abstract Artists works of the 1930s and early 1940s.
In keeping with the art of the 1960s and 1970s, her paintings are large,
and their movements are often deliberate. Such paintings as *Palingenesis*,
1971 (plate 89), titled after the Greek word for rebirth, which are notable
for their sweeping rhythms and slower cadences, may represent the artist's
tipping her hat to Frank Stella's quasi-minimalist Protractor series, as
well as a rethinking of such Earth Green paintings as *The Seasons*, 1957
(plate 53). Krasner's later style is increasing calculated and balanced: an
expected period of concision and summation after almost four decades
of painting activity.

90. **Comet** (formerly **Confrontation**, 1966), 1970. Oil on canvas, 70 x 86 inches.
Pollock-Krasner Foundation, Inc., courtesy Robert Miller Gallery, New York

Eleven Ways to Use the Words to See

Not content, however, to continue quoting and then editing her well-established major themes for the rest of her life, Krasner embarked in 1976 on a radical new course in which she dramatized confrontations between modernism and incipient postmodernism in the important series Eleven Ways to Use the Words to See, which includes such pieces as *Imperative*, 1976 (plate 91), *Imperfect Subjunctive*, 1976 (plate 92), *Present Conditional*, 1976 (plate 93), *Imperfect Indicative*, 1976 (plate 94), and *Present Subjunctive*, 1976 (plate 95). The significance of the different verb tenses used to title this series is that it changes the act of looking from Clement Greenberg's and Michael Fried's insistence on the *presentness* of modernist art in the 1960s to a delayed and extended form of viewing more in keeping with the post-structuralist theories of Jacques Derrida.

The year before Krasner created this series, an exhibition of her works on paper, beginning with works from the year 1933 and continuing to the present, opened at the Corcoran Gallery of Art.[226] It was curated by well-known critic Gene Baro. In addition to this showing, the print and drawing room of Marlborough Gallery (formerly Marlborough-Gerson) in New York featured a companion exhibition subtitled "Works on Paper: 1937–1939." The two exhibitions were selected in part from a cache of Krasner's Hofmann School drawings (ca. 1937–1940) that British curator Bryan Robertson in the early 1960s had found stored in a barn on The Springs property where they had been summarily deposited almost two decades earlier and promptly forgotten. At the time Robertson was

Lee Krasner's hands at work cutting up pieces for a collage. Photograph by Charles Eames, February 8, 1976

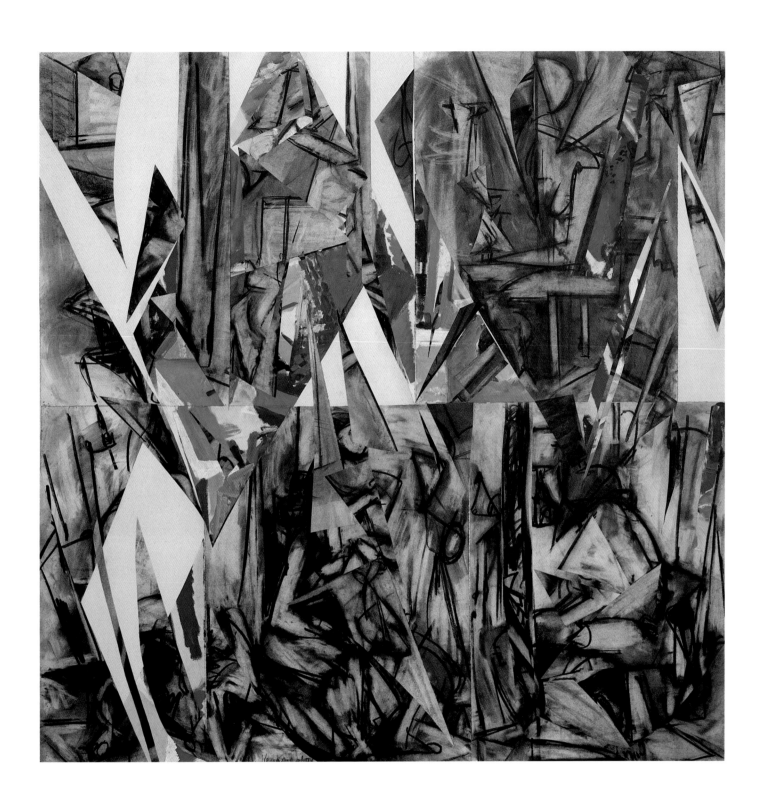

91. **Imperative**, 1976. Oil, charcoal, and paper on canvas, 50 x 50 inches.
National Gallery of Art, Washington, D.C.; gift of Mr. and Mrs. Eugene Victor Thaw
in Honor of the 50th Anniversary of the National Gallery of Art

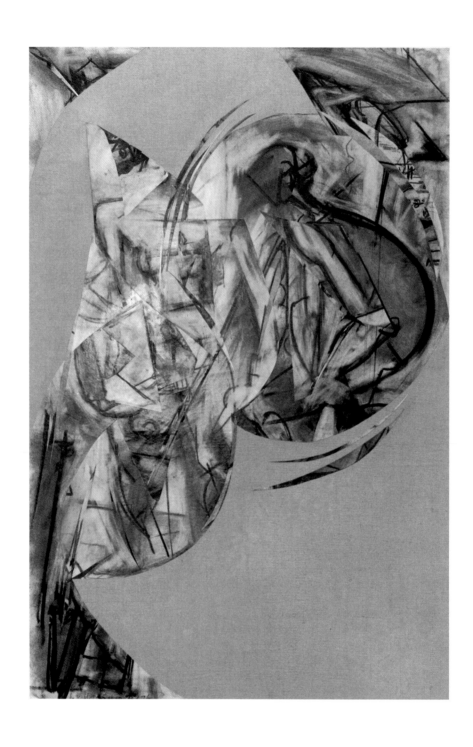

92. **Imperfect Subjunctive**, 1976. Collage on canvas, 40 x 27 inches.
Collection of Byron & Dorothy Gerson

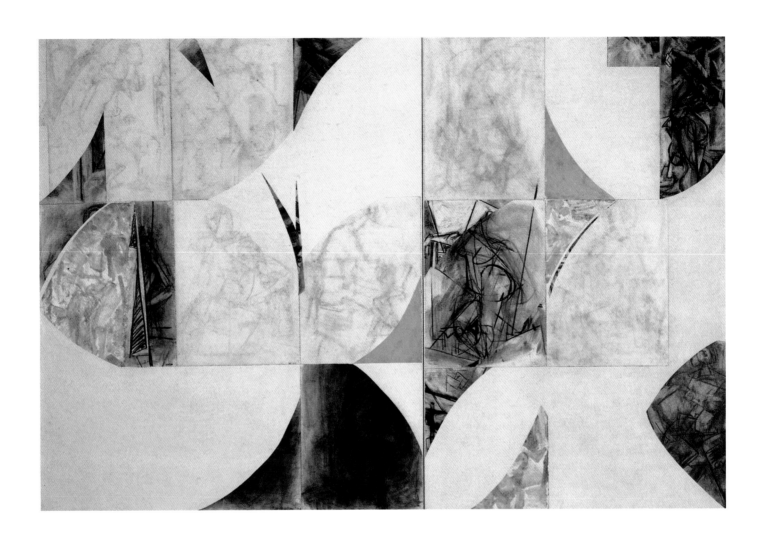

93. **Present Conditional**, 1976. Collage on canvas,
two panels: left, 72 x 60 inches; right, 72 x 48 inches.
Courtesy Robert Miller Gallery, New York

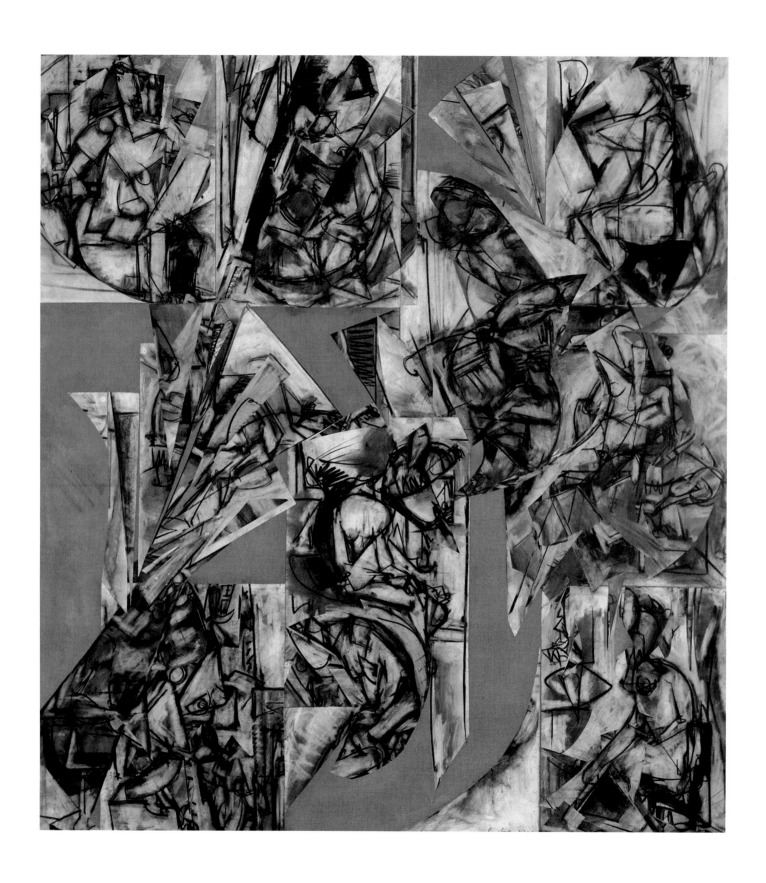

94. **Imperfect Indicative**, 1976. Collage on canvas, 78 x 72 inches.
Pollock-Krasner Foundation, Inc., courtesy Robert Miller Gallery, New York

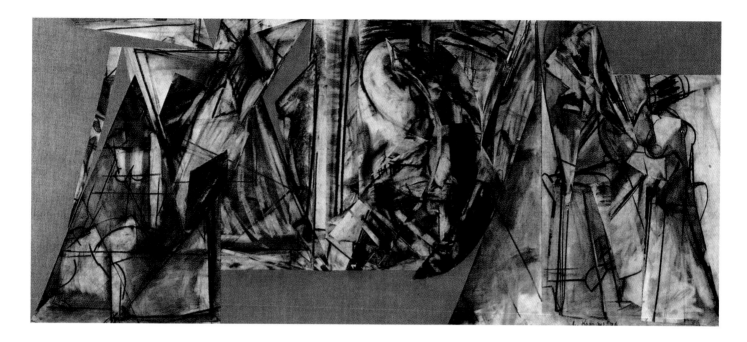

95. **Present Subjunctive**, 1976. Collage on linen, 31 x 71 inches.
Pollock-Krasner Foundation, Inc., courtesy Robert Miller Gallery, New York

assiduously searching for works by Krasner to include in her first
retrospective exhibition for the Whitechapel Art Gallery. He chided her
for not using fixative on these early pieces since some charcoal drawings
had smudged, while still others had left mirror impressions on the sheets
covering them. After selecting the best works, Krasner put the rest in
storage and again ignored them until the Corcoran and Marlborough
exhibitions caused her once again to remember this early body of work.[227]

The year following these two exhibitions, Krasner began thinking
yet again about these drawings and decided to use discarded pieces for a
series of monumental collages. Such a process had been important for both
her relatively small black-and-white and large, intensely colored collages
of the 1950s, and so she repeated this practice albeit with an important
difference: instead of cohering the collected remnants into a seamless
work, she exaggerated differences between the old drawings and the new
structures under which they were now subsumed. "At first I did have some
nostalgia about the drawings," the artist recalled, "but then I began to
look at them as if they weren't done by me—simply pieces of material for
making new work."[228] The thirty-five- to forty-year-old drawings were
mostly studies of studio models in which Krasner had carefully adhered

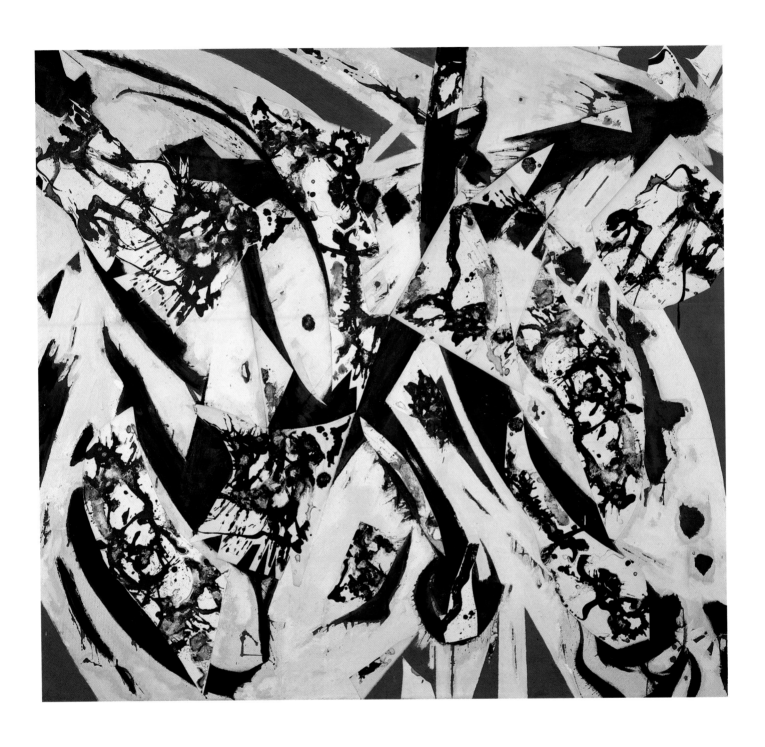

96. **To the North**, 1980. Oil and paper collage on canvas, 58 ½ x 64 inches.
Pollock-Krasner Foundation, Inc., courtesy Robert Miller Gallery, New York

to Hofmann's method and had taken as a key compositional determinant the overall dimensions of the paper employed.

Her collages during the late 1970s share affinities with the feminist art movement that was then being led by an associate of the early 1950s, Miriam Schapiro, who was the wife of Pollock's friend, painter Paul Brach. As part of her feminist program, Schapiro had developed a new hybrid art form based on patchwork quilts and collage that she called "femages." Among the works that Krasner no doubt saw in the 1970s were Schapiro's widely published Collaboration, Fan, and Vestiture series that looked like the shaped canvases of Frank Stella, with the important proviso that they were composed of laces, richly embroidered silks, velvets, sequined appliqués, and chintzes. Although Krasner did not indulge in the use of such elaborate materials for her work, her collage method did parallel Schapiro's desire to collect the fabric of women's lives—namely her own— and use it as a basis for her art.

Far less romantic and idealistic than Schapiro, Krasner was appropriating modernist exercises into compositions in which the original intent and meaning of the Hofmann School drawings were deflected. To appreciate the critical act that Krasner's collages enact, it is helpful to compare her approach with that of contemporary linguists. Prior to the 1960s, linguists operated like modernists in positing ideal channels of communication in which messages were unmediated by misunderstandings and in ignoring the general cultural noise that might interfere with the original intent of a communiqué. Slowly, however, linguists became aware, as have postmodernists, that there are no ideal speaker/listener situations and no totally homogeneous communities ensuring perfect understanding.

What Krasner does in the collages, ironically titled Eleven Ways to Use the Words to See, is to turn early works into decorative patterns that are then cut up and rearranged without consideration of their original intention, thus interrupting their original message. The resulting collages exhibit a lack of sync between Hofmann's codification of the rules of modern art (exhibited in the original drawings) and the uses to which Krasner later subjects them. In this series, she dispenses with Hofmann's universally oriented modernist grammar as she raises the question of artistic language to a new level in which her German teacher's modernism becomes the object, but not the subject of the new works of art. In her collages, language is viewed diachronically and dialectically and no longer in terms of the harmonious universals that Hofmann had originally intended.

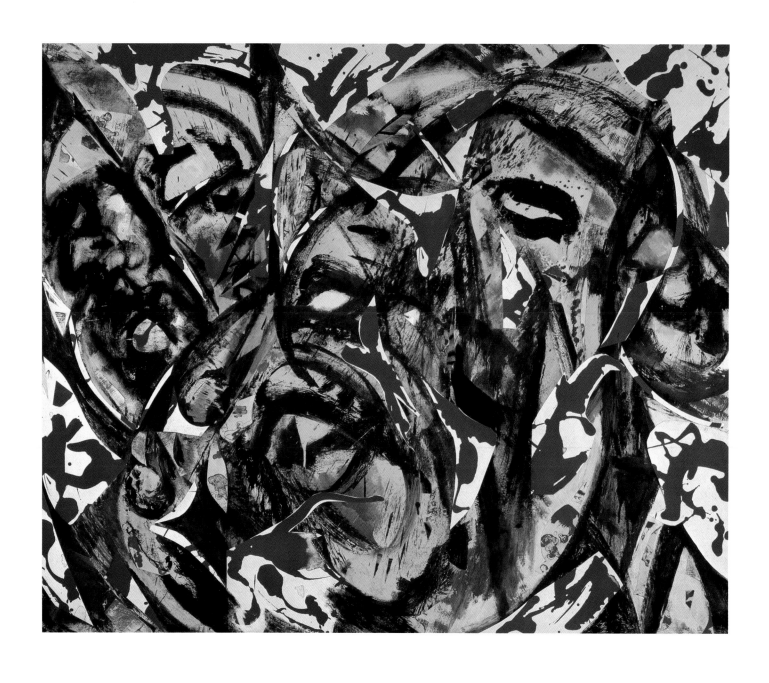

97. **Between Two Appearances**, 1981. Oil and paper collage on canvas, 47 x 57¼ inches.
Pollock-Krasner Foundation, Inc., courtesy Robert Miller Gallery, New York

Postmodern Modernism

Instead of working with Friedman and Howard to title Eleven Ways to
Use the Words to See, Krasner relied on conversations with John Bernard
Myers. Although Myers certainly contributed to the titles of these series,
the idea of dealing with time through references to verb tenses was a
suggestion made by Krasner's longtime friend Saul Steinberg, who posed
the idea of "a linguistic system suggesting time and its conditions" as the
subject for these works.[229] The importance of such elaborate verb tenses
as "imperative," "present conditional," and "past continuous" is that they
undermine the full presence of the work of art—presence having been
transformed into a modernist orthodoxy in the 1960s by Greenberg and
his close disciple Michael Fried—at the same time that they acknowledge
multifaceted ways of looking at art. In addition, the series's ongoing
dialectic between past and present enables Krasner to debunk the theory
that artists create works with a unitary focus. In these collages, she carries
on a point/counterpoint discussion with her past self about the continued
relevance of modernism, its ghostly impressions, and aftermath. The artist
quotes herself, only to undermine herself, and thus to throw art into a
quandary of possibilities similar to the internal gaps occurring in Rimbaud's
poetry that force viewers to develop their own readings of particular works
that are then retroactively attributed to them.

This internal dialectic between the artist's selves that have changed over
time is also evident in the later piece, *Crisis Moment*, 1972–80 (frontispiece),
for which she cut up lithographs from her *Pink Stone* editions (part of the
Primary Series, 1969) to create a collage painting. For *To the North*, 1980
(plate 96), lithographs from the *Blue Stone* edition (taken from the same
Primary Series) were employed. A similar deflection of present and past
times can be seen in the postmodern *Between Two Appearances*, 1981
(plate 97), in which the spontaneity of Krasner's dripped oil paint on
paper has been reconstrued as a series of collage elements so that she
both creates and cites quotations of her own creativity in this piece.

Conclusion

Tough, though often kind, shrewd, sometimes guileless, loaded with
common sense, and known among her friends for her quick piercing wit
and love of gossip, Krasner was far more demanding of herself than others.
In her intransigence and relentless pursuit of an ever evasive self is to be
found her special contribution to Abstract Expressionism, for she was
unable to settle for long into the comforts of a distinctly individual style.
Although she doubted herself, she pursued her uncertainties with dogged

determination, finding not just chimeras but convincing personas that soon revealed themselves to be beautiful, yet static masks unable to keep pace with life's dynamisms.

Unable to be completely convinced by any construction of her own creation, she continued the investigation of selfhood through decades of modernism, existentialism, analyses of language and the problems of communication, finally reaching the state of institutionalized self-doubt termed "postmodernism." But her apprehension of it was too early in the history of the movement for her to enjoy its later ability to legitimize the slipperiness of language and to demonstrate the ease with which naturalized views of the self can be deconstructed. Had she lived longer, Krasner probably would have taken issue with postmodernism too, for her extreme skepticism questioned all claims of knowledge not based on immediate experience. And even then she sometimes doubted the supposed terra firma represented by experience.

Despite their abstractness, her last works continue the modus operandi of her painting made in the summer of 1930 in her parents' backyard in Huntington, Long Island, when she represented herself as a momentary reflection trying to come to grips with itself. In her last works, however, there is no longer a belief in an unflinching and resolute self standing outside the picture. Instead, these late works resemble parallel mirrors reinforcing a state of mirrored reflexiveness, which does not give undue credence to the passing glimmers of reality coming under its purview. In them, Krasner reveals the self (i.e., the postmodern subject) to be an ever-recurring question mark, punctuated by intervals of resolute self-determination.

Endnotes

1. Prominent members of the group include William Baziotes, James Brooks, Willem de Kooning, Arshile Gorky, Adolph Gottlieb, Philip Guston, Hans Hofmann, Franz Kline, Lee Krasner, Robert Motherwell, Jackson Pollock, Barnett Newman, Richard Pousette-Dart, Ad Reinhardt, Mark Rothko, Theodoros Stamos, Clyfford Still, and Bradley Walker Tomlin.

2. Krasner scholars are indeed fortunate to be able to rely on a tremendous amount of research already undertaken by several eminent and assiduous scholars and critics. Among the most important are Cindy Nemser, Barbara Rose, Anne Middleton Wagner, and Ellen G. Landau. After completing her Ph.D. dissertation "Lee Krasner: A Study of Her Early Career (1926–1949)" at the University of Delaware in 1981, Ellen G. Landau embarked on several exhibitions and a truly remarkable catalogue raisonné on this artist that includes a most useful and complete chronology by Jeffrey D. Grove. All prospective students and scholars of Lee Krasner's work would be well advised to consult Dr. Landau's *Lee Krasner: A Catalogue Raisonné* (New York: Harry N. Abrams, 1995).

In 1993, Abbeville Press published my monograph on Lee Krasner as part of its Modern Master Series. In that publication, I presented Krasner as an important critic of the Abstract Expressionists' emphasis on the heroic self and showed how her work was interactive rather than monolithic. A crucial source for this new approach was my realization that Krasner's psychoanalyst in the mid-1950s, Dr. Leonard Siegel, employed the methods of Dr. Henry Stack Sullivan. This theory has recently been supported by Dr. Landau in her essay "Channeling Desire: Lee Krasner's Collages of the early 1950s," *Woman's Art Journal* 18, no. 2 (fall 1997/winter 1998): 27–30. My present study advances my earlier findings by considering in greater depth Krasner's relationship to the ideas of Sullivan, as well as those of Arthur Rimbaud. Another new area of investigation is existentialism.

3. Anne Middleton Wagner, *Three Artists (Three Women): Modernism and the Art of Hesse, Krasner, and O'Keeffe* (Berkeley: University of California Press, 1996), 109, 308 n. 9. Wagner cites a conversation with Landau in which the latter repeated Krasner's contention "that she had decided her own course, rather than having it foisted upon her."

4. A. T. Baker, "Out of the Shade," *Time* 102, no. 21 (November 19, 1973): 76; Bill Hutchinson, "Overshadowed by Late Husband: Lee Krasner's an Artist, Too," *Miami Herald* (Wednesday, March 13, 1974), sec. C, pp. 3–4; Sandra McGrath, "Out of the Shadows to Gain Recognition," *The Business Australian* (January 30, 1979) [clipping in artist's file, Robert Miller Gallery]; Amei Wallach, "Lee Krasner: Out of Jackson Pollock's Shadow," part I, *Newsday* 41, no. 352 (August 23, 1981): 10–15, 29–31, 33–34 and part II, *Newsday* 43, no. 336 (August 7, 1983): 19; Robert Hughes, "Bursting Out of the Shadows," *Time* 122, no. 21 (November 14, 1983): 93; Michael Kernan, "Lee Krasner, Shining in the Shadow," *Washington Post* (June 21, 1984), sec. B, pp. 1, 9; and Stephen Polcari, "In the Shadow of an Innovator," *Art International* (August 1990): 105–107.

5. Cindy Nemser, *Art Talk: Conversations with 12 Women Artists* (New York: Charles Scribner's Sons, 1975), 90.

6. Clement Greenberg, "Jackson Pollock Biography," *Evergreen Review* 1, no. 3 (1956): 95–96.

7. Baker, "Out of the Shade."

8. "How to Keep Out Michelangelo," *New York Times* (February 16, 1933), p. 8.

9. Nemser, *Art Talk*, 84.

10. Lionel Abel, telephone conversation with author, November 19, 1998. In this conversation, Abel referred to Krasner as an intellectual and noted that he was deeply impressed with her in-depth knowledge of modern painting and ability to articulate her ideas.

Krasner herself addressed the issue of the artist as intellectual when she told Bruce Glasser in "Jackson Pollock: An Interview with Lee Krasner," *Arts Magazine* 41, no. 6 (April 1967): 37:

The painter's way of expressing himself is through painting not through verbal ideas, but that doesn't preclude the presence of highly intellectual concepts. The painter is not involved in a battle with the intellect.

11. Ellen G. Landau, "Lee Krasner's Early Career, Part Two: The 1940s" *Arts Magazine* 56, no. 3 (November 1981): 88. According to Landau, Krasner ". . . first met Clement Greenberg at a literary party given by Rosenberg and his wife c. 1937–38. On this occasion, Krasner had advised Greenberg that he might want to attend Hans Hofmann's lectures to learn more about the principles of modern art. This suggestion was evidently a profitable one since a few years later, Greenberg wrote, 'This writer. . . owes more to the initial illumination received from Hofmann's lectures than to any other source.'" (See Greenberg's "Art," *The Nation* 160, no. 16 [April 21, 1945]: 649 for this quote.)

12. According to Dore Ashton in *The New York School: A Cultural Reckoning* (New York: Viking Press, 1973, reprint 1992), p. 53, "Lee Krasner recalls that she and Harold Rosenberg, having been assigned as assistants to the muralist Max Spivak, who had little need for them, sat around his Ninth Street studio all afternoon, talking and talking."

13. Ibid., 53.

14. Lionel Abel, "Harold Rosenberg 1906–1978," *ARTnews* 77 (September 1978): 76.

15. If one did not understand their closeness, the following statement by Krasner might suggest that Rosenberg was her worst enemy:

Rosenberg, for instance, never acknowledged me as a painter, but as a widow, I was acknowledged. Whenever he mentioned me at all following Pollock's death, he would always say Lee Krasner, widow of Jackson Pollock, as if I needed that handle.

Cf. Barbara Cavaliere, "Lee Krasner: A Meeting of Past and Present," *Soho Weekly News* (February 1, 1979), p. 41.

On another occasion, Krasner managed to disparage Rosenberg's major essay "The American Action Painters" when she told Barbaralee Diamonstein, "I hate the term action painting. I don't think it's been defined aesthetically."

But even so, she readily used the word "arena," one of Rosenberg's key terms from this essay, to describe her own work. Cf. Barbaralee Diamonstein, "Lee Krasner" in *Inside New York's Art World* (New York: Rizzoli, 1980), 203. Also cf. n. 119 of this book regarding her conversation with Richard Howard.

16. B. H. Friedman, *Jackson Pollock: Energy Made Visible* (New York: McGraw-Hill, 1972), 137. Friedman notes, "With Pollock, Rosenberg would eventually play poker, fish, drive, 'do boys' things,' as his wife remarked."

17. Abel (telephone conversation with author) recalls that during the summer of 1943 he, Matta, and Ralph Mannheim rented the house that the Rosenbergs later purchased. Abel confirmed that the Pollocks were drawn to the area because of the Rosenbergs.

18. Elaine O'Brien, telephone conversation with author, November 19, 1998.

19. Arthur Rimbaud, *A Season in Hell: Un Saison en Enfer*, trans. Delmore Schwartz (Norfolk, Conn.: New Directions, 1932), 27.

20. Eleanor Munro, *Originals: American Women Artists* (New York: Simon & Schuster, Inc., A Touchstone Book, 1979), 111.

21. Harold Rosenberg, "The God in the Car," *Poetry* 52, no. 6 (July 1938): 334.

22. The early issues of *Partisan Review* were published by the John Reed Club of New York. The last issue to be so listed is in January–February 1935. After that, the magazine was subtitled "A Bi-Monthly of Revolutionary Literature," and in October–November 1935 even this reference was dropped. The John Reed Clubs were communist organizations named for the American journalist whose eyewitness account of the 1917 Russian Revolution is entitled *Ten Days That Shook the World* (1919). Reed helped found the Communist Labor party in the United States. He was later distinguished by being buried in the Kremlin after dying of typhus in Moscow.

23. Harold Rosenberg, "The Profession of Poetry," *Partisan Review* 9, no. 5 (September/October 1942): 407.

24. Ibid.

25. Ibid., 409.

26. Harold Rosenberg, "Preface" to *From Baudelaire to Surrealism* by Marcel Raymond, trans. G. M., vol. 10 of *Documents of Modern Art* (New York: Wittenborn, Schultz, 1950), ix–x.

27. Cynthia Goodman, "Hans Hofmann as a Teacher," *Arts Magazine* 53 (April 1979): 120–5, is an excellent source for Hofmann's pedagogy.

28. For an overview of Hans Hofmann's thought, cf. Cynthia Goodman, *Hans Hofmann* (New York: Abbeville Press, 1986).

29. John Post Lee, "Interview with Lee Krasner, East Hampton, New York, November 28, 1981" in "Lee Krasner and Eleven Ways to Use the Words to See" (senior thesis, Vassar College, December 4, 1981), 36.

30. Ibid.

31. Ellen G. Landau, "Lee Krasner's Early Career, Part One: 'Pushing in Different Directions,'" *Arts Magazine* 56, no. 2 (October 1981): 14.

32. Rimbaud, *A Season in Hell*, 67.

33. André Breton and Diego Rivera, "Manifesto Towards a Free Revolutionary Art," trans. Dwight MacDonald, *Partisan Review* 6 (fall 1938): 50–52. When it was originally published, this essay was signed by Breton and Rivera. Later, its authorship was correctly established by Breton in his letter of February 12 1982, to Peter Selz: "This text," Breton writes, "in its entirety, was drawn up by Leon Trotsky and me, and it was for tactical reasons that Trotsky wanted Rivera's signature substituted for his own. On page 40 of my work *La Clef de Champs* (Paris: Sagittaire, 1953), I have shown a facsimile page of the original manuscript in additional support of this rectification." Herschel Browning Chipp, *Theories of Modern Art: A Source Book by Artists and Critics* (Berkeley: University of California Press, 1968, reprint 1993), 457–58, n. 1.

34. Leon Trotsky, "Letter," *Partisan Review* 6, no. 2 (winter 1939): 127.

35. André Gide, "Literature and Society" (paper delivered at the First International Congress of Writers for the Defense of Culture, Paris, June 21–25, 1935), trans. Samuel Putnam, *Partisan Review* 2, no. 9 (October/November 1935): 33–40. This position was outlined by the French writer André Gide when he debated whether writers should maintain an elitist stance in the face of the world revolution that Soviet Communism anticipated. Gide writes:

> Communion with his own class is out of the question for the bourgeois writer; and as for communion with the people—well, I should say that it is equally impossible, so long as the people remain what they are today, so long as they are not what they might be, what they should be, what they will be, if we lend them our aid. The only thing left is to address the unknown reader, the reader to come; and the way to be sure of reaching him is by attaining to what is most deeply and irreducibly human in oneself. (pp. 38–39)

36. George L. K. Morris, "Art Chronicle," *Partisan Review* 6, no. 3 (spring 1939): 63.

37. George L. K. Morris, "Art Chronicle," *Partisan Review* 5, no. 5 (fall 1939): 32ff.

38. Clement Greenberg, "Avant-Garde and Kitsch," *Partisan Review* 6, no. 5 (fall 1939): 36ff.

39. "Statement of the L.C.F.S. [The League for Cultural Freedom and Socialism]" *Partisan Review* 6, no. 4 (summer 1939): 125–127.

40. Ibid., 127.

41. Barbara Rose, *Lee Krasner: A Retrospective* (Houston: Museum of Fine Arts; New York: Museum of Modern Art, 1983), 37.

42. Lee Krasner, conversation with author, June 10–12, 1977. During the several days that I spent with Krasner at The Springs, she brought up this fact several times. (Trotsky was in fact assassinated in Mexico City three months after this failed attempt.)

43. Greta Berman ("Abstractions for Public Spaces, 1935–1943" *Arts Magazine* 56, no. 10 [June 1982]: 82) writes:

> The basic lines were drawn between painters influenced by the Bauhaus, Kandinsky, and Klee and those who espoused Cubism and Neo-Plasticism. Bolotowsky remembered a conflict between artists who wanted to abstract from nature and "those who dared to abstract without any nature at all." He and Balcomb Green (at the time) counted themselves among the latter faction, unlike the majority who studied under Hans Hofmann and learned from his principles of painting strongly affected by Picasso and Matisse.

44. Krasner, conversation with author.

45. Alan G. Stavitsky, "New York City's Municipal Broadcasting Experiment: WNYC, 1922–1940" (paper submitted for presentation to the Mass Communication and Society Division, AEJMC, Kansas City, August 1993). Both this and the information that follows are indebted to Stavitsky's excellent summary.

46. Landau, *Catalogue Raisonné*, 76. This paralleling of influences follows Landau's assessment of this work and its sources.

47. Marcia Epstein Allentuck, *John Graham's System and Dialectics of Art* (Baltimore: Johns Hopkins Press, 1971).

48. Diamonstein, *Inside New York's Art World*, 201.

49. Allentuck, *John Graham's System and Dialectics of Art*, 95.

50. Ibid., 135.

51. Ibid., 95.

52. Ibid., 102.

53. Krasner, conversation with author.

54. Sidney Simon, "Concerning the Beginnings of the New York School: 1939–43, An Interview with Robert Motherwell Conducted by Sidney Simon in New York in January 1967," *Art International* 11, no. 6 (summer 1967): 20–23.

55. Griffin Smith, "Lee Krasner—A Re-evaluation at Last," *Miami Herald*, (March 17, 1974), sec. G, p. 10.

56. Nemser, *Art Talk*, 86ff.

57. Grace Glueck, "Scenes from a Marriage: Krasner and Pollock," *ARTnews* 80, no. 10 (December 1981): 60. Krasner elaborated (p. 59) on these paintings by saying, "I would work on paintings for months, building up kind of relief slabs of no color and getting nowwhere. It was all very frustrating, and at that time I didn't really love people or things."

58. Wallach, "Lee Krasner: Out of Jackson Pollock's Shadow," 29.

59. Harold Rosenberg, "Man as Anti-Semite" in *Discovering the Present: Three Decades in Art, Culture, and Politics* (Chicago: University of Chicago Press, 1973), 241. "Man as Anti-Semite" was originally entitled "The Possessed" and was published as a review of *A Guide for the Bedeviled*, by Ben Hecht, in *Contemporary Jewish Record*, vol. 1 (1944).

60. Alfred Kazin, *New York Jew* (Syracuse: Syracuse University Press, 1978), 44.

61. Ibid.

62. Munro, *Originals*, 109.

63. Kazin, *New York Jew*, 44ff.

64. Harold Rosenberg, "Sartre's Jewish Morality Play" in *Discovering the Present*, p. 272. A revised version of "Does the Jew Exist?: Sartre's Morality Play about Anti-Semitism," this essay was first published in *Commentary* 7, no. 1 (January 1949).

65. Ibid., 287.

66. Harold Rosenberg, "Jewish Identity in a Free Society" in *Discovering the Present*, p. 261. This article comes from a lecture given to an engineering club composed of Jewish graduate students at Columbia University. It was initially published in *Commentary* 9, no. 6 (June 1950).

67. Ibid., 265.

68. Ibid., 269.

69. Shoshana Felman and Dori Laub, *Testimony: Crises of Witnessing in Literature, Psychoanalysis, and History* (New York and London: Routledge, 1992).

70. Otto Rank, *Art and Artist: Creative Urge and Personality Development* (New York: W. W. Norton & Company, 1989), 252. First published by Alfred A. Knopf, Inc. in 1932. Rank (1884–1937) was one of Freud's first and most important pupils. He later moved away from Freud's ideas. According to Anais Nin, Rank was ". . . a rebel of a man who stood in a symbolic father-and-son relation to Freud, and who dared to diverge from his theories. . . . Otto Rank was a poet, a novelist, a playwright, in short a literary man, so that when he examined the creative personality it was not only as a psychologist, but as an artist . . . " But of course Freud was also well acquainted with the artistic process.

71. Nemser, *Art Talk*, 83.

72. Barbara Novak, "Excerpts from an Interview with Lee Krasner," (Boston, October 1979) in *Lee Krasner: Recent Work* (New York: Pace Gallery, 1981).

73. Marcia Tucker, *Lee Krasner: Large Paintings* (New York: Whitney Museum of American Art, 1973), 16.

74. Michael Cannell, "An Interview with Lee Krasner," *Arts Magazine* 59, no. 1 (September 1984): 88.

75. Munro, *Originals*, 104.

76. Lee Krasner, interview by Dorothy Seckler, December 14, 1967, Archives of American Art, Washington, D.C., p. 8, and Lee Krasner, interview by author, June 10, 1977.

77. Novak, "Excerpts from an Interview with Lee Krasner."

78. Rimbaud, *A Season in Hell*, 67. In Rimbaud's letter to Demeny the young poet establishes a program for becoming a visionary poet of Promethean proportions, capable even of stealing the celestial fire of divine inspiration from the gods. In order to accede to this awesome power, Rimbaud needed to court the margins of sanity, even invoking a demented state so that his senses might coalesce synaesthetically, rather than normally. To do this Rimbaud subjected himself to drinking great quantities of alcohol, smoking hashish, and pushing his body to its limits through excess fatigue, hunger, and thirst.

79. Allentuck, *John Graham's System and Dialectics of Art*, 144.

80. Sigmund Freud, *The Interpretation of Dreams* in vols. 4 and 5 of *The Standard Edition of the Complete Psychological Works*, James Strachey, ed. (London: Hogarth Press, 1953–74), 4: 341.

81. B. H. Friedman, "Introduction" in *Lee Krasner: Paintings, Drawings and Collages* (London: Whitechapel Gallery, 1965), 10.

82. This Kabbalist account of creation appears to be a substantial source for Jacques Derrida's characterization of the traditional roles accorded speech and writing.

83. Julia Kristeva, *Language the Unknown*, trans. Anne M. Menke (New York: Columbia University Press, 1989), 100.

84. Ibid., 101.

85. Nemser, *Art Talk*, 90.

86. These discoveries have formed the basis of a now standard theory. According to the section, "Evolution of the Origins of the Alphabet" s.v. "Writing" in *The New Encyclopaedia Britannica*, 15th ed., "If the signs' external form. . . is ignored and only their phonetic value, number, and order are considered, the modern Hebrew alphabet may be regarded as a continuation of the original alphabet created more than 3,500 years ago. The Hebrew order of the letters seems to be the oldest."

87. P. J. Philip, "Oldest Dictionary is Found in Syria," *New York Times*, August 9, 1930, pp. 1, 4.

88. "4,000-Year-Old City Discovered in Syria: Adds to Early Dictionary," *New York Times*, August 10, 1931, p. 17.

89. "Poem of Biblical Days is Discovered in Syria," *New York Times*, July 12, 1933, p. 20.

90. "1400 B.C. Tablets Give Light on Bible," *New York Times*, November 11, 1933, and Sir Charles Marston, "New Bible Evidence in Ancient Tablets," *New York Times*, November 19, 1933, section 8, p. 2.

91. Ibid.

92. "Topics of the Times: Church and Nazis," *New York Times*, November 19, 1933, sec. 4, p. 3.

93. Articles appeared in the *New York Times* on the following dates: February 15, 1949, March 19, 1949 (two articles), April 2, 1949, April 25, 1949, August 14, 1949, August 21, 1949, December, 29 1949, and December 30, 1949. In addition *Newsweek* published an article on August 22, 1949 and *Time* did the same on October 31, 1949.

94. "Scrolls' Age Confirmed," *New York Times*, March 19, 1949, p. 7.

95. Landau, "Lee Krasner's Early Career, Part Two: The 1940s," 85.

96. Munro, *Originals*, 119.

97. John Bernard Myers, "Naming Pictures: Conversations between Lee Krasner and John Bernard Myers," *Artforum* 23, no. 3 (November 1984): 69.

98. Meyer Schapiro, *Late Antique, Early Christian and Mediaeval Art* (New York: George Braziller, Inc., 1979), 1–11.

99. Ibid., 1.

100. A comparison of Krasner's painting with Schapiro's piece should not be taken too far. It would be a stretch to conclude that Krasner subscribed to all the meanings Schapiro enumerated. For example, Schapiro noted,

> In popular magic and folklore, the mouse is a creature of most concentrated erotic and diabolical meaning. It is the womb, the unchaste female, the prostitute, the devil . . . its liver grows and wanes with the moon; it is important for human pregnancy; it is a love instrument; its feces are an aphrodisiac. . . . [sic.]

101. Landau, *Catalogue Raisonné*, 113–114, provides an excellent discussion of this painting and publishes a section of Myers' undated letter (c. 1948–49) to Krasner that elaborates on the importance of both literary and plastic meanings for works of art.

102. Robert Hobbs, *Lee Krasner* (New York: Abbeville, 1993). In this book, I referred to this group of *Little Image* paintings as "Traceries."

103. Landau, *Catalogue Raisonné*, 108.

104. Barnett Newman, "The Ideographic Picture" in *Barnett Newman: Selected Writings and Interviews*, ed. John P. O'Neill (New York: Alfred A. Knopf, 1990), 107. The exhibition, "The Ideographic Picture," was held at Betty Parsons Gallery in New York on Jan 20–Feb, 8 1927. It included Newman, Hans Hofmann, Pietro Lazzari, Boris Margo, Ad Reinhardt, Mark Rothko, Theodoros Stamos, and Clyfford Still. Unlike Krasner, Newman revels in universals in his text. He equates the Kwakiutl artist's "terror of the unknowable" with that of modern humanity, and he refers to the "pure idea" that transcends time.

105. Kristeva, *Language the Unknown*, 4.

106. In order to set the record straight, I need to mention another interpretation of hieroglyphs that derives from the Roman philosopher Plotinus who was working in the third century A.D. Believing that Egyptian hieroglyphs connoted a wisdom going far beyond the limitations of discursive languages because of the immediacy of the distinctly individual pictures represented, Plotinus conjectured that this language was able to communicate immediately. If translated, it would suffer because its presence would be irretrievably lost. Although it is possible that Krasner knew of Plotinus's theories, it is highly unlikely that she subscribed to them since her art repeatedly affirms the importance of tradition, interaction, and displacement of the self. In addition, she would have known that the pictures making up Egyptian hieroglyphs were not unique entities, but instead were constituent parts of an overall system.

107. David Smith, "Tradition and Identity," (1959) in Clifford Ross, ed., *Abstract Expressionism: Creators and Critics* (New York: Harry N. Abrams, 1990), 184.

108. Sidney Janis. *Abstract Art and Surrealist Art in America* (New York, 1944), cited in Lawrence Alloway, "Melpomene and Graffiti" in *Topics in American Art Since 1945* (New York: W. W. Norton & Company, 1975), 27.

109. Adolph Gottlieb and Mark Rothko with Barnett Newman, "Statement" (*New York Times*, June 13, 1943) in Charles Harrison and Paul Wood, *Art in Theory 1900–1990: An Anthology of Changing Ideas* (Oxford: Blackwell Publishers Ltd., 1992), 562.

110. Gerard Manley Hopkins' term was often bantered about in the 1940s by Surrealist Matta Echaurren, who was close to a number of the artists who became known as Abstract Expressionists, particularly William Baziotes and Robert Motherwell. Robert Motherwell, interview by author, April 11, 1975.

111. Newman, "The First Man Was an Artist," 158.

112. Among Sartre's works that were published in English by 1950 are the following: *The Flies* (1946), *No Exit* (1946), *Existentialism* (1947), *The Age of Reason* (1947), *The Reprieve* (1947), *Existentialism and Humanism* (1948), *The Psychology of the Imagination* (1948), *Dirty Hands* (1949), and *Troubled Sleep* (1950). His plays *No Exit* and *Red Gloves* (an unfortunate re-titling of *Dirty Hands*) were given brief runs on Broadway during the fall seasons of 1946 and 1948 respectively.

113. Ann Eden Gibson, *Abstract Expressionism: Other Politics* (New Haven and London: Yale University Press, 1997) p. 194, n. 28 referring to an interview with Rosenberg's widow May Tabak, states, "It surely is no coincidence that Sartre and Rosenberg were close friends; Sartre, who published Rosenberg's writing in *Les Temps Modernes*, would stay with the Rosenbergs when he was in New York in the 1940s."

Elaine O'Brien in a telephone conversation with the author, November 19, 1998, opines that while Sartre stayed with Rosenberg, they were not close friends. She describes them as bohemian intellectuals who would regularly open their houses to their peers and would form agreeable associations but not close friendships.

Lionel Abel in a telephone conversation with the author, November 19, 1998, concurs with O'Brien. A close friend of Sartre and translator of his work, Abel never remembers Rosenberg being particularly close to Sartre. He acknowledges, however, that Rosenberg and Maurice Merleau-Ponty, who was one of the founding editors of *Les Temps Modernes*, became close friends, and he notes that Sartre's lifelong significant other, Simone de Beauvoir, proposed that Rosenberg write an essay for this periodical.

114. Peter Kahn, conversation with author, December 6, 1976. Peter Kahn shared a studio with de Kooning in the early 1940s and stressed the importance of Kierkegaard for de Kooning's developing existentialism.

115. Among the most important publications in periodicals and newspapers are: Hannah Arendt, "French Existentialism," *The Nation* 162, no. 8 (February 23, 1946): 226–28; Arendt, "What is Existenz Philosophy?," *Partisan Review* 13, no. 1 (winter 1946): 34–56; Jean-Paul Sartre, "The Root of the Chestnut Tree," *Partisan Review* 13, no. 1 (winter 1946): 25–33; William Barrett, "Talent and Career of Jean-Paul Sartre," *Partisan Review* 13, no. 2 (spring 1946): 237–246; John G. Brown, "Chief Prophet of the Existentialists: Sartre of the Left Bank has a Philosophy That Provokes Both Sermons and Fistfights," *New York Times Magazine* (February 2, 1947), 20ff; and Justus Buchler, "Concerning Existentialism," *The Nation* 165, no. 17 (October 25, 1947): 449–50.

William Barrett's *What is Existentialism?* (New York: Partisan Review, 1947) was apparently developed from his writings into a book. The Justus Buchler essay cited above compares it with Sartre's *Existentialism*.

Published in 1948, the American periodical, *Instead*, coedited by Lionel Abel and Matta Echaurren, incorporated

both Surrealist and existential ideas. As Ann Gibson in *Issues in Abstract Expressionism: The Artist-Run Periodicals* (Ann Arbor: UMI Research Press, 1990), p. 42, points out:

> Instead . . . *did not simply revive Surrealist concerns, although a pervasive influence is evident. As Matta recalled, he was expelled from the Surrealist camp in 1948. He believed that Surrealism had a life-period, which was over, and that it would be a mistake "to really do a renaissance." Existential concerns as discussed in* Les Temps Modernes, *founded in 1945 and edited by Jean-Paul Sartre and Maurice Merleau-Ponty, appeared in* Instead. *Abel admired the early* Les Temps Modernes *and remembers that one could get it in New York. . . . "*

116. John Meyers, *Tracking the Marvelous* (New York: Random House, 1983), 60.

117. Harold Rosenberg, "The American Action Painters," *ARTnews* 51, no. 8 (December 1952): 22, 23, 48, 49, 50.

Jean-Paul Sartre, *Existentialism and Humanism*, trans. Philip Mairet (London: Eyre Methuen Ltd, 1948, reprint 1977), 7, 41.

Nancy Jachec, "The Space Between Art and Political Action: Abstract Expressionism and Ethical Choice in Postwar America 1945–50," *The Oxford Art Journal* 14, no. 2 (1991): 18–29. Jachec provides what she terms "the glut of literature available in New York on the subject [of existentialism] as early as 1945." (pp. 18–19)

Humanities and American studies scholar Daniel Belgrad in his recent book *The Culture of Spontaneity: Improvisation and the Arts in Postwar America* (Chicago: University of Chicago Press, 1998) builds a case for Sartrean existentialism as a form of disembodied consciousness out of kilter with the more phenomenologically oriented work of such artists as de Kooning and Pollock whose artmaking entails grand gestures. But he does not take into consideration the following statement from the chapter entitled "The Root of the Chestnut Tree" of Sartre's novel *Nausea* that was excerpted in *Partisan Review* 13, no. 1 (Winter 1946):

> *Existence is not something which can be thought at a distance: it must invade you. . . like a huge lifeless animal— or else it is nothing at all.*(p. 30)

He also seems to be unaware of the fact that Harold Rosenberg formed a close friendship with the phenomenologist Maurice Merleau-Ponty. When he wrote in "The American Action Painters," "At a certain moment the canvas began to appear to one American painter after another as an arena in which to act. . . the canvas was not a picture but an event" (p. 22), Rosenberg joined the concept of the significance of embodied consciousness, presented by Merleau-Ponty in his *Phenomenology of Perception* (1945), with Sartre's theory of engagement and imperative to act. In addition, as Sartre's character Antoine Roquentin discovers in *Nausea*, existence is neither a mere concept nor a spectator sport: it is a concrete reality that must be encountered and incarnated and is thus phenomenological.

The popularity that this recent European philosophy enjoyed among maturing Abstract Expressionists in the United States in the late 1940s, however, has not accorded with the later ideological conception of them as the foremost representatives of this country's newly won international supremacy in the visual arts. The need to sustain a belief in both the independence and hegemony of art in the United States is one possible reason why many art historians have been reluctant to accept an existential basis for this art during its crucial transitional phase in the late 1940s, even though intellectuals in the general humanities have assumed an

existential and Abstract Expressionist alliance to be perhaps too obvious and easy a connection to make. Belgrad writes, "However, existentialism was far less central to the work of the postwar avant-garde than it has been made out to be." (p. 104)

Yet the most conscientious art historians dealing with this school have at least felt a need to acknowledge this coalition of French thought and American practice. In *The Triumph of American Painting: A History of Abstract Expressionism* (New York: Harper & Row, 1970), Irving Sandler tantalizes readers with his aside that "the gesture painters found the existentialist conception of freedom more to their liking than Surrealist automatism. . . " (p. 98) and then adds a pertinent quotation from William Barrett's book *The Irrational Man* (1958) to corroborate his insight. More closely attuned to New York/Paris continuities than most, Dore Ashton in *The New York School: A Cultural Reckoning* (New York: Viking Press, 1973, reprint 1992) devotes an entire chapter to existentialism (pp. 174–192). She perceptively concludes that "Sartre's often reiterated belief that in 'choosing' what he would be in essence, a man was choosing for all men" (p. 181) formed a rationale whereby Abstract Expressionist subjectivity could be universally relevant. In his overview of this movement entitled *Abstract Expressionism and the Modern Experience* (New York: Cambridge University Press, 1991), Stephen Polcari limits his discussion of existentialism (pp. 197–200) primarily to affinities between Barnett Newman's *Onement I* (1948) and Alberto Giacometti's work, which had been exhibited at Pierre Matisse's gallery in New York City and was accompanied by a catalogue containing Sartre's essay entitled "A Quest for the Absolute."

In his important revisionist study, *Reframing Abstract Expressionism: Subjectivity and Painting in the 1940s* (New Haven: Yale University Press, 1993), Michael Leja is reluctant to accord a preeminent place to existential ideas in the work of these American painters even though he mentions that others have sought to do so:

> *While histories of this art commonly have traced its notions of self and the human situation to new 'existentialist' philosophies filtering in to the U.S. from Europe in the wake of the war, there is reason to argue that the subjective identities shaped by the artists and imbricated in their paintings were already highly developed and thoroughly implemented by them.* (p. 249)

While Leja's idea that the formal changes resulting in mature Abstract Expressionism cannot be attributed to existential ideas is reasonable, the move from mythic thinking to a new emphasis on individually intuited visions, coupled with a concomitant concern for the crisis of the self, is no doubt indebted to this school of thought.

118. Rosenberg, "The American Action Painters," 48.

119. Although the terms became ubiquitous, it is worth noting that Krasner referred to the canvases used for her Umber and White Series as an "arena" in her conversation with Richard Howard. Cf. "A Conversation with Lee Krasner" in *Lee Krasner Paintings 1959–1962* (New York: Robert Miller Gallery, 1963).

Considering the enormous difficulty Krasner experienced in the early 1940s with her gray slabs and also her close association with Rosenberg, it is highly likely that her frustrations, in addition to those of Pollock and de Kooning which are usually cited as sources for this essay, may have formed a compelling backdrop for Rosenberg's piece.

120. Because Rosenberg believed that Sartre had misrepresented him in an essay in *Les Temps Modernes* and was unable to convince him to rescind his statement, he

allowed Elaine de Kooning to present the piece to Tom Hess, editor of *ARTnews*, who published it. Elaine de Kooning's role as emissary may have been the determining factor in Willem de Kooning's becoming the ultimate model for the piece. According to Lionel Abel (conversation with author) Pollock claimed to have provided the key ideas for the article one night when he and Rosenberg were taking a train from New York to East Hampton. This story is supported by the claim made years later by Lee Krasner about the sense of surprise and betrayal that both she and Pollock felt when they saw the published article: they both expected Pollock to be presented as the key figure, and Rosenberg had obviously opted for de Kooning. (Krasner, conversation with author).

In an interview with critic Max Kozloff, Robert Motherwell reoriented the original, existential rhetoric of Rosenberg's article to Dadaism. According to Motherwell:

Actually the notion of "action" is gratuitous. A critic's finger in the stew. It was taken by Harold Rosenberg from a piece by Huelsenbeck. . . . At that time I was editing "Dada" proofs of Huelsenbeck's which ultimately appeared in the Dada anthology as "En Avant Dada." It was a brilliant piece. . .

Harold came across the passage in proofs in which Huelsenbeck violently attacks literary aesthetes, and says that literature should be action, should be made with a gun in the hand, etc. Harold fell in love with this section, which we then printed in the single issue that appeared of "Possibilities." Harold's notion of "action" derives directly from that piece.

Although Motherwell's account does not preclude an existential reading, in the art historical literature his anecdote has become the accepted explanation.

121. While Dewey's book might seem crucial to the formulation of Abstract Expressionism, his idealist roots, which influenced his quest to develop a new theory of experience, caused him to veer away from mere subjective feeling. He looked for a means to mediate between subjectivity and objectivity by devising the concept, "consummations," which he describes as experiences reconstructed by intelligence. In the aesthetic domain, Dewey rejects the inchoate and indeterminate flow of life in favor of intensified consummations in which harmony and integrity prevail. Such a resolution of experience clashes with the Abstract Expressionists' emphasis in their art on the indeterminate and unpredictable nature of life. Although Dewey's book pointed them in the direction of process, it formulated the concept of a new empiricism too conventionally. It was important, however, in helping them to articulate their need to focus on experience, which in turn made them receptive to existentialism.

122. Simon, "Concerning the Beginnings of the New York School," 20–23.

123. The first *Surrealist Manifesto*, written by the twenty-eight-year-old Breton, defined Surrealism in the following manner:

Surrealism. n. masc., pure pscyhic automatism, by which an attempt is made to express, either verbally, in writing or in any other manner, the true process of thought. Thought's dictation in the absence of all control by the reason and every esthetic or moral preoccupation being absent.

124. Sartre, *Existentialism and Humanism*, 49.

125. Ibid.

126. Sartre, "The Root of the Chestnut Tree," 29.

127. Sartre, *Existentialism and Humanism*, 28.

128. Tucker, *Lee Krasner: Large Paintings*, 11. On p. 17, Tucker notes that such statements as this one come from an interview that she conducted with Krasner in July 1973.

129. Motherwell, interview by author, October 10, 1974.

130. The German phenomenologist Edmund Husserl, who influenced Sartre's ideas although the two differed greatly in their thought, termed this initial phase of bracketing an *epoche* and intended it to be a crucial step in which existence gets bracketed off from the natural or everyday world so that the normal relations to the universe, or one's concepts about phenomena, are suspended.

131. To his rhetorical question regarding the meaning of existence preceding essence, Sartre responds in *Existence and Humanism*, "We mean that man first of all exists, encounters himself, surges up in the world—and defines himself afterwards. If a man as the existentialist sees him is not definable, it is because to begin with he is nothing. He will not be anything until later, and then he will be what he makes of himself. (p. 28)

132. M. H. Abrams, *The Mirror and the Lamp: Romantic Theory and the Critical Tradition* (London: Oxford University Press, 1953, reprint 1971), 23.

133. T. S. Eliot, "Hamlet and His Problems" in *Selected Essays*, 3d ed. (New York: Harcourt Brace, 1950), 124.

134. Motherwell, conversations with author, 1974–1979. During the period of writing my dissertation on Motherwell's *Elegies to the Spanish Republic*, followed by the year I lived in Motherwell's guest house while teaching at Yale (1975–76) and the period of co-curating the exhibition *Abstract Expressionism: The Formative Years* for the Herbert F. Johnson Museum of Art, Cornell University, and the Whitney Museum of American Art, I had the occasion to spend many hours discussing Abstract Expressionism with Robert Motherwell. At that time, the term "objective correlative" was one of his favored ways of referring to his art.

135. Robert Motherwell, "A Process of Painting [October 5, 1963]" in *The Collected Writings of Robert Motherwell*, ed. Stephanie Terenzio (New York: Oxford University Press, 1992), 139.

136. Ibid.

137. Sartre, *Existentialism and Humanism*, 34.

138. Pollock evidently wrestled with this brand-name identification that he alternately embraced and discarded during his final years of self-doubt that were exacerbated by his alcoholism.

139. Alloway, "Systemic Painting," *Topics in American Art*, 87–89.

140. Anne M. Wagner, "Lee Krasner as L.K.," *Representations* 25 (winter 1989), 42–56.

141. Wagner, *Three Artists (Three Women): Modernism and the Art of Hesse, Krasner, and O'Keeffe*, 188–189.

142. Richard Shiff, "Originality" in Robert S. Nelson and Richard Shiff, *Critical Terms for Art History* (Chicago: The University of Chicago Press, 1996), 108. In this instructive essay, Shiff writes, "priority for the modern artist becomes a matter of establishing a new principle in a new form, that is to say, an idiosyncratic manner of working. Originality is becoming the first of oneself: 'I am the primitive of my own way,' Cezanne was reported to say."

143. Mark Rothko, "Statement," *Tiger's Eye* 1, no. 9 (October, 1949): 114.

144. Clyfford Still, "Letter to Gordon Smith, January 1, 1959" in Gordon M. Smith, *Clyfford Still* (Buffalo: Buffalo Fine Arts Academy and Albright Art Gallery, 1959), 7.

145. Shiff, "Originality." In this essay Shiff contrasts romantic and classic definitions of originality.

146. Jerry Tallmer, "Scissors, Paste & Bits of Survival," *New York Post* (Saturday, February, 19 1977), p. 10.

147. Novak, "Excerpts from an Interview with Lee Krasner."

148. Ibid.

149. Lee Krasner, interview by Gaby Rogers, 1977; Archives of American Art, Washington, D.C. (microfilm 3774).

150. Tucker, *Lee Krasner: Large Paintings*, 8.

151. Munro, *Originals*, 119.

152. Barbara Cavaliere, "An Interview with Lee Krasner" *Flash Art* 94–95 (January–February 1980): 16.

153. Diamonstein, *Inside New York's Art World*, 205.

154. Bryan Robertson, "Krasner's Collages" in *Lee Krasner Collages* (New York: Robert Miller Gallery, 1986), recalled, "In a long conversation that I once had with Clement Greenberg in the early sixties, he told me that the exhibition of Krasner's collages at the Stable Gallery in 1955 was in his view one of the great events of the decade. It is clear that these grandly composed works marked a decisive break in Krasner's evolution and led to some of her grandest paintings almost immediately afterward."

Based on this exhibition and on the subsequent *Earth Green Series* which impressed him greatly, Greenberg offered Lee an exhibition at the French & Co. Galleries. Later, he and Lee broke off relations, and she did not show with French & Co.

Landau, "Lee Krasner's Early Career, Part Two: The 1940s," p. 88, points out that although their relationship was checkered, Greenberg later acknowledged in a lecture given at the Hirshhorn Museum and Sculpture Garden, Washington, D.C., on May 22, 1980 that Lee was the "greatest influence" on Pollock's work.

155. Krasner later told Cindy Nemser (Nemser, *Art Talk*, 96), "I had one year of analysis at the time I painted *Prophecy*. It was a splinter group from the Sullivan school and if one must separate Jung and Freud, this would be in the direction of Freud."

Jeffrey Potter has elaborated on her therapy in *To a Violent Grave: An Oral Biography of Jackson Pollock* (Wainscott, New York: G. P. Putnam's Sons, Pushcart Press, 1987), 221ff,

> For some time Lee had been having counseling sessions with a psychotherapist, Dr. Leonard Siegel, whose approach was akin to the Sullivanian. Jackson also consulted him regarding their marriage, and in early summer he was considering therapy with another practitioner of an offshoot of the Sullivanian approach, Dr. Ralph Klein. However, Jackson still had faith in the Jungian approach.

156. In 1995 when I gave a lecture on Lee Krasner's art to the Studio School on Eighth Street in New York City, a number of Krasner's and Pollock's old acquaintances, who were devoted followers of Sullivan's ideas, were in the audience. Their continued enthusiastic endorsement of Sullivan's approach indicates the wide reception his thought received in the 1950s.

157. An excellent source for Sullivan's concepts is Patrick Mullahy, ed., *The Contributions of Harry Stack Sullivan* (Northvale, New Jersey: Jason Aronson Inc., 1995, reprint 1952).

158. Irving Howe, "The Self in Literature" in George Levine, ed., *Constructions of the Self* (New Brunswick, New Jersey: Rutgers University Press, 1992), 252. Howe's essay comes from his series of Tanner Lectures at Princeton University, March 1990.

159. Glueck, "Scenes from a Marriage," 61.

160. Munro, *Originals*, 116.

161. Sanford Friedman, interview by author, February 2, 1998; Richard Howard, interview by author, January 30, 1998.

162. Howard, "A Conversation with Lee Krasner."

163. Munro, *Originals*, 104.

164. Ibid. Krasner recounted, "Father—I adored him. . . . He told stories. Marvelous tales? About tales! About forests. Beautiful, beautiful stories, always like Grimm. Scary things."

165. Rena "Rusty" Kanokogi, conversation with author. Ms. Kanokogi is Lee Krasner's niece.

166. Jeffrey D. Grove, "Chronology: Lee Krasner 1908–1984" in Landau, *Catalogue Raisonné*, 305. Mercer's letter to Krasner is dated July 15, 1940; it is reproduced in the *Catalogue Raisonné*.

167. Cindy Nemser, "The Indomitable Lee Krasner," *The Feminist Art Journal* 4, no. 1 (spring 1975): 9.

168. Aaron Brav, "The Evil Eye Among the Hebrews" in Alan Dundes, ed., *The Evil Eye: A Folklore Casebook* (New York: Garland Publishing, 1981), 44–54. The following discussion on the evil eye in Judaic culture is indebted to Brav's excellent summary.

169. Harold Rosenberg, "Four Poems," *Poetry* 40, no. 4 (July 1932): 207.

170. Robert Motherwell, conversations with author, 1975–77. During this time Motherwell often pointed out how Rosenberg had been mesmerized by this opening scene of the film.

171. Otto Rank, *The Trauma of Birth* (Routledge & Kegan Paul Ltd., London, 1929), 25.

172. Ibid., 4.

173. B. H. Friedman, telephone conversation with author, January 22, 1999.

174. Allentuck, *John Graham's System and Dialectics of Art*, 191.

175. Howard, "A Conversation with Lee Krasner."

176. Rank, *Art and Artist: Creative Urge and Personality Development*, 227ff.

177. Jacques Derrida, *Signeponge/Signsponge*, trans. Richard Rand (New York: Columbia University Press, 1984), 56.

178. Although dealing with Romanesque art in general rather than the problem of secular marginalia per se, Meyer Schapiro's "On the Aesthetic Attitude in Romanesque Art," contained in *Romanesque Art: Selected Papers* (London: Thames and Hudson Ltd., 1993), 1–27, which is a republication of an essay in *Art and Thought: Issued in Honor of Dr. Ananda K. Coomaraswamy on the Occasion of His 70th Birthday*, ed. K. Bharatha (London: Luzac and Company Ltd., 1947), 130–150, is the fullest account of his theories regarding the importance of secular imagery in a highly spiritual age.

179. Howard, interview by author; Lee, interview by author. In these interviews both men stressed the importance of the Book of Kells for Krasner. She herself referred to it during her interview with John Post Lee (see page 37 of that interview).

180. Munro, *Originals*, 105.

181. Ibid.

182. Schapiro, "On the Aesthetic Attitude in Romanesque Art," 17.

183. Ibid. 8.

In medieval studies a number of other scholars have attempted to reconcile the often ribald nature of these marginal decorations with the sacred texts occurring on the same pages with them. In his study of Abbot Suger entitled *Abbot Suger On the Abbey Church of St.-Denis and Its Art Treasures* (Princeton: Princeton University Press, 1946/79), pp. 19ff, which he edited, translated, and annotated, Erwin Panofsky invokes the anagogical approach, or "upward-leading

method," which involves the theories of Dionysius the Pseudo-Areopagite, who was important to Suger. This anagogical approach posits a connection of God's essence from the highest forms, represented by the scripture itself, to the lowest life forms seen in the vignettes decorating them. Both are an affirmation of God's power and ubiquity; their difference allows the faithful to move from the material to the immaterial world.

The art historian Lilian M. C. Randall, in *Images in the Margins of Gothic Manuscripts* (Berkeley: University of California Press, 1966), points out that fabliaux and exempla became important ways of teaching and may have influenced illuminated manuscripts (p. 7ff), even though she is also willing to write off the frequency of marginalia in private devotional books as part of a ". . . medieval propensity for juxtaposition of contrasting elements. . . . provocation by contrast." (p. 14). The author gratefully acknowledges Dr. Sharon Hill's suggestion of this source.

A more inclusive summary of the received wisdom regarding these drolleries is provided by Umberto Eco in *The Name of the Rose*, trans. William Weaver (San Diego: Harcourt Brace Jovanovich, 1980). First, is the idea that these monstrous apparitions emphasize the ideal through its antithesis. Second, citing the Areopagite, Eco points out that God remains the great unknowable and thus can only be suggested through deliberate misrepresentation and through the lower forms on earth because that is what is most familiar to human beings. Eco's character William says, "He shows Himself here more in that which is not than in that which is, and therefore the similitudes of those things furthest from God lead us to a more exact notion of Him. . . . " And finally, these curiosities serve the important function of keeping undeserving individuals from knowing about those spiritual things that are beyond them. The author gratefully acknowledges Christopher Gilbert's recommendation of this source.

184. Howard, interview by author.

185. Richard Howard, "Lee Listening: Lee Krasner Pollock," *Grand Street* 4, no. 1 (autumn 1984): 183–186.

186. In the 1950s Richard Howard became the foremost translator of Alain Robbe-Grillet's fiction, including *The Voyeur* (1958), *Two Novels: Jealousy and In the Labyrinth* (1960), and *Last Year at Marienbad* (1962), as well as the translator of André Breton's *Nadja* (1961).

187. Enid Starkie in *Arthur Rimbaud* (New York: W. W. Norton, 1947) discusses the poet's early years and the importance of both his Latin studies and his early fascination with the Middle Ages, pp. 37–54. Rimbaud's talent for Latin verse is evidenced by the first prize he won for his Latin poem at the Concours Académique.

188. This is a new interpretation of Rimbaud's *Illuminations* that I am advancing.

189. Starkie, *Arthur Rimbaud*, 215.

190. Dee Reynolds in *Symbolist Aesthetics and Early Abstract Art: Sites of Imaginary Space* (Cambridge: Cambridge University Press, 1995) provides an important discussion of the function of the imagination in Rimbaud's work.

191. Samuel Taylor Coleridge, "Text of Lectures 1, 2, 6, 7, 8, 9, and 12 of the 1811–12 Series as published by John Payne Collier in *Seven Lectures on Shakespeare and Milton* (1856)" in *The Collected Works of Samuel Taylor Coleridge*, ed. Kathleen Coburn, vol. 2, *Lectures 1808–1819 on Literature*, ed. R. A. Foakes (Princeton: Princeton University Press, 1987), 495.

192. Friedman, interview by author.

193. Howard, interview by author.

194. Lee, "Interview with Lee Krasner, East Hampton, New York, November 28, 1981," 34.

195. Jane Ellen Harrison, *Ancient Art and Ritual* (Oxford: Oxford University Press, 1951). Even though Friedman does not recollect discussing this book with Krasner, Howard remembers well their talks. According to Friedman, Howard should be considered the most reliable source when it comes to such details in the past. Friedman and Howard, interviews by author.

196. Apparently Krasner was later confused about the source of this title since she attributed it to her maid's daughter, Little Frances. In conversation with Barbaralee Diamonstein, she stated, "Well, she [Little Frances] titled something I had painted many years before, and it was and still is called *The Bull*, while when she looked at it, it was *The Happy Dragon*." Cf. Diamonstein, *Inside New York's Art World*, p. 208. The evidence provided by Jane Harrison's book *Ancient Art and Ritual* confirms this title to have been Sanford Friedman's suggestion.

197. Ibid., 83.

198. Ibid., 84.

199. Ibid., 89.

200. Ibid., 89ff.

201. Ibid., 104.

202. Ibid., 83.

203. Ibid., 67.

204. In the following note recounting one of her dreams, Krasner indirectly suggests that she herself might be the Sun Woman:

From whom did you inherit your greed —Must you have all—Why not learn to live with the fragments that are meant for you—Do you really think you can harness the sun?
Cf. Grove, "Chronology" in Landau, *Catalogue Raisonne*.

205. B. H. Friedman, letter to author, January 27, 1999. Although this account differs from many published references, the particulars have been checked by Mr. Friedman, who commissioned the piece and who was working with Uris Buildings Corp. at the time.

206. Howard, "A Conversation with Lee Krasner."

207. Krasner notes how against the grain these works seemed at the time in Richard Howard, "A Conversation with Lee Krasner," when she states baldly:

It's also of interest that in this period, what's happening to my contemporaries or to the generation following, is that color-field painting becomes very prominent—a very different form of painting from what is happening with me. A great many artists become tied into that—so once more I find myself going against the stream, up stream. . . I wonder what it would feel like to be swimming with everybody else instead of the other way.

208. Ibid.

209. Ibid.

210. Ibid.

211. Ibid.

212. Starkie, *Arthur Rimbaud*, 272.

213. Howard, "A Conversation with Lee Krasner."

214. Ralph Waldo Emerson, "Circles," in *Essays* (Boston: Houghton, Mifflin, 1904), 304.

215. Ibid., 303.

216. Krasner, interview by author.

217. Hilton Kramer, "Art: Elegiac Works of Lee Krasner," *New York Times* (Friday, February 9, 1979), sec. C, p. 25.

Krasner told Kramer, "I realized that if I was going to work at night, I would have to knock color out altogether, because I wouldn't deal with color except in daylight."

218. Georges Bataille, *Prehistoric Painting: Lascaux or The Birth of Art* (Lausanne: Skira, 1955). Krasner's palette in the Umber and White Series bears an astonishing similarity to that used by Cro-Magnon painters at Lascaux with the exception of iron oxide, which was abundantly used at Lascaux.

219. Howard, interview by author. Also, Helen A. Harrison, telephone conversation with author, January 22, 1999. Ms. Harrison, Director of the Pollock-Krasner House and Study Center, a Project of the Stony Brook Foundation, noted that the book was either purchased at the Braider House of Books and Music or was a gift from Carol and Donald Braider.

220. Bataille, *Prehistoric Painting*, 18.

221. Ibid., 11.

222. Ibid., 12.

223. Ibid., 30.

224. Krasner, "Statement" in *Lee Krasner: Paintings, Drawings and Collages*, 19.

225. In the 1930s, soon after completing his series of images of cabbages, Weston exhibited at such New York venues as Brooklyn Botanic Garden, Delphic Studios, Brooklyn Museum, Julien Levy Gallery, and Brentano's Bookstore. Krasner may have seen images of cabbage leaves at this early time or later, and misremembered them as lettuce leaves. In his daybook entry of August 23, 1930, Weston notes his intention to show these works in New York, "Whether I do more or not, these [his images of halved and quartered red cabbages] will go at once into my printing file for N.Y. show. They are extraordinary, significant—more than a cabbage." Cf. Nancy Newhall, ed. *The Daybooks of Edward Weston*, (Millorton, New York: Aperture, 1973), 184.

226. The exhibition was entitled *Lee Krasner: Collages and Works on Paper, 1933–1974*. It was shown at the Corcoran Gallery of Art in Washington, D.C. from January 11 to February 16, 1975. Then it traveled later that year to the Pennsylvania State University and to the Rose Art Museum, Brandeis University.

227. Lee, interview by author. According to John Post Lee it is not surprising that Krasner kept these drawings for so long since she kept practically everything. Fully imbued with the need to be frugal from the Depression, she even kept Pollock's clothes decades after his death. In 1981, John Post Lee remembers finding Pollock's T-shirts and boxer shorts in the drawers of one of the upstairs bedrooms.

228. Grace Glueck, "Art People: How to Recycle Your Drawings," *New York Times*, February 25, 1977, sec. C, p. 18.

229. Jeanne Siegel, "Collage Expanded," Visual Arts Museum, New York, October 1–October 20, 1984.

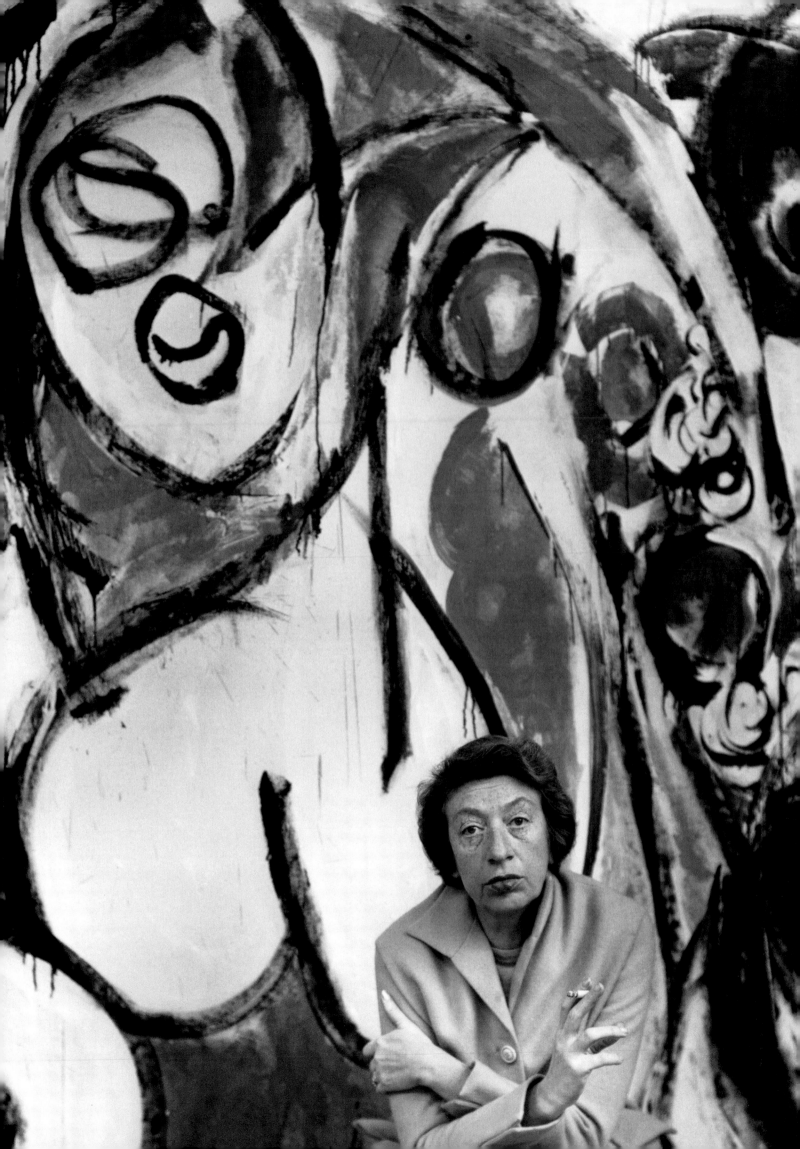

Chronology

1908

Lee Krasner (named Lena Krassner) was born on October 27, 1908, nine months and two weeks after her mother Anna—together with her four living children—was reunited with her husband, Joseph, who had emigrated from a small village near Odessa to Brooklyn three years earlier. She grew up in an Orthodox Jewish home in rural Brooklyn; her parents supported themselves by running a combination green grocery and fish market.

1921

As a young teenager and now referring to herself as Lenore, she completed grade school—P.S. 72 in Brooklyn—and went on to Girls' High in Brooklyn. She had applied to Washington Irving High School in Manhattan (for its special arts program) but had not been accepted.

1922–25

Krasner was finally accepted at Washington Irving High School in 1922, and transferred there from Girls' High. Under the influence of her older brother, she became interested in Russian literature and opera. During this time, she also discovered the writings of Nietzsche and Schopenhauer. She graduated from high school in spring 1925.

1926–28

She attended the Women's Art School of the Cooper Union from winter 1926 until spring 1928.

1928–32

In summer 1928, for one month, she took a drawing course at the Art Students League of New York before enrolling at the National Academy of Design in the fall and continuing there until spring 1932. During her time at the National Academy she began a close friendship with White Russian emigré Igor Pantuhoff, who was three years her junior; soon after, they began living together, a relationship that lasted for most of the 1930s.

Lena Krassner (sixth from left, first row) at her graduation from P. S. 72, Brooklyn, 1921

1932–34

Krasner decided to obtain a teaching certificate by taking courses at City College in New York. During this time she met art critic Harold Rosenberg and literary critic Lionel Abel while working as a silk-pajama-clad cocktail waitress at a Greenwich Village nightclub called Sam Johnson's. In spite of her position, she earned the respect of these two men and began a lifelong, on-again/off-again friendship with Rosenberg. Several months after meeting him, she and Pantuhoff agreed to rent rooms in the West Fourteenth Street apartment leased by Rosenberg and his wife, May Natalie Tabak. *January 1934*: Krasner was appointed to the Public Works of Art Project. She worked there until March, after which she was assigned to the Temporary Emergency Relief Administration, where she worked for more than a year.

1935

Krasner and Pantuhoff found housing on Twelfth Street and Second Avenue. Beginning in August, Krasner worked for the Federal Art Project of the Works Progress Administration (WPA/FAP). She and Rosenberg were assigned to assist muralist Max Spivak, who preferred for them to run errands and discuss politics rather than assist him with his paintings. (Krasner continued working in a variety of different posts for the WPA/FAP until June 1943, when the WPA was abolished due to increases in private-sector jobs resulting from World War II.)

1936

Krasner met Jackson Pollock in December at an Artists Union loft party, where they danced together and he made an inappropriate advance.

1937

At some point in the late 1930s, Krasner stopped using the name Lenore and adopted the more streamlined "Lee," which she continued to use for the rest of her life. In 1937, she received a scholarship to study at Hans Hofmann's School of Fine Arts in Greenwich Village, at 52 West Eighth Street, after Hofmann's administrator and student Lillian Olinsey saw her work. She also demonstrated in protests organized by the Artists Union; and her work was included in an exhibition challenging periodic WPA firings and rehirings, entitled *Pink Slips Over Culture*, which was held at the ACA Galleries, New York (July 19–31).

1939

Krasner was appointed to the Executive Board of the Artists Union and became embroiled in debates regarding Stalinist versus Trotskyite politics. She also became a member of the American Abstract Artists, the most avant-garde organized art group in the United States at that time, which was closely affiliated with recent European art trends. Her work was included in AAA's annual exhibitions from 1940 to 1943.

Lee Krasner in Washington Square, late 1930s

1941

Burgoyne Diller, who was head of the WPA mural division in New York City, commissioned her to make a proposal for an abstract mural for radio station WNYC, which already had murals by Stuart Davis, Byron Browne, and John von Wicht; due to the U.S.'s entry into WWI, it was never executed.

John Graham invited Krasner to participate in a group exhibition, *French and American Painting*, to be held in 1942. The purpose of the exhibition was to demonstrate the strengths of American artists when seen in the company of such important Europeans as Braque, Matisse, and Picasso. Included among the Americans would be Stuart Davis, Graham, Willem de Kooning, Walt Kuhn, and Jackson Pollock. In late 1941, soon after receiving an invitation to participate in this exhibition, Krasner (who did not realize that she had met Pollock several years earlier) visited him and introduced herself. He lived only a block away from her

at 51 East Ninth Street. In the fall, she and Pollock took over the apartment that he had been sharing with his brother and sister-in-law. It is at this time that she probably began sharing Pollock's studio.

1942

January: The group exhibition *French and American Painting* is presented at the midtown design firm McMillen Inc.; it is the first time that Krasner's and Pollock's works are shown together.

When the U.S. entered the war, the WPA/FAP became the War Services Project. Krasner remained in a supervisory capacity and oversaw the development of a series of nineteen photocollages for department-store windows in Manhattan and Brooklyn, to promote war-related training courses offered in local colleges. She hired Pollock to assist her on this project.

1943

Reassigned to vocational training in aviation sheet metal, Krasner learned mechanical drafting. During this time, she worked to promote Pollock's career by introducing him to important avant-garde artists, critics, curators, and gallerists. Beginning that year and continuing until 1946, she attempted to create intuitive paintings featuring thick slabs of gray paint.

1944

Krasner stopped painting in Pollock's studio and joined Reuben Kadish in taking over Roberto Matta Echaurren's old space. She spent the summer in Provincetown with Pollock.

1945

Both Krasner and Pollock were included in Howard Putzel's first exhibition in his Gallery 67, *A Problem for Critics*, which opened May 14. Putzel had been Peggy Guggenheim's secretary and adviser, and was partly responsible for her becoming Pollock's dealer in 1943.

After summering with the Kadishes on Long Island near East Hampton, Krasner and Pollock decided to move to the country. *October 25*: They were married at the Marble Collegiate Church, New York. *November 5*: With the help of Peggy Guggenheim, they purchased a simple farmhouse on Fireplace Road in The Springs, a small village outside East Hampton. The house was near that of their friends Harold Rosenberg and May Natalie Tabak, who had been a witness at their wedding.

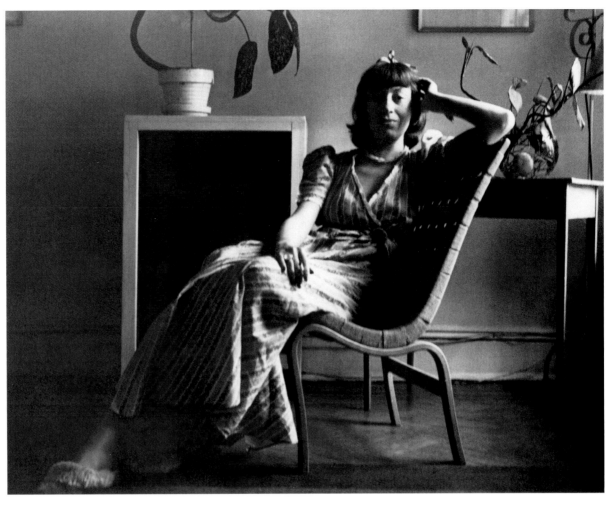

Lee Krasner, ca. 1938.
Photograph by Igor Pantuhoff (?)

1946

Spring: Using the living room of their house at The Springs as a studio, Krasner began the Little Image series.

1947

Spring: After Pollock moved his studio from the upstairs bedroom to the barn, Krasner took over the upstairs space. She created the first of two mosaic tables, using a variety of found materials and iron wagon-wheel rims as an armature. The second table was made the following year.

1948

Fall: The Bertha Schaefer Gallery in Manhattan exhibited one of the mosaic tables, together with a Little Image painting. The exhibition was entitled *The Modern House Comes Alive—1948–49*, and Krasner's work was praised in the *New York Herald Tribune*.

1949

Both Krasner and Pollock lent work to the Sidney Janis Gallery exhibition *Artists: Man and Wife*.

Lee Krasner with *Untitled,*
ca. 1940–43

1950

Krasner stopped working on the Little Image series and went through a
period of hesitation and false starts, in which she periodically returned
to a pared-down version of the geometric abstraction that she first initiated
during her American Abstract Artists period of the early 1940s.

1951

In early 1951 the Pollocks stayed in Alfonso Ossorio's New York town house
so that Pollock could visit his Sullivanian therapist, Ralph Klein. Krasner
created work for her first New York exhibition, *Paintings 1951: Lee Krasner*
(October 15–November 13) for the Betty Parsons Gallery, New York. The
exhibition was held simultaneously with another that included the collages
of Anne Ryan.

1952

Krasner began seeing the Sullivanian therapist Dr. Leonard Siegel. In May,
Pollock left the Betty Parsons Gallery, which had been showing his work
since spring 1947, because not enough of his recent paintings were selling.
At that time Krasner was also asked to leave the gallery.

1953

Krasner began recycling both her own and Pollock's discarded work to
make a series of increasingly large collages.

1954

Summer: Krasner participated in an all-women exhibition, *Eight Painters, Two Sculptors*, at the Hampton Gallery and Workshop, Amagansett, New York. *August 15*: A one-day exhibition of her work was held at Donald and Carol Braider's House of Books and Music in East Hampton, in which many of her Little Image paintings were shown for the first time.

1955

Eleanor Ward featured Krasner's large collages in a solo exhibition at the Stable Gallery, New York (September 26–October 15). The exhibition was a critical success.

1956

Summer: Krasner painted the troubling work *Prophecy* and left it on her easel when she sailed for Europe in July. Their marriage had been severely tested by Pollock's alcoholism, his inability to paint for almost a year and a half, and his bad temper caused by his difficulty in maintaining the premier position in the art world that he first attained in the late 1940s with his drip paintings—and he had initiated an affair with a young painter, Ruth Kligman. The European trip was a trial separation that proved difficult for both of them. *August 11*: Pollock was in an automobile accident, and was killed instantly. With him were Ruth Kligman, who survived, and her friend Edith Metzger, who was also killed. Critic Clement Greenberg telephoned Krasner in Paris with news of the accident, and she returned home for the funeral. Krasner was the sole heir of Pollock's estate. Instead of going into a period of deep mourning, she initiated a series of monumental paintings that become known as the Earth Green series.

1957

Krasner took out a two-year lease on an apartment at 147 East Seventy-second Street. She began living in New York in the winter and spending summers in The Springs.

1958

Krasner exhibited her Earth Green paintings at the Martha Jackson Gallery in Manhattan (February 24–March 22). B. H. Friedman, vice-president of Uris Brothers, commissioned her to create two immense mosaic panels for a new corporate building at 2 Broadway in New York City.

1959

The death of her mother catalyzed her Umber and White series, which continued until 1962. A show proposed by Clement Greenberg for French & Co. was canceled because of a disagreement. Krasner signed an exclusive contract with the Howard Wise Gallery in Manhattan. *Lee Krasner, Paintings 1947–59* was shown at the Signa Gallery in East Hampton (July 24–August 20).

1960

She exhibited paintings from the Umber and White series at the Howard Wise Gallery (November 15–December 10).

1962

Krasner showed a second group of Umber and White paintings at the Howard Wise Gallery (March 6–30). *December 25*: She developed a brain aneurysm, which temporarily kept her from painting and resulted in an end to her Umber and White series.

1963

Because of a dizzy spell experienced during the summer, Krasner fell and broke her right arm. She continued to work by teaching herself to paint with her left hand. She left Howard Wise Gallery that same year.

1964

Although she suffered from another serious illness, Krasner worked with British curator Bryan Robertson in putting together her first retrospective exhibition, which would open at the Whitechapel Gallery, London, in the fall of 1965.

1965

Krasner leased another New York apartment at 70 East End Avenue; later she purchased an apartment at 180 East Seventy-ninth Street. Her White-chapel Gallery retrospective, *Lee Krasner: Paintings, Drawings and Collages*, opened in London in September and was on view until October. Afterward, it traveled to York, Hull, Nottingham, Manchester, and Cardiff under the auspices of the Arts Council of Great Britain.

1966

Krasner joined the Marlborough-Gerson Gallery, which had already been representing the Pollock estate for a number of years.

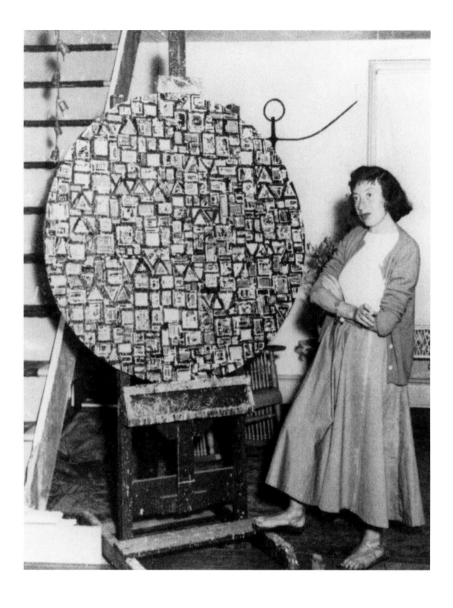

Lee Krasner with *Stop and Go*, ca. 1949

1968
March: Exhibition of her recent work at the Marlborough-Gerson Gallery.

1969
Krasner's recent gouaches were presented at the Marlborough-Gerson Gallery (September 27–October 18).

1972
As a member of Women in the Arts, Krasner picketed MoMA in April to protest the museum's preference for showing male artists. That autumn, she turned over the management of the Pollock estate to E. V. Thaw.

1973
Marlborough Gallery presented a show of Krasner's recent paintings (April 21–May 12). Marcia Tucker organized *Lee Krasner: Large Paintings* for the Whitney Museum of American Art (November 13, 1973–January 6, 1974).

1975

Gene Baro curated *Lee Krasner: Collages and Works on Paper, 1933–1974* for the Corcoran Gallery of Art, Washington, D.C. (January 11–February 16), and it traveled later that year to Pennsylvania State University and then to the Rose Art Museum, Brandeis University.

1976

Krasner left the Marlborough Gallery and joined Pace Gallery.

1977

Pace Gallery presented *Lee Krasner – Eleven Ways to Use the Words To See* (February 19–March 19).

1978

Lee Krasner: Works on Paper 1938–1977 was shown at the Janie C. Lee Gallery, Houston (September 21–October 31). Krasner was the only woman included in the first overview of early Abstract Expressionism, *Abstract Expressionism: The Formative Years*, curated by Robert Hobbs and Gail Levin; it opened at the Herbert F. Johnson Museum of Art, Cornell University (March 30–May 14), and then traveled to the Seibu Museum of Art, Tokyo (June 17–July 12), and the Whitney Museum of American Art, New York (October 5–December 3).

1979

Pace Gallery held the exhibition *Lee Krasner: Paintings 1959–1962* (February 3–March 10).

1981

Lee Krasner: Paintings, 1956–1971 was shown at the Janie C. Lee Gallery, Houston (February 7–March). *Lee Krasner/Solstice* was presented at Pace Gallery (March 20–April 18). Guild Hall in East Hampton opened *Krasner/Pollock: A Working Relationship* (August 8–October 4), curated by Barbara Rose; a separate catalogue was produced for the showing of this exhibition at the Grey Art Gallery and Study Center, New York University (November 3–December 12). During this year Krasner began to suffer from arthritis and colitis.

1982

January: Krasner was awarded the Chevalier de l'Ordre des Arts et des Lettres by the French government. Toward the end of the year, she left Pace Gallery and joined the Robert Miller Gallery. Robert Miller, who had been her studio assistant in the early 1960s, was a close and trusted friend. The Robert Miller Gallery presented a mini-retrospective of Krasner's Umber and White series in *Lee Krasner: Paintings from the Late Fifties* (October 26–November 20).

1983

Barbara Rose curated *Lee Krasner: A Retrospective* for the Museum of Fine Arts, Houston (November 28, 1983–January 8, 1984), along with a supplemental educational exhibition, *Lee Krasner: The Education of an Artist*. After closing in Houston, both shows were presented at other venues, traveling to the San Francisco Museum of Modern Art (February 9–April 1), the Chrysler Museum (April 26–June 17), and the Phoenix Art Museum (August 23–October 7).

1984

Krasner died on June 19. A reduced version of her traveling retrospective was shown at the Museum of Modern Art, New York (December 19–February 1985). The Brooklyn Museum presented *Lee Krasner: Works on Paper* (December 20, 1984–February 25, 1985).

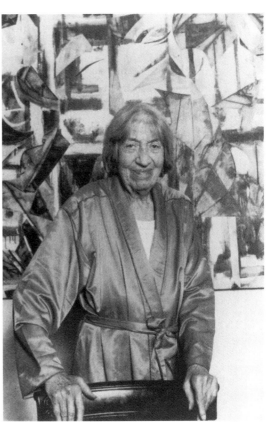

Lee Krasner, ca. 1980s

1985

The educational exhibition that had originated in Houston and that was first intended to complement the Museum of Fine Arts retrospective was featured in the Great Hall Lobby of the Cooper Union (January 16– February 22), augmenting the *Lee Krasner: Works on Paper* exhibition at the Brooklyn Museum.

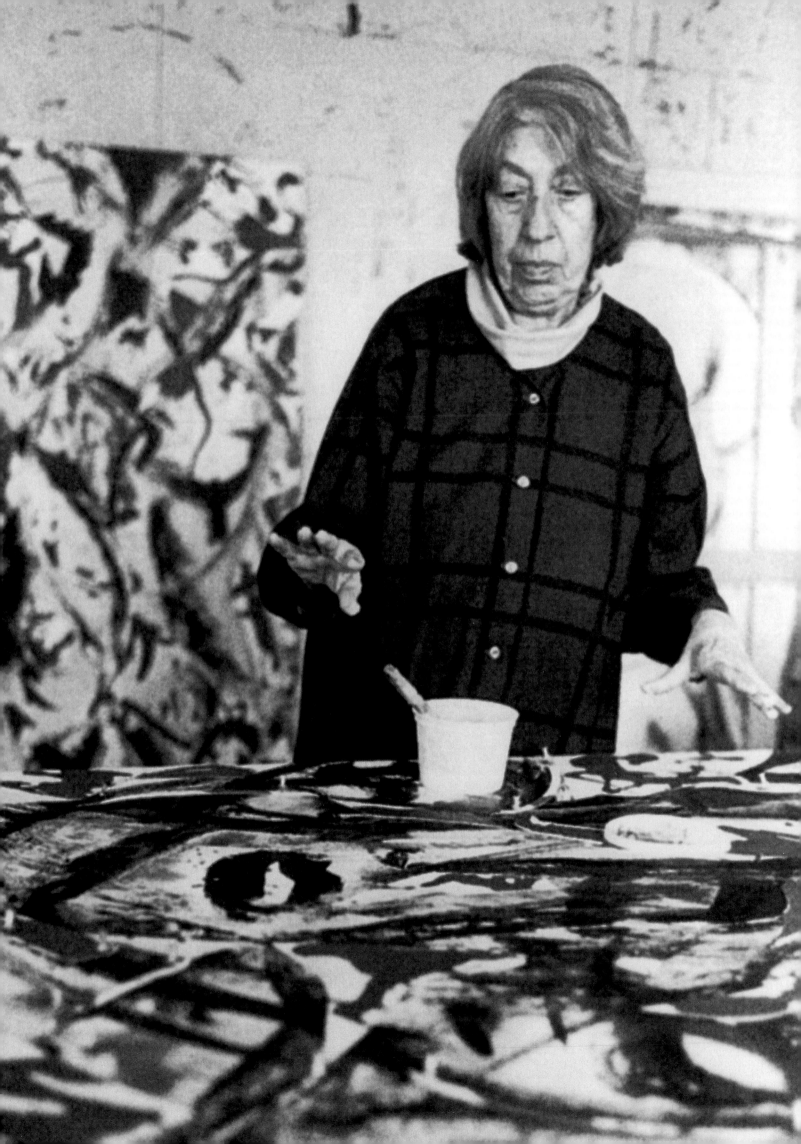

Selected Bibliography

Books and Catalogues

Auping, Michael, ed. *Abstract Expressionism: The Critical Developments.* Buffalo: Albright-Knox Gallery, and New York: Harry N. Abrams, Inc., 1987.

Baro, Gene. *Lee Krasner: Collages and Works on Paper, 1933–1974.* Washington, D.C.: Corcoran Gallery of Art, 1975.

Chadwick, Whitney and Isabelle de Courtivron, eds. *Significant Others: Creativity and Intimate Partnership.* London: Thames & Hudson, 1993.

Cheim, John, ed. *Lee Krasner Paintings 1965 to 1970.* New York: Robert Miller Gallery, 1991.

Diamonstein, Barbaralee. *Inside New York's Art World.* New York: Rizzoli, 1980.

Fine, Elsa Honig. *Women and Art.* Montclair, NJ, and London: Allenheld & Schram, 1978.

Friedman, B. H. *Jackson Pollock: Energy Made Visible.* New York: McGraw-Hill Book Co., 1972.

Gibson, Ann. *Abstract Expressionism: Other Politics.* New Haven and London: Yale University Press, 1997.

Hobbs, Robert. *Lee Krasner.* New York: Abbeville, 1993.

Hobbs, Robert Carlton and Gail Levin. *Abstract Expressionism: The Formative Years.* Herbert F. Johnson Museum of Art, Ithaca, NY: Cornell University, and New York: Whitney Museum of American Art, 1978.

Howard, Richard. *Umber Paintings 1959–1962.* New York: Robert Miller Gallery, 1993.

Kuthy, Sandor and Ellen G. Landau. *Lee Krasner—Jackson Pollock: Künstlerpaare-Künstlerfreunde, Dialogue d'artistes-résonances.* Bern, Switzerland: Trio-Verlag, 1989.

Landau, Ellen G. *Jackson Pollock.* New York: Harry N. Abrams, Inc., 1989.

_____. *Lee Krasner: A Catalogue Raisonné.* New York: Harry N. Abrams, Inc., 1995.

Lee, John Post. "Lee Krasner and *Eleven Ways to Use the Words to See*" (senior thesis, Vassar College). This thesis contains an interview with Lee Krasner, East Hampton, New York, November 28, 1981.

Lee Krasner Recent Work. New York: Pace Gallery, 1981. [Excerpts from Barbara Novak's October 1979 interview with Lee Krasner are published in this catalogue.]

Lee Krasner—Eleven Ways to Use the Words to See. New York: Pace Gallery, 1977.

Lee Krasner Collages 1939–1984. New York: Robert Miller Gallery, 1986.

Leja, Michael. *Reframing Abstract Expressionism: Subjectivity and Painting in the 1940s.* New Haven and London: Yale University Press, 1993.

Marter, Joan. *Women and Abstract Expressionism: Painting and Sculpture, 1945–1959.* New York: Baruch College/CUNY, 1997.

Munro, Eleanor. *Originals: American Women Artists.* New York: Simon & Schuster, 1979.

Naifeh, Steven and Gregory White Smith. *Jackson Pollock: An American Saga.* New York: Clarkson N. Potter, 1989.

Nemser, Cindy. *Art Talk: Conversations with 12 Women Artists.* New York: Charles Scribner's Sons, 1975.

Polcari, Stephen. *Lee Krasner and Abstract Expressionism.* Stony Brook, NY: University Gallery, State University of New York, 1988.

Lee Krasner at work in her studio, 1981

_____. *Abstract Expressionism and the Modern Experience*. Cambridge, England and New York: Cambridge University Press, 1991.

Potter, Jeffrey. *To a Violent Grave: An Oral Biography of Jackson Pollock*. New York: G. P. Putnam's Sons, 1985.

Rose, Barbara. *Krasner/Pollock: A Working Relationship*. East Hampton: Guild Hall, 1981.

_____. *Krasner/Pollock: A Working Relationship*. New York: Grey Art Gallery and Study Center, New York University, 1981.

_____. *Lee Krasner: A Retrospective*. Houston: Museum of Fine Arts, Houston; New York: The Museum of Modern Art, 1983.

Robertson, Bryan and B. H. Friedman. *Lee Krasner: Paintings, Drawings, and Collages*. London: Whitechapel Art Gallery, 1965.

Rubinstein, Charlotte Streifer. *American Women Artists*. New York: Avon, 1982.

Schwartz, Constance. *The Abstract Expressionists and Their Precursors*. Roslyn Harbor, NY: Nassau County Museum of Art, 1981.

Solomon, Deborah. *Jackson Pollock: A Biography*. New York: Simon & Schuster.

Strassfield, Christina Mossaides. *Lee Krasner: The Nature of the Body Work. Works from 1933 to 1984*. East Hampton, NY: Guild Hall Museum, 1995.

Tucker, Marcia. *Lee Krasner: Large Paintings*. New York: Whitney Museum of American Art, 1973.

Wagner, Anne Middleton. *Three Artists (Three Women): Modernism and the Art of Hesse, Krasner, and O'Keeffe*. Berkeley: University of California Press, 1996.

Selected Articles

Cavaliere, Barbara. "Lee Krasner: A Meeting of Past and Present," *SoHo Weekly News*, February 1, 1979, p. 41.

_____. "An Interview with Lee Krasner." *Flash Art* 94–95 (January–February 1980), pp. 14–16.

Cannell, Michael. "An Interview with Lee Krasner," *Arts Magazine* 59, no. 1 (September 1984), pp. 87–89.

Glasser, Bruce. "Jackson Pollock: An Interview with Lee Krasner," *Arts Magazine* 41, no. 6 (April 1967), pp. 36–9.

Glueck, Grace. "Scenes from a Marriage: Krasner and Pollock," *ARTnews* 80, no. 10 (December 1981), pp. 57–61.

Howard, Richard. "Lee Listening: Lee Krasner Pollock," *Grand Street* 4, no. 1 (autumn 1984), pp. 183–186.

Landau, Ellen G. "Lee Krasner's Early Career, Part One: 'Pushing in Different Directions,'" *Arts Magazine* 56, no. 2 (October 1981), pp. 110–22.

_____. "Lee Krasner's Early Career, Part Two: The 1940s." *Arts Magazine* 56, no. 3 (November 1981), pp. 80-89.

_____. "Channeling Desire: Lee Krasner's Collages of the Early 1950s." *Woman's Art Journal* 18, no. 2 (fall 1997/winter 1998), pp. 27-30.

Myers, John Bernard. "Naming Pictures: Conversations Between Lee Krasner and John Bernard Myers," *Artforum* 23, no. 3 (November 1984), pp. 69–73.

Nemser, Cindy. "The Indomitable Lee Krasner," *The Feminist Art Journal* 4, no. 1 (spring 1975), pp. 4–9.

Wagner, Anne Middleton. "Lee Krasner as L.K.," *Representations* (winter 1989), pp. 42–56.

Index

Lenders to the Exhibition

Albright-Knox Art Gallery, Buffalo

Roberta Rymer Balfe

Brooklyn Museum of Art

John Cheim

Dallas Museum of Art

Dr. Jerome and Rhoda Dersh

Des Moines Art Center

Deutsche Bank AG, New York

Byron and Dorothy Gerson

Robert Glickman

Mr. and Mrs. Graham Gund

Halley K. Harrisburg and Michael Rosenfeld

Dr. and Mrs. Jerome Hirschmann

Indianapolis Museum of Art

Mrs. Audrey M. Irmas

IVAM. Instituto Valenciano de Arte Moderna. Generalitat Valenciana

Rena "Rusty" Kanokogi

Mr. & Mrs. David Margolis

The Metropolitan Museum of Art, New York

Robert Miller Gallery, New York

The Museum of Contemporary Art, Los Angeles

The Museum of Modern Art, New York

National Gallery of Art, Washington, D.C.

Norfolk Southern Corporation, Norfolk, Virginia

The Pollock-Krasner Foundation, New York

Fayez Sarofim

Mr. and Mrs. Eugene V. Thaw

Thyssen-Bornemisza Foundation, Castagnola-Lugano, Switzerland

University Art Museum, California State University, Long Beach

Whitney Museum of American Art, New York

Michael Williams, The Ginny Williams Family Foundation, Denver

Mr. and Mrs. Jerome Zimmerman

Roy Zuckerberg

Private collections in Boston, Dallas, New York, Madrid, and
 Short Hills, New Jersey

Photography Credits

© 1971, Aperature Foundation, Inc., Paul Strand Archive, page 67 (fig. 8)

AP/Wide World Photo, pages 29 (fig. 2), 30

Maurice Berezov, courtesy Archives of American Art, Smithsonian Institution, page 11

Courtesy Brooklyn Museum of Art, plate 88

Courtesy Cheim & Read, New York, plate 51

Ann Chwatsky, courtesy Robert Miller Gallery, page 1

Jerry Cooke, courtesy Janice Van Horne, page 29 (fig. 1)

D. James Dee, plates 6, 7, 26, 28, 85, 93, 95

Halley Erskine, © Estate of Lee Krasner, courtesy Robert Miller Gallery, page 17

Courtesy Byron & Dorothy Gerson, plate 92

Bernard Gotfryd, page 213

Ernst Haas Studio, New York, page 214

Martha Holmes/Life Magazine © Time Life, page 12

Lee Krasner Papers, Archives of American, Smithsonian Institution, pages 21, 28, 50, 182, 205, 207, 208

Courtesy Meredith Long & Co, Houston, plate 12

Robert Mapplethorpe, 1982, © The Estate of Robert Mapplethorpe by permission of Art and Commerce, New York, page 26

Courtesy The Metropolitan Museum of Art, New York, plates 3, 86

Courtesy Robert Miller Gallery, front cover, frontispiece, plates 1, 2, 4, 5, 11, 14, 15, 16, 17, 19, 22, 24, 25, 27, 31, 36, 37, 38, 40, 43, 44, 45, 46, 47, 48, 49, 50, 53, 54, 55, 57, 58, 59, 60, 61, 62, 63, 65, 66, 67, 69, 70, 71, 72, 73, 74, 76, 77, 78, 80, 81, 82, 83, 87, 90, 91, 94, 97

Courtesy, ©1999, The Museum of Modern Art, New York, plates 64, 79

© 1999, Estate of Hans Namuth, pages, 14, 117, 202, back cover

Irving Penn, courtesy Vogue, Copyright ©1972 by the Condé Nast Publications, Inc., page 224

Courtesy Philadelphia Museum of Art, plate 33

Beth Phillips, courtesy Robert Miller Gallery, plates 18, 68, 75

Phillips/Schwab, courtesy Robert Miller Gallery, frontcover, plates 9, 13, 30, 35, 84, 96

Courtesy Private Collection, plate 56

Courtesy Michael Rosenfeld Gallery, plate 34

Richard Sandler, page 67 (fig. 7)

Courtesy Fayez Sarofim Collection, plate 8

Scala/Art Resource, New York, page 31

Snark/Art Resource, New York, page 52

Steven Sloman, plate 20, 21, 42, courtesy Robert Miller Gallery

Michael Tropea, courtesy the Des Moines Art Center, plate 39

Courtesy Thyssen-Bornemisza Foundation, Lugano-Castagnola, plate 10

Unidentified Photographer, page 211

Waintrob-Budd, pages 6, 204

Zindman/Fremont, courtesy Robert Miller Gallery, plates 23, 29, 32, 41, 52, 89

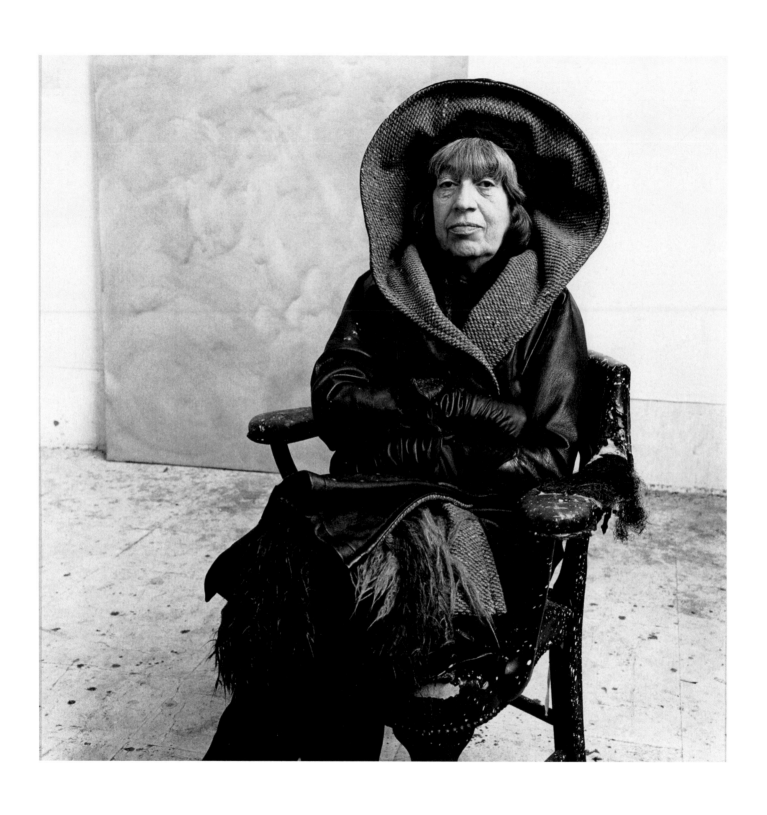

Lee Krasner, The Springs, 1972
Photograph by Irving Penn
Courtesy Vogue ©1972 by the
Condé Nast Publications, Inc.